TIMELESS CITIES

TIMELESS CITIES

An Architect's Reflections
on Renaissance Italy

David Mayernik

Westview
PRESS
An Icon Edition

A Member of the Perseus Books Group

Copyright © 2003 by Westview Press, a Member of the Perseus Books Group

Published in the United States of America by Westview Press, A Member of the Perseus Books Group, 5500 Central Avenue, Boulder, Colorado 80301–2877, and in the United Kingdom by Westview Press, 12 Hid's Copse Road, Cumnor Hill, Oxford OX2 9JJ.

Find us on the world wide web at www.westviewpress.com

Westview Press books are available at special discounts for bulk purchases in the United States by corporations, institutions, and other organizations. For more information, please contact the Special Markets Department at the Perseus Books Group, 11 Cambridge Center, Cambridge, MA 02142, or call (617) 252-5298, (800) 255-1514 or email j.mccrary@perseusbooks.com.

Library of Congress Cataloging-in-Publication Data
Mayernik, David.
 Timeless cities : an architect's reflections on Renaissance Italy / David Mayernik.
 p. cm.
Includes bibliographical references and index.
 ISBN 0-8133-6592-9 (hardcover)
 1. Architecture, Renaissance—Italy. I. Title.
NA1115.M39 2003
720'.945'09024—dc21
 2003014595

The paper used in this publication meets the requirements of the American National Standard for Permanence of Paper for Printed Library Materials Z39.48–1984.
Interior Design by Lisa Kreinbrink
Typeface used in this text: 11-point Sabon

10 9 8 7 6 5 4 3 2 1

To T.N.R., who dares to dream of cities

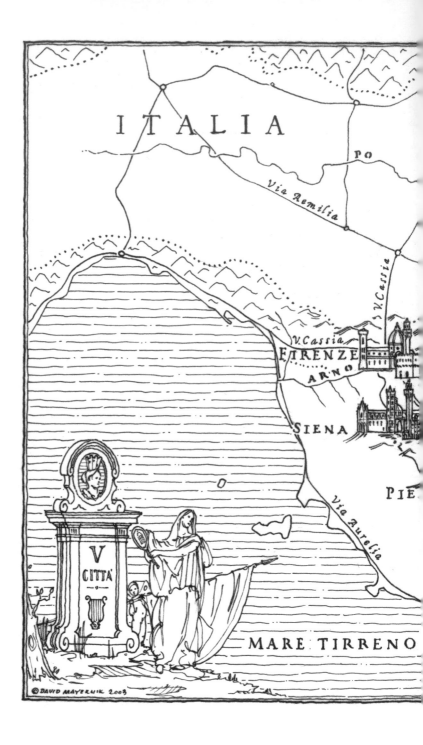

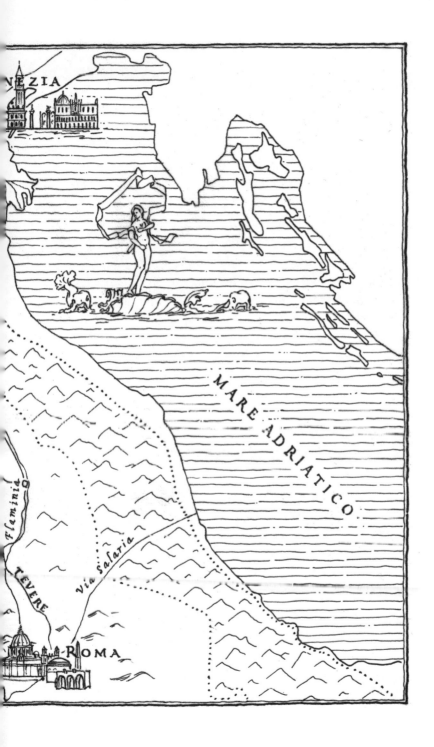

The ancients, Varro and Plutarch among others, mention that our ancestors used to set out the walls of their cities according to religious rite and custom. On an auspicious day they would yoke together a bull and a cow, to draw a bronze ploughshare and run the first furrow, which would establish the course of the town walls. The fathers of the settlement would follow the plough, the cow on the inside and the bull on the outside, turning any uprooted and scattered clods back into the furrowed line, and piling them up to prevent their being dispersed. When they reached the point where the gates were to be, they carried the plough by hand, leaving the threshold of the gate untouched. By this means they deemed the whole course and fabric of the walls consecrated, with the exception of the gates, which could not rightly be called sacred.

—Leon Battista Alberti,
On the Art of Building in Ten Books

CONTENTS

Introduction

Everyone relies on the city and all the public services that it contains. If we have concluded rightly, from what the philosophers say, that cities owe their origin and their existence to their enabling their inhabitants to enjoy a peaceful life, as free from any inconvenience or harm as possible, then surely the most thorough consideration should be given to the city's layout, site, and outline.
　　　–Leon Battista Alberti, *On the Art of Building in Ten Books*

For millennia the City was the touchstone of human achievement.[1] Arguably cities may still be the most important of all human artifacts, in no small part because of their enormous impact on our landscape, ecology, economy and society. But they also say much about us as a culture—our image of ourselves, our values, priorities and aspirations (or lack thereof)—at the same time that they actually *form* who we are and who we become. As

Winston Churchill said, "First we shape our buildings, and then our buildings shape us." The cities with which Leon Battista Alberti was familiar in the fifteenth century, and which he would also help to shape, were products of humanist culture; that culture gave those cities a mythology and a self-image. Humanist cities, as much as their human inhabitants, had personas shaped by their history and aspirations, and it is no accident that their physical form is a direct consequence of that urban self-image. For many centuries cities in European culture shared to an extraordinary degree a set of ideals and mythologies that created the remarkable living civic artifacts that their residents continue to enjoy and tourists flock to visit. The dramatic change to that self-image in the eighteenth century thereafter fundamentally changed the course of city building, and therefore also changed the lives of city dwellers in ways we only dimly recognize today.

One might ask, How practically important is the Idea of a city to its actual construction? Indeed it would seem that in the past (just as now) much of the urban fabric was shaped by accident, by chance, sometimes by ideas contrary to what will be argued had been the dominant cultural vision for much more than a millennium. In many ways Rome is a perfect example. For centuries virtually forgotten, the city of Rome has been subject to all the chaos any urban fabric could hope to endure. Rome has been built over, within, around and on top of majestic ruins, left to inhabitants who stripped the marble facing from the Colosseum to burn in lime kilns, jostled over by warring baronial families. And yet she emerged with perhaps the richest palimpsest of a coherent story possible, one that is the envy of cities everywhere. That is in fact the point. The dream of what Rome could be, and the memory of what it once had been, guided a process that the architectural historian Joseph Connors has called *incremental urbanism*: Establish a piazza here, design a new facade there, place a door to align with a street, straighten

a street or bend it toward a monument. Those urban projects that blossomed out of localized building activity also left traces of grander visions on their immediate context. The only way by which that process, worked out over centuries, could be knit together into any kind of coherent noble result was with a collective cultural vision: Rome is the long-term wish fulfillment over hundreds of years of like-minded and idealist humanists, patrons and popes—more or less, anyway. There are innumerable instances of where this didn't quite happen, and no doubt Bernini's great patron, Pope Alexander VII, went to his grave feeling much was left to do. Cities as works of art are rarely, if ever, complete in any absolute sense; only the occasional town built *ex novo*—from scratch, and by design—or the monastery give a glimpse of completely realized urban ideals. Yet the Idea of a city can leave its mark on every incremental bit of urban design, and when this idea is consistent, powerful and a good stretch beyond the ordinary, the city it generates can become more than a mere background to our daily lives. It can become virtually a foretaste of paradise that, as Alberti believed, gives us the fullest possibility of living the good life here on earth.

This book will trace the continuity of the Idea of the City in five Italian cities from late antiquity to the eighteenth century, looking most deeply at the extended Renaissance, examining both the urban artifacts themselves and the people who built them said and thought about them. The urban story that unfolds is a powerful testimony to the beauty of cities and the nobility of city dwelling, but ultimately to the importance of coming to grips with what we want to say with our own urban legacy.

Consider this book as a guide or mental map in its own way to how cities were seen in the past. If the past really is a foreign country, this way of looking at cities may seem strange indeed; I can assure you it is certainly foreign to the builders of our urban landscape during the last two centuries. But cities that were built

from this point of view are still accessible to us, and they often strike visitors as oddly familiar, more like home than home itself. The itinerant Bordelaise essayist Michel de Montaigne observed after his first and prolonged visit to Rome in 1580–1581 that "The pleasures of residence in this city are increased by more than half with acquaintance." This book opens a door to some of the formative ideas behind a city such as Rome's pleasures, but also may inspire an understanding of what Rome can represent for us today: a living civic model that transcends both time and place.

THE CITY AS AN IDEA

The mobs of great cities add just so much to the support of pure government as sores do to the strength of the human body.

—Thomas Jefferson, "Notes on the State of Virginia"

America is, if one believes the Census Bureau, an urban culture simply because a majority of our population lives in or near centers of some modest population density.[2] At the same time it must be said, however, that the American consciousness has not exactly had a love affair with the Idea of cities. As children of our Enlightenment founders, for centuries we have instead organized our collective imaginations almost exclusively around a Rousseauian Romantic idyll. It is enough to watch television commercials to witness the landscape of our dreams: Whether driving a car or falling in love, the background is mostly rolling countryside and wide open spaces, rugged mountains or rocky seashores. Or have a glance at our cemetery parks—our own modern, misty, picturesque Elysian Fields. In this we share every Modern society's dream to escape the very image of the city in

both life and death that grew up, as did the United States, in tandem with the Industrial Revolution. Dickens's sooty, cruel London; the cold, heartless Paris of Puccini's *La Bohème*; the crowded tenements of immigrant New York—places of dirt, disease and crime that confirmed Jefferson's pessimistic view of urban life. If that reputation has been rehabilitated at all in the last century, it is either in a new romance of the city's dangers—the edgy, bohemian film noir image of New York's Soho or the Lower East Side that lives on somewhere in myth even as those neighborhoods have become safe commercial districts—or the pragmatic resignation to and indeed celebration of the City as a thumping heart of Commerce. The Dutch architect Rem Koolhaas has even made a romantic virtue of the visual chaos of Manhattan in his deconstructionist manifesto *Delirious New York*, likening it favorably to Coney Island.[3] When we finally do tame our cities, it is often only to repackage them into safe, bland shopping malls.

This has been in many ways a self-fulfilling philosophy. The less we have loved cities, the more we have made of them what we fear or dislike; or else we resign ourselves to their aggressive banality. Cities, towns and neighborhoods that have made "comebacks" in the last century first had to overcome the hurdle of defining why what they have is worth saving in the first place. In many cases our most meager aspirations unfortunately relegated whole segments of society to a dangerously dehumanizing urban existence where they were warehoused and forgotten. Even when we have built well, our aspirations for our cities have not extended much beyond satisfying the promenading *flâneur* in all of us. We never really expect our cities to *say* something important about who we are and what we collectively value.

It was not always this way. Saint Augustine of Hippo, writing in the early fifth century as Rome and the whole classical

culture she stood for fell to barbarian invasion (a barbarian by definition was someone not from an urban *civil*ized culture), uses the City as a metaphor for Paradise in his most famous and influential work, *De Civitate Dei* (The City of God). For better or worse the Rome he knew was the center of her empire's collective consciousness: what her armies fought for, her poets extolled, her architects exported. Augustine wanted to imagine a better Rome, ultimately a heavenly one, but no concrete image could come to mind for a paradise that summed up and embodied the fullness of the human condition (including the divine part) better than a City. He wrote the book against the backdrop of a dispirited conquered Rome, one that blamed Christians for having weakened the empire's martial resolve.[4] Augustine's point is that Christians are living for a second Rome, one not part of this world, and only that image—the vision of this celestial City, the good twin to the flawed earthly one—can sustain our collective souls. Or conversely, the earthly city instead could strive to become—since it could not ever really match heaven—a vestige, a shadow, a mirror or a trace of the *civitas dei*. Since the Heavenly City existed outside of time or contingency, one could live simultaneously in the Earthly and Heavenly Cities, the former being a physical necessity, the latter a spiritual goal. While never meaning to be an architectural theorist, Augustine still gave Western society an idea of heaven in the form of a city that partly redeemed an urban culture in crisis. Surely not his main point, this vision—in a way a prophecy—about a resurgent image of the celestial city as an alternative to the corrupt dying cities that he knew sustained the City as an idea in the European imagination. Yet urban reality proved to be much more cruelly destructive over the next few centuries.

In its own way this was again a self-fulfilling prophecy. Augustine's unrivaled reputation as a doctor of the Church ensured

for him a prominent place in the theology of post-Roman Europe, and his *City of God* also locked itself into society's psyche as not just a spiritual goal but an architectural one. Every medieval monastery (especially those that effectively took the place of urban culture in the centuries after Rome's fall) and many medieval towns saw themselves as Cities of God, New Jerusalems, Cities on a Hill. Augustine did not really invent this idea—it is in Psalm 122, for example, and in the Book of Revelation—but he gave it weight and clarity and allied it to classical culture. The Idea of the City as a metaphor for the Earthly Paradise eventually reached an apogee of building energy in the resurgent cities of the Renaissance, beginning most famously with Florence. Whether daily existence for ordinary citizens in those places ever matched their culture's architectural aspirations is another story. But we have inherited from those centuries a built legacy of spectacularly beautiful and remarkably humane cities across the European continent that says much for the value of believing in the Idea of a city and in the City as an ideal.

Augustine's whole frame of reference was in many ways representative of classical humanist culture in both its pagan, or secular, form as he had learned it in school and its Christian form as he himself transformed it. This is the way succeeding centuries would draw on and wrestle with it. So in order to weave this thread of the story of the Idea of the City, it is worth a brief look at the world of classical and Christian humanism, a world that was for more than a millennium the intellectual wellspring of that urban Idea.

Humanism is a term that has often been coopted in the last century and a half to define a decidedly secular and mostly scientific culture concerned with what secular humanists consider our properly "human" nature—that is, rational and nonreligious, as opposed to one guided by religion and faith. And conversely,

many others have used it instead as a pejorative term to describe precisely the same attitude.[5] Here the term *humanism*, however, is used as historians of Western culture have used it, although admittedly it is a rather newer word than the period it defines, one that really didn't come into our lexicon until the nineteenth century (via German cultural scholars). While the definition of humanism has been the subject of a tug-of-war for more than a century, humanists have been easier to define in art-historical circles. The American art historian Ingrid Rowland gives this succinct definition of Renaissance humanists: "people who had undergone the course of classical studies known in their own day as humane letters, *studia humanitatis*."[6] The *studia humanitatis* evolved through the centuries from the courses of the classical *trivium* (the three disciplines of grammar, rhetoric and logic) and *quadrivium* (the other four fundamental disciplines of music, astronomy, geometry and arithmetic) taught in late imperial Rome and medieval Europe.[7] Today's university courses we define as the Humanities wouldn't include fields such as astronomy or geometry. These only make sense together with the arts if we recognize that there was not a big gap in the classical humanist mind between what we know as philosophy and what they called natural philosophy (the understanding of the physical world, or what we call the sciences). Further, classical humanists saw these classical studies as the source of the ideal of the fully formed human consciousness that was meant by the *artes liberales*, the "liberal" arts that defined the free person. "*Humanitas*, as Cicero understood it, was closely associated with the old Roman virtue of *clementia*.. . . [I]t was the study of art and literature rather than of philosophy which was supposed to result in 'humanity'."[8]

As an educational program in what we would call the humanities, humanism therefore formed the academic background of people as diverse in time and temperament as the second-

century Roman emperor Hadrian and the fifteenth-century pope Pius II.[9] Indeed since virtually all educated people in the long period in which we are interested were schooled in the humanities, it is those who excelled in and continued that education throughout their lives whom we properly distinguish as humanists. Humanism gave them a broad-based interest in everything that touched human life, a confidence in the potential of human achievement derived from an appreciation of the canon of past achievements and a common mythic-narrative repertoire that could sustain a rich, accessible allegorical tradition. Their humanist culture was the seedbed of these ideas about cities we will be investigating, and so perhaps an introduction to Leon Battista Alberti, one of the Renaissance's most renowned and influential humanists, may also be in order.

Renaissance Man was virtually coined to describe Alberti.[10] Born in Genoa to an ancient, noble Florentine family in exile, Alberti was trained as a lawyer and schooled in the classics. An expert autodidact in everything from augury to architecture, he wrote perhaps the first-ever treatise on the art of painting, another one on the family (although, ordained a priest after his schooling in Bologna, he never had one of his own), and still others on horsemanship and sculpture. An inventor, poet, rhetorician and sculptor, he was even quite a good athlete (it was said he could leap over the head of a standing man). Alberti is especially of interest here owing to his work as an architect but even more so, to his well-received treatise on architecture *On the Art of Building in Ten Books*. And what is particularly important about him is how he saw the role of architecture as in many ways an extension of the art of rhetoric, which had been neatly summarized by Cicero as the art of "the good man speaking well." In other words Alberti thought buildings should say something—about their owner, their city, their culture, their patron saint—and he was especially concerned about saying whatever it was

well. This was not a novel idea (indeed that is what *everyone* was doing who built cities until Alberti's time, as we will see), but he was unique in the clarity, rigor and eloquence he brought to the articulation of that idea. He staked out the conceptual ground rules for what Renaissance architects would do for the next three centuries, making architects and patrons across Europe into good men and women speaking well through their buildings. "Our own Latin ancestors chose to express the deeds of their most famous [citizens] through sculpted histories. This gave rise to columns, triumphal arches, and porticoes, covered with histories (*istorie*) in painting or sculpture."[11]

Leon Battista Alberti was more than a writer about building, he also had been an architect, or at least a dilettante. He actually tried to put his theories into practice, and at the same time his theories were often shaped by practice. For the most part his built work was either an addition or modification to an existing structure, or else was left unfinished (that is, for others to finish). But as an adept courtier, his impact was perhaps most profound behind the scenes, where he had the ear of a succession of popes and other powerful people. Moreover, more than a century would pass before another architect attempted to publish a compelling, culturally and philosophically holistic treatise such as his, and in many overt and subtle ways his treatise provided the deep intellectual armature for the whole of the Renaissance and beyond.[12] Alberti's ideas and interests play a large role in the development of the cities of the Renaissance that we will encounter in subsequent chapters.

This book, which touches on the history of five Italian cities, is written by an architect—that is, someone with a vested interest in how we make the fabric of our cities today. While this book ranges across 1,800 years of the history of Italian urban culture, the role of history here—as it was for the Greek writer Plutarch in his collection of *Lives* of eminent figures of antiq-

uity—is to teach. In other words the author presumes that the legacy of great cities embodies a way of thinking about making the urban fabric that is not only worth knowing about, it is especially worth learning from again. The weight of this presumption depends on the compelling qualities of some of those most remarkable cities that we admire today: Rome, Venice, Florence, Siena and little Pienza. And its purpose implies both that we have mostly forgotten how these cities were made in the past and that we are therefore unaware of how we might make our own cities as compelling today. These cities are more than the sum total of their material facts—their plans and façades, bricks and mortar, sculpture, streets and sewers—and more than records of the powers and politics that shaped them. They are, most profoundly, the products of the dreams and desires of those who built them. So to learn lessons from them must mean, at some level, understanding and appreciating those dreams and desires of the culture from which they sprang. Making our own cities speak well for our own culture's dreams and desires depends for its success on our remembering how this was done in the past.

Since the book addresses several cities and covers many centuries, our visits to each must be relatively brief, and concise. The goal is to present a group of crucial, formative and specifically urban ideas about each place, the aggregate of which, at the end of our short Italic excursus, will add up to a broadly representative cross section of the mind and culture of city builders before the Enlightenment.

There are some essential reasons why I have chosen to define the terminus of this story after the middle of the eighteenth century. First, I assume an essential continuity of worldview until that time, from antiquity through the Renaissance and Baroque periods (not leaving out the Middle Ages). For me this is underpinned by both the accepted cultural canon obtaining in those

centuries (a canon that I define as the humanist tradition in phi-
losophy, literature and the arts)—which often wobbled but never
really fell—and by the fundamental understanding during that
long period that the primary role of any work of art, most espe-
cially the art of making cities, was to speak. Style per se was only
a part of speaking well, but certainly not the ultimate goal. To
my mind the change toward emphasizing style over content de-
fines a large part of the monumental shift that took place in all
the arts in the late 1700s, and it is almost exactly coincident with
the devaluation of the City as a metaphor for culture generally
and for Paradise in particular. Second, regarding cities specifi-
cally, the making of cities for millennia was an art form; a rising
rationalism that defined the Enlightenment made city design,
from then on known as urban planning, into something that
wanted to be a science. There was still much of art in the think-
ing about cities throughout the nineteenth and even into the early
twentieth century, but it is a telltale fact that from roughly 1800
on city planning is done far more often by engineers than by ar-
chitects, much less by artists. Inversely, the seeds of this attitude
can be traced to the century before the eighteenth, in part to
France and Louis XIV's military engineer and city builder
Vauban. As Alberto Perez-Gomez says in his seminal book *Archi-
tecture and the Crisis of Modern Science*, "For Vauban, only ra-
tional quantitative considerations were to determine the choice
of site for a new city. No thought was spent on the traditional
question of the place's 'meaning'."[13] The conclusion will trace
the trajectory of this decline of the art of meaning in city making.
But the art of meaning's basic assumptions—that cities as works
of art "spoke" for their societies' aspirations and that their aspi-
rations transcended mundane functions—underlie the view
about how cities were imagined throughout the chapters.

Cities to the European imagination before the Enlightenment
were more than simply Places, they were built Ideas suffused

with cultural Memory. For a culture that had developed an elaborate visual mnemonic technique—constructed around using mental images of places to remember abstract ideas (which will be explored in chapter 1)—a city was the most elaborate memory place imaginable. And so the urban landscape (both real and imaginary) came to be seen as a kind of map of the mind, a three-dimensional model of the mental matrix, a mnemonic mirage. As much as this use of the city shaped the personal mnemonic skills of those adepts who were trained in this system (who depended on powerful mental images of cities to recall voluminous texts), more profoundly it also reverberated back to real cities. They themselves came to be seen more and more like real, built models of the mind, or even *the* Mind, the Divine Mind that ordered the very cosmos. Moreover, with Christian culture supplanting (in fact synthesizing) the evaporating classical pagan culture after the fall of Rome, cities were also invested with the images of Paradise that Saint Augustine, perhaps inadvertently, attached onto them with his book *The City of God*. For city builders for more than a thousand years after Augustine the urban realm became a great memory theater where our best aspirations were played out, the place where we said the most substantial things about who we are and what we long for. The City at its best was nothing other than a microcosm of the world, a model of the human mind and an image of heaven. For those of us lucky enough to visit Rome, Venice, Florence, Siena or Pienza now, on one of those memorable days with an early autumn chill in the air, when the late afternoon light is fading toward dusk and we can smell logs of holm oak beginning to be burned in the fireplaces, when we hear bells ringing from campaniles close by and echoes from others far off, and we perhaps have a shapely carved stone bench to sit on, we would have to say that they weren't far from wrong.

1

Rome

THE MEMORY CITY

*A*eneas, refugee from Troy and mythical pater of the Roman people, founded his first Latin city, Alba Longa, on the site of the current Albano Laziale in the hills above Rome. He is said to have determined the site by following a pregnant sow to the spot where she gave foal. Two generations later his semidivine grandson Romulus ceremonially traced the outline of the future city of Rome's walls with a plow attached to a cow and a bull. This act was considered so sacrosanct that he killed his twin brother, Remus, for violating the sacred precinct that the plow had defined.[1]

The strength of all this seemingly anachronistic agricultural symbolism, of bovine fecundity and potency literally drawing the physical profile of urban Rome, forged for the ancient Romans a sense of the fertile destiny of their city that would sustain them for almost a thousand years. For us, tracing the outline of the Idea of the City in the European imagination must

begin (and eventually should end) in Rome. Why? In part because the ancient city grew to dominate such a wide empire that its agenda, form and influence spread with its armies from England to Romania, founding towns in the image of the *magna mater*, the Great Mother's city, as it went.[2] Those towns often survived after, and indeed thrived beyond, the collapse of the empire—places such as Paris (Lutetia), London (Londinium), or Florence (Florentia) were sometimes relatively minor outposts in the ancient scheme of things, but rebounded after the empire's collapse to become important centers of power and culture.

Rome itself has been continually inhabited—at least in myth—since its foundation by Romulus on 21 April 753 B.C. This remarkable continuity, in fragmentary evidence everywhere around the city even today, belies a much more tenuous historical thread. In fact three great phases of the city's past have shaped the real and imaginary fabric of the present Eternal City in unique ways; those phases were marked as much by destruction as building. Ancient Rome's emperors left their monumental marks on the city, shaping the image of Rome in ways so enduring that centuries of devastating sacks beginning in the fifth century failed to eradicate the city's imperial remains.

In the Middle Ages, between the fall of the Western Roman empire and the rebirth of classical humanist culture in the Renaissance, an often beleaguered citizenry inhabited the shell of the former city while the papacy repeatedly struggled to maintain and rebuild the churches that represented the inheritance of classical civilization. Having been refounded as the capital of the Catholic Church, Rome acquired in that intervening millennium a new mission and a new mythology, both of which contributed as much as the ancient remains to the Renaissance's triumphant reinvention of the urban ideal. The papacy and humanists at the papal court gave the city through those centuries of turmoil a continuous consistent agenda that eventually sent Rome on a

trajectory in the Renaissance, which made it again a model for pan-European urban development.

ANCIENT ROME

The experience of walking the streets of ancient Rome has long since been lost, but substantial fragments of her most important buildings have survived to combine with what we know from contemporary writings to give us some sense of what the ancient city was like. Since we are focusing on cities we can actually experience today, our visit to ancient Rome will therefore be brief. The reign of Octavian Augustus Caesar, which began in 31 B.C. with his victory over Marc Antony and Cleopatra at the Battle of Actium and ended with his death in A.D. 14, is as good a place as any to stop and delve into the Rome of antiquity.

The Rome of the Emperor Augustus

Nothing is too good for the gods.

—Slogan from the reign of Octavian
Augustus Caesar, late first century B.C.

Octavian assumed the title Augustus for himself in 27 B.C., using the adjective to invest himself and his reign with its connotations of dignity, sanctity and good omens; we get our month August from him, the Senate renaming the formerly sixth month, Sextilis, after him.[3] He was the emperor who claimed to have "found a city of brick and left a city of marble." Augustus is pivotal for the whole idea of an imperial Rome, since his adoptive uncle, Julius Caesar, had certainly not established any degree of stability in the structure of power he

created for himself—as Brutus and his coconspirators for the re-
turn of the republic proved. Indeed the Rome Julius knew was
still uncomfortably trying to assimilate the Greek culture that
was alternatively welcomed and reviled in the formerly rustic
republican city on the Tiber. No one before Augustus had so
consciously and effectively used imagery, architectural and oth-
erwise, to stabilize and inspire Rome. Emperors after him
would invariably refer to the *Sæculum Augustum*—the Augus-
tan Age—as a model of political and urban acumen. As the
noted Roman scholar Paul Zanker observes,

> Never before had a new ruler implemented such a far-reaching
> cultural program, so effectively embodied in visual imagery;
> and it has seldom happened since. A completely new pictorial
> vocabulary was created in the course of the next twenty years.
> This meant a change not only in political imagery in the narrow
> sense, but in the whole outward appearance of the city of
> Rome, in interior decoration and furniture, even in clothing.[4]

The *Ara Pacis*—the Augustan altar of Peace—was one of the
emperor's most illustrative urban symbols. Superficially its ex-
ceedingly refined carving, of swirling acanthus foliage and clas-
sically composed figures in procession, was a proclamation of
cultural sophistication and achievement, an assertion of Rome's
claim to the Hellenistic cultural stage. Symbolically its narrative
procession of the Augustan family and entourage (the guaran-
tors of future peace through dynastic continuity) was inter-
woven with images of Roman foundational myths to suggest
that this, peaceful at last, *Sæculum Augustum* was both in-
evitable in light of the Roman myth and destined to last. The
Ara Pacis was in a sense a large piece of urban furniture, but all
of Augustus' other larger urban and architectural projects
would expound on these same themes.

Like many great leaders, Augustus was an excellent judge of character and talent, and one of his wisest appointments was naming the general and admiral Marcus Agrippa as *aedile*, or Head of Public Works. As any public figure in a similar role would attest, marshaling public resources to build infrastructure is very much like a military campaign. Agrippa set himself to the very practical tasks, in their own way just as symbolic as any temple or tomb monument, of bringing water to the city in the form of aqueducts, of cleaning out sewage in the form of the great drain known as the Cloaca Maxima (there is no accident in the implicit reference to the corrupt influences his emperor was sweeping from public life), of building baths (again cleansing the city literally and figuratively) and so on. This infrastructure acknowledged the growing scale of a great city that had begun centuries earlier as a collection of obscure primitive hill villages, a city now in command of the world stage, whose plumbing had to be just as imperial as her *fora*.

Patrons and civil servants, just like the gods, needed architects; ironically, in this period of building that would shape centuries of monumental imagery, the architect that we know best had little to do with much of this public work. It is only because during Augustus' reign an elderly, moderately successful architect addressed a treatise on his discipline to the August emperor that we know this architect's name, and while Marcus Pollio Vitruvius would mostly escape imperial notice in practice, his written treatise lived on—while so many other books perished after Rome fell—to become a wellspring of ideas for ensuing centuries about how Romans and Greeks saw the art of building. Even today it continues to inform a new rebirth of interest in canonical architecture.[5] Vitruvius tells us much about the art of building in his own day, but he is idiosyncratic too, not always well organized in his argument, and with many opinions that later centuries would struggle to reconcile with the often

very different architectural remains from his and later imperial eras. Vitruvius' *Ten Books on Architecture* range from the practical to the poetic, but they are pitched especially to define and defend the nobility of his profession. The *Ten Books* outline the forces put in motion when a building project begins, not the least of which is the symbolic power of great architecture. He was near the end of his career when the emperor Augustus began his own, and Vitruvius saw his role no doubt as a sage veteran advising an important new patron on the nature and value of his art. Wise beyond his years and no doubt preoccupied with matters of state, the new emperor probably never read Vitruvius' *Ten Books*, but he did very cleverly begin his extensive building campaign with a seemingly odd sort of monument that instead made a powerfully symbolic architectural statement: his own family tomb.

It might seem strange to us that an optimistic thirty-year-old heir to empire, in the course of solidifying his power by victories over his rivals (Actium, however, was still in the offing), would begin an enormous tomb for himself, his family and his loyal friends in a prominent park location just beyond the northern city edge. Yet if his last remaining rival seemed to be moving toward reestablishing the empire's capitol in the eastern Mediterranean at Alexandria (where his Egyptian queen, Cleopatra, lived), no better proof of Octavian's loyalty to Rome herself could be given than such a monumental declaration of his desire to be buried there—albeit *someday* in the distant future. The Mausoleum of Augustus is today a misshapen brick husk of its former self, but in its day it must have been quite impressive in a brooding sort of way, an alternating series of stacked marbleclad drums interspersed with sloping mounds, culminating in a crowning hillock planted with cypresses and capped by a gargantuan bronze statue of the deified emperor. No Egyptian pyramid this; instead it was an

honest-to-goodness, old-fashioned Etruscan earthen tomb writ large: Italic, sober and just a bit rustic.

His Apollo temple was another matter altogether. Augustus maintained a relatively humble house for himself on the Palatine, the hill that would later see so many monumental imperial residences that it has given us the word *palace*. But adjacent to this overt display of domestic humility he built an enormously imposing temple on a high podium, overlooking the Circus Maximus to the south, dedicated to the god with whom he developed a deliberate association: Apollo. Even in front of his modest house the *princeps inter pares*—that is, "first among equals"—had planted two laurel trees, sacred to the god, the leaves of which formed the crown of victory (and of poetry). In his role as *princeps* he was also high priest, so here adjacent to the temple, in his own house, he was also acting as custodian of the cult, pious and attentive.[6] As a measure of the importance Augustus accorded the new temple and its divinity, he had relocated here the famed Sibylline Books, which held prophecies about the fate of the city (a fate that Virgil and other writers claimed the new emperor fulfilled). Thus the destiny of the city, and the empire, seemed to be bound up with Apollo and his high priest, all proclaimed by physical proximity.

But why Apollo? In his struggle to claim the throne he believed he had inherited from his adoptive uncle, Julius Caesar, Octavian characterized himself as a serene, dignified alternative to the passionate, drunken, smitten-with-Cleopatra Marc Antony, who had styled himself as a new Dionysus (or Bacchus). Octavian seized on the negative, exotic and Orientalizing connotations of Antony's wanton patron god to champion himself instead as a nobler, clearer-headed Apollonian character—and proclaiming the connection by effectively camping out at the foot of the Apollo temple made the point as evidently as possible. Rome shaped by Octavian-become-Augustus would become

an Apollonian city: that is, a city of dignified temples with simple forms and excruciatingly elegant ornamentation, where the works inspired by the god who presided over the Muses on Mount Parnassus would be just as evident in several new theaters and in the elegant and noble writing style of such authors as Virgil, Livy and Horace (and of course Ovid, even though he was sent into exile by Augustus for a still-unknown transgression). The whole culture of Rome, not just her buildings, would drink of Apollo's cup and be a living durable monument, as Horace claimed for his writings, "more lasting than bronze." And as we shall see in later chapters, Virgil's *Aeneid* did in fact exert a lasting impact on the sense of destiny of Rome and her offspring, even fifteen hundred years later in the Renaissance.

We may want to recall finally that Roman temples were in a sense museums in that they often were ornamented with spoils of battle and great works of art, which were expropriated from conquered cities and their Greek temples. Great artworks sustained the aura and majesty of the temples and therefore of the city that held them; beauty could indeed be a powerful tool of statesmanship. As Zanker has pointed out about the Apollo temple and Augustus' program generally,

> The decoration of the new Temple of Apollo would, however, have attracted most attention, from the more educated visitor at least (Propertius 2.31), on account of the wealth of famous works of Archaic and Classical Greek art on display there, proclaiming a new cultural agenda and new standards in art. . . . Soon it would become apparent that it was a part of the new emperor's cultural program not only to imitate the best the Greeks had to offer, but to create something that would be the equal of Classical culture.[7]

The point of this brief introduction to the themes of Augustus' Rome—the continuity with Roman traditions and emula-

tion of the great legacy of the Greeks—is that this golden age, in its ideals and its ruins, would exert a profound impact on the later empire and all subsequent renaissances of it, much of which can be distilled to one core principle: that the city could be a great work of art, imbued not just with elegant form but with powerful evocative meanings. Augustus meant his city to be read as an elaborate homage to the ideals he wished for his culture, and it is essentially this dream, if nothing else of Augustan Rome, that survived him for almost two millennia.

In jumping ahead roughly a century from Augustus' death to the reign of Hadrian, who would invoke the *Sæculum Augustum* as Augustus had invoked the old Roman traditions and virtues, we will be skipping over such remarkable works as the Colosseum and the Stadium of Domitian (now the Piazza Navona). But here in the ancient city our goal is to breathe some of the air of classical urban achievement from a magnificent buried city that later centuries would try to uncover. And it could be argued that no two emperors invested so much energy into the Idea of Rome as these two.

The Rome of the Emperor Hadrian

The reign of Publius Aelius Hadrianus (A.D. 117–138), emperor and amateur architect, marks a hinge point in the development of the city, one that looks back to his illustrious role model Augustus and forward to the developments of the Renaissance. In terms of sheer power Hadrian's tenure marks the greatest geographical extent of the Roman empire, limits pushed in reality by the conquests of his overachieving predecessor, Trajan. In fact Hadrian scaled back the borders of the empire he had inherited, borders that he believed (rightly, as it turned out) to be too extended to be adequately defended. He abandoned Trajan's recently conquered territory across the Euphrates (prudently

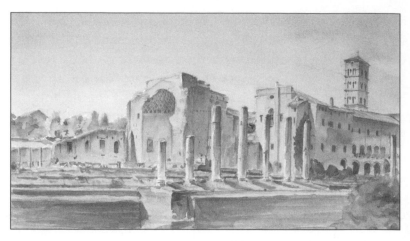

Fig. 1.1 Ruins of the Temple of Venus and Rome

withdrawing back across the river that Augustus had mandated should forever form one of the empire's boundaries). Thus Hadrian's Wall, which stretches across Britain, still in evidence, marks a pullback line, a sensible compromise with reality. Hadrian, militarily at least, was a realist. But when it came to architecture, his aspirations were ambitious.

We will look at two aspects of Hadrian's patronage and design of architecture: his buildings in the city of Rome herself, and his villa, a quasi-urban experiment outside the city on the via Tiburtina on the way to modern-day Tivoli.

The building that made Hadrian's reputation for future generations was his Temple of Venus and Rome, set on a small rise between the Colosseum and the old Republican Forum (the Forum Romanum). Built over the site of the vestibule of Nero's notorious Golden House, Hadrian's twin temple deliberately evoked classical Greek architecture, even while it literally doubled its venerable Hellenic religious models.[8] The building is in a way a pun: Two identical Greek temples are set back to back, one dedicated to Venus—*Amor* (Love) in the form of a god-

dess—and the other to *Roma*. Roma–Amor, Amor–Roma—that is, a palindrome, which means one is expected to translate the building's function into words to "get it." Certainly, though, more is going on here than simply a play on words. Venus is represented in her temple as Venus Genetrix or Venus Felix, as Mother of Aeneas, progenitor of Rome and the Romans, but also perhaps as a new Athena (Minerva), patroness of Athens, through the association with Aeneas and Roma. Roma is meant to be seen as Roma Æterna, Eternal Rome—a dedication that marked in fact the earliest example of the worship of the City (*Urbs*) as a deity within the capital. Indeed, "[t]he real innovation of the Hadrianic cult of Venus and Roma was the worship of Roma in Rome itself."[9] The two female cult statues were evidently fairly similar. Back to back and therefore inextricably linked, the double temple to the Mother of Aeneas and to Roma herself celebrates the origins, status and destiny of the city—and thus celebrates the very Idea of the place, the genius loci. In its siting on the Velia Hadrian deliberately created a public civic monument in place and on top of Nero's extravagantly private one. He also required that all newly married couples offer sacrifice at the new Venus temple, thereby tying the future of the city to its growing populace as much as its mythology, and investing the place again with civic rather than private significance.

The words *Roma* and *Amor* certainly have meaning; therefore the building must be saying something about Venus, mother of the founder of Rome. It "speaks" about two sides of the coin of Roman identity—beauty and power—and the destiny of the city set in motion by Homer's Paris having chosen Venus as recipient of the prized Golden Apple. (And thus making her rivals Juno and Athena jealous, causing Paris to abduct Helen, which starts the Trojan war that creates the Trojan refugee Aeneas, who arrives on Italic shores to fulfill his destiny of founding a new city, realized by his grandson Romulus and so on.) Obviously

without knowing to whom the building is dedicated the mirrored plan would have little left of its raison d'être.

Yet the key to the importance of this attitude toward speaking buildings is in the almost conversational exchange going on, the dialogue between one building and another that depends on a common language of recognizable forms and symbols. This is really the crux of Hadrian's influence on the later urban narratives we will explore. All of his buildings and building complexes develop dialogues across metaphorical time and physical space—back to Rome's founding or to Augustus, and between points in the city and over the broad site of his villa. Even the setting of this double building, overlooking the Forum to the west and the Colosseum to the east, established a series of relationships across the Roman topography, and these relationships were reinforced by the iconography that the building presented on its pedimented fronts and by its twin dedications. The orientations give us clues as to which side was dedicated to which goddess. The east pediment, facing in the general direction of the formerly marshy area where the abandoned twins Romulus and Remus were found, depicted their mother, Rhea Silvia, and the she-wolf giving suck to the twins. It could be therefore that this side of the twin temple was dedicated to Venus and housed her statue. On the west pediment,

> Gazing on the relief of a white sow encircled by her litter of thirty young, sculpted "in most brilliant Parian marble," [the early thirteenth-century English visitor Magister] Gregorius recalled the passage from Virgil's *Aeneid* in which Priam's son, Helenus, had foretold the site at Alba Longa where Aeneas was to found his city.[10]

Facing the Forum and the Capitoline hill in the distance, this relief and its temple's conjectural dedication to Roma would make

connections with the ancient public heart of the city and the hill
above that had been the mythical site of a city founded by the
god Saturn.

Hadrian made his reputation on this building, however, not
for its multiple references but for his thin skin. When his imperial
predecessor Trajan's veteran architect, Apollodorus of Damascus,
criticized the statues of the seated goddesses in the grand double
recesses as too tall to fit in the niches were they to stand up (a crit-
icism, by the way, equally applicable to the Greek temples
Hadrian loved and emulated), the Roman historian Dio Cassius
says that the emperor-architect had poor Apollodorus executed. If
the tale is true, from that moment on everyone must have known
who was in charge; if it's not, the story still says something about
the scale of Hadrian's aspirations as an architect.

The Pantheon and the Tomb of Augustus. Of all the buildings
that have survived from antiquity in the heart of Rome, none is
better preserved or more powerful in form than the Pantheon. It
owes its survival to having been converted to a church in the
seventh century, saving it from being cannibalized for building
materials; its relative wholeness explains part of its remarkable
influence on a wide range of architects. From Renaissance Saint
Peter's to Thomas Jefferson's University of Virginia Rotonda,
the Pantheon has served for centuries as a model of an ideal, in-
deed perfect, architecture.[11] Gianlorenzo Bernini in the seven-
teenth century said that there were a hundred faults in Saint
Peter's, but the Pantheon had none. This didn't stop some later
neoclassical architects from quibbling about details here and
there, especially about the anomalies around the front portico.[12]
Certainly it is the simple harmony and power of the circular in-
terior, whose diameter in plan is equal to the height from the
floor to the oculus of the dome, that has resonated throughout
the centuries with those who have wanted to build an earthly

perfection that matched Pythagoras' perfectly spherical model of the heavens.

Hadrian's Pantheon is actually a memorial to an earlier pantheon that had burned down on the site, and to the patron behind the earlier building: Augustus, the archetype of an emperor, and his *aedile* Agrippa, to whom Hadrian humbly rededicated the temple. Recently a connection has been discovered between the Pantheon and another Augustan building, the Mausoleum of Augustus in the upper Campus Martius area, which is almost due north of the Pantheon. Augustus' tumulus-type tomb, monumental in scale (roughly 89 meters wide at its base), was built as we have seen in imitation of earlier Etruscan burial mounds (since Augustus was traditional to an extreme in his public comportment) to stress his continuity with Rome's preimperial past. Its entrance was flanked by two obelisks, which are now found in piazzas Quirinal and Esquiline. There in front of the entrance, facing south in the Pantheon's direction, on what is left of the original paving stones are scratched lines that describe a pedimented portico that correspond exactly to the dimensions of the Pantheon's portico.[13] Whether this means that Hadrian intended to build an identical portico onto the older Mausoleum or that his masons used the tomb precinct as a vast layout table for the new round temple's portico, the connection between the memory of Augustus, embodied in his tumulus, and his temple was evidently seen by Hadrian to be an explicit one. The tomb being round, some have even seen it as a formal ante-type to the Pantheon. Hadrian, obsessed with the connection, even made his own tomb, now the Castel Sant' Angelo, an enormous restatement of the round tumulus Augustan type.[14]

At noon on the birthday of Rome, April 21, the mythical date of the city's founding by Romulus, the light shining through the Pantheon's oculus illuminated the entry door and shone in the direction of Augustus' tomb to the north. Even

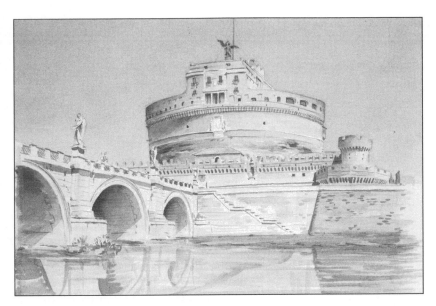

Fig. 1.2 Hadrian's tomb, now the Castel Sant' Angelo, with the Ponte, Sant' Angelo in the foreground (the ancient Pons Aelius)

Apollo and the chariot of the sun seemed to describe the connection between Hadrian and his archetype across the century that separated their reigns.

These formal and symbolic references stitched the labyrinthine ancient city fabric together, but they also stitched together the imperial narrative of the city. Hadrian deliberately reaffirmed and evoked the memory of his august model predecessor, and made deliberate connections with Augustan monuments not only to connect the city aesthetically but also to connect his reign symbolically with Octavian's. His many projects in Rome didn't focus on any one area of the urban fabric but were decidedly scattered over the cityscape; within their compass those projects developed their own internal narrative about Hadrian himself and his image of Rome. For any urban resident, knowing the connections between things in the city (because the forms and their meanings were

legible and memorable) allows him or her to begin to read the whole city as a comprehensible story. With Rome's entire political and cultural identity bound up with the very city herself, memorializing her myths and histories was much of what monumental building was all about in the *caput mundi* (literally and figuratively head of the world). Thus the *urbs* became a symbol of itself, with a narrative told through buildings and the arts that was supremely self-referential. If one building such as the Pantheon could say so many different things, a broader building campaign could begin to weave an even more elaborate pattern of meanings. Imagine then what the possibilities might be if the process could begin from scratch, on virgin ground. Indeed Hadrian again, this time outside of Rome, pushed the limits of architecture-as-storytelling in an extensive building complex that would exert as profound an impact on later cities as his Pantheon did on individual buildings. To understand its significance for the later history of Rome, however, we need to know something about the ancient memory techniques that were the common currency of rhetoricians and, I would suggest, of architects and their patrons. These memory techniques directly shaped the image of architecture as an art of embodied ideas.

Ancient Memory Techniques

> *Images are as words by which we note the things we have to learn, so that as Cicero says, "we use places as wax and images as letters."*
>
> —Quintilian, quoted in Yates, *The Art of Memory*

Essentially the classical *mnemotechnic* (consciously practiced memory technique) used visual imagery—figures, buildings and cities—as cues to help remember words and abstract concepts. With such powerful memorable architecture as the Pantheon,

mirroring three-dimensionally the harmony of the classical image of the universe, it is no wonder that the Greeks and Romans perfected a memory technique that relied on images of architecture, painting and sculpture to remember ideas. Without the printing press the ancient world put a high value on personal memory skills; one could in effect carry a library in one's head. The technique survived with many interesting mutations the fall of the Roman empire and persisted well into the seventeenth century; Jesuit missionaries who used the technique, such as Matteo Ricci, remembered years later whole books that they had read in seminary.

> The real purpose for all these mental constructs was to provide storage spaces for the myriad concepts that make up the sum of our human knowledge. To every thing that we wish to remember, wrote Ricci, we should give an image; and to every one of these images we should assign a position where it can repose peacefully until we are ready to reclaim it by an act of memory.[15]

Ancient mnemotechnics were intimately dependent upon striking visual imagery; essentially one invented a mental architecture in the act of remembering a text that one mentally "revisited" when it was necessary later to recall the text. Hellenistic writers on the subject, from Cicero to the ancient grammar manual known by its dedication as the *Ad Herennium*, oscillate between recommending real or imaginary buildings, streets and cities as loci, or image places, on which to mentally attach ideas and words. No matter whether the loci were real or imaginary, what is of interest to us is the reliance on *places* to store *ideas*. (The reason this was supposed to work, according to the ancient writers, was that the visual memory was considered to be the strongest mnemonic sense faculty, and so one relied on the stronger to aid the weaker.) Such a reliance on images of places

to remember rhetorical or poetic texts suggests that, conversely, when the Hellenistic architect thought about buildings and cities, he imagined them containing memories of ideas. Thus some of the same rules that governed the making of imaginary memory cities for the rhetorician also informed the architect's process of making real cities memorable. This process or art, as a corollary to the mental technique of mnemotechnics, I would call *mnemotectonics*.

Notably the ancient world saw the visual sense as the most powerful of the five, and so they inevitably devoted much attention to its satisfaction. For a city to be memorable it needed to be visually striking (or dramatic) and at the same time highly ordered (coherent and cohesive, like a logical train of ideas); for a city to be classical it had also to be beautiful. While the memory treatises could advocate images that were memorable because they were brutal or repugnant, classical architectural decorum as codified by the Roman architect Vitruvius forbade concretizing anything less than the best of a society's ideals or aspirations.

Italo Calvino's poetic and beautiful book *Invisible Cities* describes an imaginary city, Zora, that provides a poignant image of how the ancient mnemotechnic might have worked for the initiate.

> Zora's secret lies in the way your gaze runs over patterns following one another as in a musical score where not a note can be altered or displaced. The man who knows by heart how Zora is made, if he is unable to sleep at night, can imagine he is walking along the streets and he remembers the order by which the copper clock follows the barber's striped awning, then the fountain with the nine jets, the astronomer's glass tower, the melon vendor's kiosk, the statue of the hermit and the lion, the Turkish bath, the caffè at the corner, the alley that leads to the harbor.[16]

To hold images of cities in the mind in order to remember more abstract concepts implied three things. First, that the mind was composed of many "chambers" that could be represented as places in palaces, and that numerous memory palaces generated whole memory cities. Second, that the images of cities to be used were ordered and coherent, and therefore highly memorable. And third, that real cities, in their order, coherence and memorability, could therefore be models of the chambers of the mind, which means that the more beautiful and memorable and complex the city, the more profound the ideas it could contain, and the closer it approached the image of the perfect, ideal or Divine Mind.

Again Calvino provides us a poetic description.

> This city which cannot be expunged from the mind is like an armature, a honeycomb in whose cells each of us can place the things he wants to remember: names of famous men, virtues, numbers, vegetable and mineral classifications, dates of battles, constellations, parts of speech. Between each idea and each point of the itinerary an affinity or contrast can be established, serving as an immediate aid to memory. So the world's most learned men are those who have memorized Zora.[17]

Hadrian's Villa. To walk through one of these memory palaces today, we might leave Rome heading east, finding on the rolling plain before the foothills of the Apennine Mountains the ruins of what seems like a small city. Hadrian's villa outside the city walls on the via Tiburtina is indeed an ostensibly private residence on the scale of a town.[18] Actually in the Middle Ages residents of the town of Tivoli, on the hill above, referred to the villa's ruins as *Tibur vetus*—Old Tivoli. Its complex orientation and somewhat ambiguous functions make for a highly suggestive ruin, but in its original state the villa was a beehive of activity, since both

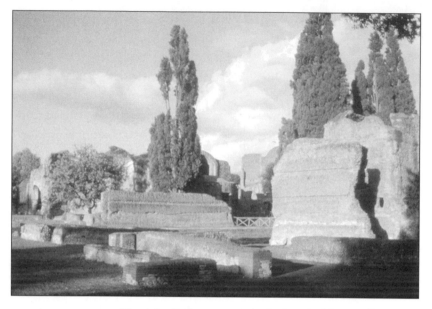

Fig. 1.3 Ruins around the Baths, Hadrian's Villa, Tivoli

practically and symbolically the capital of the empire moved there with the emperor. The villa therefore provided both a retreat from the city and many of the functions (and people) necessary in the city for running a government (and keeping the emperor happy). Hadrian was an educated man and enjoyed literate entertainment. So in fact medieval Tibertines weren't so wrong in thinking of the villa as a town; and in Hadrian's time it was a town with a not insubstantial culture.

The biographical *Historia Augusta*, contemporary with Hadrian, contains an extended architectural description of the villa, which follows immediately upon a comment that Hadrian always furnished "tragedies, comedies, certain farces, players on stringed instruments, readers or poets" at his banquets there. The emperor clearly mixed the business of government with entertainment and literary pursuits (including his own). Roman architecture historian William L. MacDonald even suggests that

"perhaps demonstrations of popular, elaborate mnemonic systems were given." Now, the ancient grammar manual *Ad Herennium* recommends using places visited while traveling as sources for memory loci. It is commonly thought that Hadrian designed his villa as a series of built recollections or evocations of places he had seen while campaigning (in part because of the evocative place names assigned to various areas of the villa, such as the Academy, the Lyceum, Serapeum and Canopus). It therefore seems possible that these recognizable and memorable forms and building plans are really discrete memory houses, decidedly distinct architecturally yet cleverly linked sequentially in several different ways so as to allow more than one experiential "reading." One can imagine the emperor, already deified and thus possessed of a truly Divine Mind, walking through his villa early in the hazy Roman *campagna* morning along any of several specifically chosen paths, using a particular route with its buildings, sculpture, mosaics and frescoes as memory images to help recall a particular rhetorical, dramatic or poetic text.

What makes Hadrian's villa especially relevant to this discussion of cities is its virtually urban scale and richly complex plan, allowing it to become an ideal civic model. In fact it justified what was already in those days the *apparent* chaos of Rome's street network as something that indeed could be a potentially enriching formal model: A city that was not a grid, with all of its potential paths, was one most analogous to the nature of narrative. While the Roman empire continued to found new practical, straightforward, regular and gridded military compounds from Britain to North Africa in imitation of an ideal Rome that never really was, the mother city after Hadrian evolved her palimpsest nature more deliberately, and imposed her formal *regula* only locally. (No more extraordinary imperial *fora* were built after Trajan's, but instead the city fabric was operated upon internally and selectively, from the Pantheon to the Amphiteatrum Castrense.) Almost a

millennium and a half after Hadrian's reign the melancholy legacy
of the memory-charged ruins of those imperial ruined palimp-
sests—Rome and *Tibur Vetus*—sparked a renaissance of classical
culture and a will to build a new Rome, often out of the actual
materials of the old one, that would be a living, triumphant,
transparent and layered *teatrum mundi* and *civitas dei* in ways
richer than anything the ancient world had known.[19]

MEDIEVAL ROME

Rome, without compare, though all but shattered;
Your very ruins tell of greatness once enjoyed.
Great age has tumbled your boasting,
The palaces of Caesar and the temples of the gods
alike lie smothering in the mud.
Fallen, fallen the prize of all that effort
At whose power the dread Araxes once trembled.
Whose prostration he laments today.
She, whom the swords of kings, the caring
foresight of the Senate,
And the gods themselves established as the head of
all creation.
 —*Hildebert of Lavardin, twelfth century*[20]

Rome's ancient monuments suffered mightily in the centuries
after her fall, but their scale and number precluded their com-
plete eradication. What's left of the texture of medieval Rome,
however, can best be read today mostly in the pattern of streets
in the area known as the *abitato*, the continually inhabited part
of the city. Little of the actual medieval building fabric survives
untouched, apart from some isolated (and usually overrestored)
small *palazzi* or the apartment blocks the Romans had called

insulæ. Many more were transformed in the ensuing centuries, becoming the bones of what appear to us now as Renaissance or Baroque palaces. Of churches, few in the historic core were untouched in later periods, and the late nineteenth- and early twentieth-centuries' restorers who sought to give back to some their medieval character inevitably imposed their own sensibilities. While much-loved buildings such as Sta. Maria in Cosmedin or San Giorgio in Velabro are fascinating, in reality they are imperfect evocations of the centuries between Constantine and the Renaissance. We know enough about the medieval pilgrims' experience in Rome, though, to begin to see the city through their eyes, and it is a strange and fascinating picture.

> The hoi poloi of [medieval] Romans and visitors, especially pilgrims, would be overwhelmed by the sheer size of a building or a colossal statue surviving in fragments and spin strange yarns about it: the Colosseum was the Temple of the Sun and had formerly been covered by a huge dome; the *pigna* in the atrium of St. Peter's had stood atop the opaion of the Pantheon, God knows how; wriggling through the four bronze supports below the obelisk near St. Peter's secured forgiveness of sins, and the bronze globe on top of the obelisk was said to contain the ashes of Caesar.[21]

Medieval Rome was a magical, often frightening place to a society that had lost so much of the skills and means to realize art and architecture on the scale of the towering ancient ruins. Perhaps the principal difference between the pilgrims and the residents of those days was that the latter, for all their awe and wonder in the face of the monumental survivors, were not so intimidated as to refrain from moving into the ruins. In the ancient Crypta Balbi, the porticoes of one of the city's great theaters, lime burners had moved into the ruins, set up shop,

lived, worked and worshiped in a small church that had also
been built there. What we know about this area today is the re-
sult of painstaking archaeology and research, since the whole
complex has continually been transformed through to the last
century.

One kind of survival or record that can bring us a glimpse
into how the medieval mind saw Rome are the maps produced
in the first few centuries of the last millennium. All maps are ab-
stractions, edited diagrams of how a city sees itself, which in the
modern world seem to be presented with objective clarity. Me-
dieval maps, however, really have little to do with modern car-
tography, but are instead rather ideograms, picture notes of the
Idea of the city, how it saw itself but more importantly how vis-
itors saw and remembered it. For a pilgrimage destination of the
magnitude of Rome, these portable memory maps of the city
had an enormous impact on the urban memories that people
took back with them, an impact that was pan-European in
scope and a truly Roman palimpsest in nature.

To appreciate these images some concession must be made to
the medieval way of seeing things. Maps and images of cities
from this period adopt a series of conventions that require re-
ordering our notions of perspectival space; being ideograms,
they are more concerned with relating symbolic information
than showing a thing as it really appears. To show both a build-
ing and the action taking place in a building (as in the mosaic of
Sarah and Abraham in Sta. Maria Maggiore in Rome, for exam-
ple), the artist shows the action taking place in front of a house.
We are meant to understand that what is shown is really hap-
pening inside, since we know from the story that Sarah's prepa-
ration of the bread for Abraham's guests happened *within* the
walls of her house.[22] Similarly, as Chiara Frugoni points out,
buildings placed *on top* of other buildings are meant to be un-
derstood as *behind* them. All of which points to seeing these im-

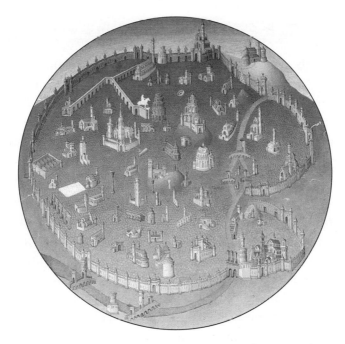

Fig. 1.4 Limbourg Brothers
(fifteenth century) Map of Rome

ages as more signs than scenes, a set of visual clues to a narrative
rather than properly illustrative, since the clues require our ac
tive participation to make sense of them, one is therefore ex-
pected to bring something to this process. If Gregory the Great
was correct in saying that the art in churches was "the bible of
the illiterate," then these works of art suggest that the illiterate
were not necessarily uninformed.[23]

As for content, one notable connotation of the City is that it
represented security, provided principally by its walls; therefore
violence or evil often is shown taking place deliberately outside
the walls, as in a fifteenth-century image of the decapitation of
Saint Cosmas and Saint Damian by Fra Angelico.[24] Indeed in
most images of the city that date from the earliest manuscripts

we have, from the sixth century to the dawning of the Renaissance in the fifteenth, the essential urban image is condensed into its walls: often circular, turreted and gated, the walls effectively *are* the city. The image of city walls owes much to the Psalms and Revelation, being really an idea *about* walls more than a picture of any actual mural circuit. The city in its architectural form, the *urbs* (the physical form of the city) that Saint Isidore of Seville would distinguish from the *civitas* (which meant the civic community), was expressly that safe and secure place separated from the wild world outside.[25]

Of all the walled cities represented in maps, mosaics, illuminated manuscripts and frescoes, none held sway over the European consciousness like Rome. Here was the papacy, the inheritors of Peter's chair and the many martyrs who died—especially Peter and Paul. The city's hegemony over the ancient world and its ruins that witnessed these events made Rome more powerfully *real* than Jerusalem as an urban ideal because Rome was closer, more palpably and historically *present*. But it was a presence charged with legend, magic and awe, and it was this quasi-mystical image that the maps tried somehow to represent.

One can't help but wonder if the fourteenth-century pilgrims, who knew Rome first from the somewhat fantastic guide *Mirabilia* (or *Marvels of Rome*) or else from the maps that circulated across the continent, were disappointed that the actual city didn't match the ideogram. Or rather did their impression match it exactly, because the image was more suggestive than documentary? I think of a more modern visitor, Goethe, who in the late eighteenth century might have been disappointed upon entering Rome's Porta del Popolo (like most northern European tourists) to find that the city didn't measure up to the impressions of it he had formed at home from his father's heroically scaled prints by Piranesi. Maybe because Piranesi *seemed* to be accurately representing reality while in fact distorting it for pictorial effect—

whereas the medieval mapmaker only compressed impressions into a pictogram—the expectations each formed would be wholly different. Certainly the medieval mind was almost more prepared to see the meaning of the thing than the thing itself; as the Dutch historian Johan Huizinga observed in his *The Waning of the Middle Ages*, "The Middle Ages never forgot that all things would be absurd, if their meaning were exhausted in their function and their place in the phenomenal world, if by their essence they did not reach into a world beyond this."[26]

This metaphorical view of the world tended to conflate the fantastic with the actual. The symbol wasn't extraneous to the thing, it *was* the thing, which meant, as Umberto Eco says in his *Art and Beauty in the Middle Ages*, "Once the symbolism had been accepted, the unicorn became even more 'real' than the ostrich or the pelican."[27] As Eco suggests, since it was just as unlikely for a medieval European to encounter an ostrich or a pelican as a unicorn, the animal with the greatest symbolic baggage was the most real. Something similar happened with distant cities, whose legends tended to grow and accrue fantastic meanings for those who never had the opportunity to visit them. Rome was perhaps first among all the cities of the known world that loomed large in the metaphorical imagination, but so too did lost cities of the ancient world. These cities were made more "real" by the symbols grafted onto them, so that grasping the symbol's meaning meant grasping the nature of the place. An early twelfth-century treatise by an anonymous cleric, the *Imago Mundi*, delves into a civic bestiary to make distant places come alive.

> The ancients conceived their cities in the shape of wild beasts, each according to the peculiar significance of its attributes. Wherefore Rome has the form of a lion, because it prevails over other animals like a king. Its head is the city constructed by

Romulus and its flanks the buildings placed on either side. Whence it is also called the Lateran[!]; Brindisi according to the form of a stag; Carthage that of a cow; while Troy had the figure of a horse [for obvious reasons].[28]

Beyond its leonine form and magical ruins, medieval Rome was a city of relics: it was these, even more than the buildings that housed them, that attracted pilgrims from all over Europe. In a way the whole city was a giant reliquary, and the tomb of the first pope and martyr, under St. Peter's basilica, was the most privileged spot of all. Not merely talismanic, relics put the pilgrim in direct contact with the saints and, if possible, with Christ Himself.

> Desire to be in touch with the humanity of Christ and to participate vicariously in His life and Passion corresponds to the trend toward piety that was everywhere in evidence in the late medieval world. In this regard primacy of place among the Roman relics went ... to the Veronica, miraculously imprinted with the features of Christ's suffering countenance. ... Preserved in its own chapel in St. Peter's, the relic was exposed by the pope for veneration from the Loggia of Benediction on Easter, Ascension and Christmas, and on every Sunday and additional feast days during Jubilee Years. The Veronica served in fact as the chief symbol of the Roman pilgrimage. Simple woodcut depictions of it appeared in the pamphlet guides to Rome, souvenir copies were sold to pilgrims, and even Albrecht Dürer, though he never went to Rome, made an engraving of it in which it was held up by two adolescent angels.[29]

The relics and tombs, sites of martyrdom or triumph, awesome ruins of antique grandeur and venerable places of worship, formed the image of Rome in the European consciousness, and it was this city that the maps documented, not the actual,

mostly neglected, sparsely populated vestige of a great city that in fact was Rome.

> Indeed, Magister Gregory [our English visitor to Rome in around 1200] saw magic in all the weird art of the ancients— his treatise, after all, is entitled, *Tale of the Marvels of the City of Rome, whether Produced by Magic Art or by Human Labour*: one could not be sure.[30]

So for the medieval pilgrim the map or the descriptive *Marvels* really *were* the city; ready to embrace the marvelous and ignore the squalid, our model medieval visitor would have seen the place exactly as the ideograms showed: scattered miraculous monuments in a sea of indifferent building. There was no connoisseurship of the picturesque or the vernacular. At the same time, for those concerned with actual construction in those indifferent zones, since the great monuments virtually *were* the city, what was left in between required little care. Of the sacred buildings that mattered, many acquired in the first centuries of the second millennium remarkable cloister gardens that were paradisical retreats from the squalor outside. Still intact today, these cloisters, like those at the Lateran basilica or the Santi Quattro Coronati, have become again even more precious retreats from the roaring chaos of automobile traffic outside. For the roughly one thousand years between the Fall of Rome and her rebirth to Tuscan humanists in the Renaissance the perception of Rome as a series of magnetic yet dispersed Christian pilgrimage sites clearly drove the building energies of popes and other patrons toward the embellishment of these monuments to the exclusion of the city as a whole. Perception may or may not have been reality but indeed helped create it.

At the same time the Church saw the surviving sacred buildings from the earliest centuries of state-supported Christianity as

living models and fostered a series of minirenaissances of those buildings both through their renovation and in new construction. Thirteenth-century artists such as Pietro Cavallini and Jacopo Torriti embraced what they believed to be Roman styles of mosaic and fresco work, reviving in actual fact almost-as-old Byzantine and early Christian sources. In many ways fantastical and practical, the ancient remains never went away, and Rome kept her memory alive, awaiting almost her full rebirth.

Only in the Renaissance would the warp and woof of those "indifferent" zones again be invested with conscious design energy equal to that accorded the scattered, isolated "paradises," making a whole that was greater than the sum of its parts. The one thing the medieval mind could embrace about what Rome had become was that, ruined or not, she was better off under Christian rulers than pagans, and it was in part this that gave later Renaissance builders the optimism to believe that they could equal or exceed antiquity's achievements.

I, Rome, can scarcely remember Rome!
But now, more than the eagles of the legions,
The standard of the Cross has gifted me;
More than Caesar, Peter;
More than armored princes, the common people;
And all this without resort to arms.[31]

RENAISSANCE ROME

Here was the castle of Evander, there the temple to
Carmenta; here the cave where Cacus dwelt, there the She-
Wolf nursing her twins and the fig-tree, more properly called
the Romularis; here the spot where Remus crossed over,
there the site of the circus races and the rape of the Sabine
women; here the marsh of Capra, where Romulus vanished,

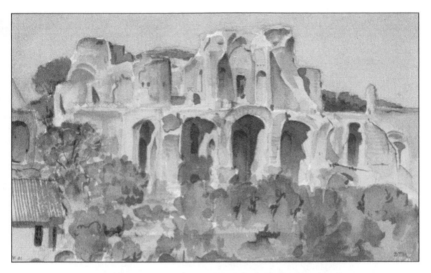

Fig. 1.5 Ruins on the Palatine, from the Circus Maximus

there the place where Egeria and Numa met, here where the
three brothers swore their allegiance over swords.

—Petrarch, fourteenth century, quoted in Jacks,
The Antiquarian and the Myth of Antiquity

Petrarch may have been the first visitor to try with some rigor to track through Rome's landscape the events of the city's historical and mythological past. In so doing he contributed no small amount to the recovery of the actual ancient city buried as much under fable and fantasy as dirt and weeds. For his part Petrarch lamented the state into which Rome had fallen.

Those crumbling ruins of the ancient city were hard to ignore in the centuries after the fall of the empire, but the citizens of Rome certainly did their best. Apart from the churches built in the centuries between the collapse and the Renaissance that often consciously (but again, not necessarily accurately) attempted to emulate the ancient pagan basilicas and the Constantinian churches, most Roman buildings used the ruins as foundations,

armatures or worse, quarries for raw materials.[32] The Renaissance, as an intellectual rebirth of the ideals and ideas of classical culture, marked a sea change in this crudely cannibalistic attitude toward the past; if nothing else, Petrarch inspired a melancholy respect for those noble remains and what they represented. Not that ancient buildings weren't still pilfered for building materials—that continued unabated for centuries—but now the ideas and forms of ancient architecture were drawn precisely and drawn upon, studied, researched and lauded. And in that one architect who came to the city late in life stood out for his creative fidelity to the past: Donato Bramante. Born near Urbino in the Marche region (like his much younger relative, Raphael), Bramante spent most of his mid career in Milan. He began his professional life as a fresco painter but soon came to architecture through his mastery of perspective drawing; he thrived in Milan under the patronage of the powerful Sforza family before resolving to come to Rome to study antiquity (and to seek papal commissions). His emulation of the power and sophistication of Roman building was so complete that he is credited with bringing High Renaissance architecture to flower in Rome almost single-handedly.

Fifty-five-year-old Donato Bramante came to Rome with a passionate desire to measure, dissect and draw the ancient buildings, not accepting commissions for any new buildings during his first months there.[33] When he did begin to accept commissions, he brought to the making of architecture the fertile, freely associative inspiration born of a saturated memory. This would eventually serve him well for Christian Europe's most important sacred site of the time: a new basilica of St. Peter's, commissioned by the hard-charging Pope Julius II (who also commissioned Michelangelo to paint the Sistine ceiling and Raphael to paint the Vatican *Stanze*; he reigned from 1503 to 1513). The lure of designing a new St. Peter's indeed may be the unspoken

reason that brought Bramante to Rome, inspiring him to study antiquity so thoroughly, even before Julius became pope and the project became real. Talk of what to do with the old St. Peter's, in a precarious structural state at least since the time of Nicholas V, half a century earlier, had obviously been in the air for a long while. Bramante had the foresight and cunning to place himself in just the right position when the commission finally came up.

Bramante's first Roman building was the cloister for the church of Santa Maria della Pace, a church that had been dedicated by Julius II's uncle, Sixtus IV. Two years later he began designing his famous Tempietto, which in a way was a small warm-up for St. Peter's. The building was for one of the most memory-charged loci in the city: one of two supposed sites of Saint Peter's martyrdom, on the Janiculum hill, in a courtyard next to the church of San Pietro in Montorio.[34] The little temple was calculated to mark the geographic midpoint of two significant reference points. These references were based on a misreading of two ancient monuments (the two pyramids at opposite ends of the city, which were thought to be the tombs of Rome's founder, Romulus, and his twin brother, Remus) and a misreading of the traditional Latin description of the site. (The *duas metas* between which the apostle Peter was crucified actually re ferred to the obelisklike markers used by the Romans as turning posts in their racetracks, whereas in the Middle Ages and Renaissance *meta* was thought to mean "pyramid.")[35] The Tempietto's hilltop setting was also laden with other built-in meanings that had accrued over the centuries. Loren Partridge, in *The Art of Renaissance Rome*, gives a succinct countdown of the many readings latent in this sacred spot on the Janiculum.

The church [San Pietro in Montorio] was commissioned by Sixtus IV and his friend and confessor Amadeo Meñez de Silva (1431–82), who had been given an earlier church on this site in

1472 for his Spanish order of reformed Franciscans, the Amadeistas. They were motivated to build such an impressive church by the writings of the humanist and curialist Maffeo Vegio (1407–58), who had recently argued that here on the Janiculum (Hill of Janus)—halfway between the two pyramids believed to be the tombs of Romulus and Remus, the legendary founders of Rome—St. Peter had been crucified upside down, as described in early chronicles. The medieval pilgrims' guide, *The Marvels of Rome*, and other sources claimed that Noah's ark landed on the Janiculum after the flood to refound the human race, and identified the Roman god Janus as Noah's son or grandson. According to Roman myth, Janus inherited his authority from Saturn on the Janiculum, and established a golden age of peace in central Italy. Janus' attribute was a key: the door to his temple (*janus* is Latin for door) signified peace when closed and war when open. After the age of Janus, the door remained open until Augustus's *pax romana*, which in turn prepared for the coming of Christ. Thus the site of S. Pietro in Montorio, dedicated to St. Peter, the new key-bearer and new carrier of religion and peace to Rome, suggested that the founding of the Roman Church had been prefigured across time by Janus, Romulus and Remus, and Augustus.[36]

Bramante chose to make the little temple circular for several reasons: The round plan embodied the perfection of Platonic geometry; it recalled the Pantheon, which Palladio would later describe as an "image of the world"; its circular colonnade suggested comparison with what was thought to be a temple of Hercules near the ancient Forum Boarium; and it alluded to the two small round temples shown next to Peter and Paul in the apse mosaic of old St. Peter's.[37] In the course of solving the design, painter-turned-architect Bramante made the diameter of his new, circular *all'antica*-style Tempietto exactly the same size

as the venerable Pantheon's open oculus.[38] That the very natures in the real world of his small, modern, round colonnaded temple and a hole in a large, ancient round temple's ceiling are wholly contrary (one being figure and the other ground, one solid while the other is void) evidently did not deter Bramante. He was more interested in how these apparent opposites could be reconciled. Now this greatest of Renaissance architects would eventually describe his design for the new St. Peter's as the bold superimposing of two antique monuments. Tradition says his project literally "placed" the Pantheon on top of the ancient Basilica of Maxentius and Constantine, known in his day as the Temple of Peace; the new basilica would be a consummately Roman hybrid of the best of the past and acquire in the bargain the accumulated meanings of his sources.[39] A network of relationships thus was established by mentally "assembling" those meaning-laden building components across the city and across time. Given this composite design (using two ancient monuments), might not his little Tempietto—so classically correct that later Renaissance architects would include it in their treatises as one of the city's ancient remains—be imagined as the crowing lantern to his new St. Peter's? If so, Bramante was masterfully, simultaneously, deferring to the past and trumping it.

Yet Bramante's fertile collage would also reshape the actual urban fabric of Rome herself to the mind and eyes of her visitors and inhabitants, because from then on everyone who saw or visited the Pantheon and the so-called Temple of Peace would see them as pieces of the bigger puzzle that was to become the new St. Peter's basilica. Indeed if we can allow ourselves to imagine the Tempietto as the new hybrid basilica's crowning lantern, then from its commanding vantage point on the Janiculum hill we can see in the city below the necessary variables for Bramante's architectural arithmetic: The Temple of Peace + Santa Maria ad Martyres + the Tempietto = the Basilica of St. Peter.

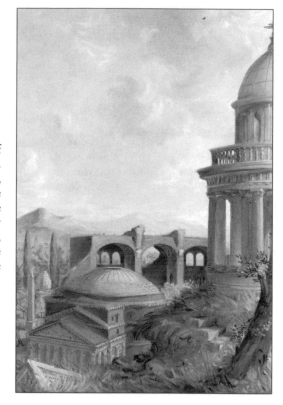

Fig. 1.6 Elements of Bramante's Basilica of St. Peter: In the foreground, the Tempietto; in the middle ground, the Pantheon; and below the hills in the distance, the so-called Temple of Peace

Bramante was composing with what the Romans called *spoglie*—literally "spoils"—from the past on the grandest scale. Its recent cleaning shows clearly that the Tempietto itself is composed of actual *spoglie*, since the columns that ring the exterior are actually antique granite (that recall the columns of the Pantheon's portico) taken from an unknown ruin. Bramante's intention in making the size of his Tempietto the size of the Pantheon's oculus was surely about more than the mystical mathematical coincidence of two numerical diameters. It was instead a meditation about both the City as a work of art and the creative process itself, which he rooted in assembling fragments from the past. He was in a way describing what every apprentice in the classical

tradition would do: working with the raw materials of the inherited tradition in order to invent new compositions.

Remember, not only would this new Temple–Basilica of St. Peter be enriched by the allusions of its salvaged constituent parts, but the real antique remains of the disparate parts themselves, scattered over the Roman cityscape, would therefore be reinvigorated by new layers of meaning by virtue of their association with St. Peter's. They would be linked together in a typical pilgrim's route through the city; and they form the elements of a kind of habitable *veduta*, or city-view tableau, spread before us like a painted canvas at the feet of the supposed site of the first pope's crucifixion on the Janiculum hill. Most important, the Vatican basilica itself as a pilgrimage destination then becomes nothing less than a kind of compendium of Ancient Knowledge (mythical, Roman and Christian history, allegory and Platonic ideal geometry) fused with Inspiration (through the humanist creative process, like a new mosaic made of ancient fragments) in the service of Faith (which supplants the ancient pagan religion, with Peter as the new Romulus founding the city anew).

What Bramante created was a kind of mental bridge across the city; to cross it one needed some knowledge of Roman topography, familiarity with the saints' lives, learned and popular mythology and an open mind. It was a memory bridge, like the strings of ideas held together in the mind of the classical mnemotechnic adepts. Those who were thus equipped could mentally stitch the city fabric together in a way that urban planners of the time could only dream of accomplishing physically.

Many other such mnemonic bridges existed across Rome, and they did not rely strictly upon architecture. An example more or less contemporary with the Tempietto is the brilliant conceptual link made by Raphael's fresco of Apollo and the Muses on Mount Parnassus, which is above the window in Pope Julius II's Library (now known as the *Stanza della Segnatura*,

after the seal put on documents when the room later became a tribunal[40]). The window looks down the long axis of Bramante's Vatican Belvedere villa toward the original *cortile* (courtyard), behind the great niche that terminates the view. This *cortile* was a container for the greatest known sculptures of antiquity, the private collection of Julius II, which was the *musæum* (a spelling that better recalls the word's original meaning of "home of the Muses" than our too familiar *museum*) of the new golden age. Renaissance artists came here to copy and learn from the finest ancient sculptures available. The connection from fresco to courtyard was therefore a deliberate link across space and time. Since Raphael was an acknowledged leader of these artists who emulated the past, the painted Parnassus proved that he could both transform poetry into painting and make antiquities into the Muses. Raphael's fresco, of Apollo and the nine Muses welcoming the greatest poets of antiquity and the modern world to the hill that was sacred to the musical god, is a painted literary foil to the visual and intellectual leap made from the window below this fresco to the distant home of the Muses on axis in the Villa Belvedere's garden. By combining a real view (window) and an imaginary scene (fresco) to connect spectator, art and history into a web of meanings Raphael sums up the humanist approach to art. That leap out the window is combined with a complex network of painted allegories in the room itself, best known for the erudite *School of Athens* on the adjacent wall. This sort of calculated arrangement of works of art, called *disposizione*, transcends the simple formal interaction between several paintings in a room, in this case by involving the local context outside in a larger, more complex narrative. "Thinking outside the box" was common for Renaissance artists and architects. Indeed it could be argued that the Muses—the divine sources of inspiration and the daughters of Memory—lived for the humanists in the creative synaptic leaps between ideas, be-

tween the ancient past and the modern renaissance. The familial relationship between Memory and Inspiration described a complex and suggestively contaminated creative process that recognized the often blurred distinction between what one sees and what one imagines one has seen. As Saint Augustine had said about the workings of memory and the imagination,

> Something similar takes place when I recall a beautifully and symmetrically intorted arch which I have seen, for example, in Carthage. In this case a certain reality, which was made known to my mind through the eyes and transferred to my memory, produces an imaginary view.[41]

For architects and artists who saw the past as a living source for the present, Rome was both the ideal museum and a working laboratory. Rather than be intimidated by the achievements of the past—a problem really more induced by disengagement from it than by intimate contact—Renaissance artists quickly made enormous leaps in achievement as they challenged themselves and each other to exceed previous accomplishments. They were also optimistic enough to want to exceed antiquity by individually mastering all of the arts, something the first century B.C. Roman writer Vitruvius had said was unknown for individuals in his own day. The optimism of Renaissance artists goes a long way toward explaining the presence of so much genius in one place at one time, and their fertile crossovers from one artistic medium to another enriched everything they did. Along with Bramante's slightly younger contemporary, Raphael, one other titan of the rebirth of classical design also branched out from his training in painting and sculpture to become a great architect and shaper of the city of Rome—Michelangelo Buonarotti.

Michelangelo considered himself a Florentine, and it was there that he had apprenticed in his teens. But when he came to

Rome, he found a new kind of teacher: Immersing himself in antiquity, his work blossomed as it rivaled then exceeded his esteemed models. Patrons from Julius II on would find his inexhaustible inventive energy the perfect vehicle for their visions of a wholly reborn Rome, and Buonarotti would spend more and more of his later life on architecture and urban design than on either painting or sculpture.

Michelangelo's Piazza del Campidoglio, the Capitoline hill piazza, began with a ragtag assembly of buildings from various epochs: Over the ancient Tabularium (the ancient archives building) had been built the medieval Palazzo for the lone appointed Senatore; adjacent to it Pope Nicholas V built in the fifteenth century a Palazzo for the elected Conservatori, which sat at an oblique angle to the old Tabularium.[42] In Michelangelo's brilliant design the haphazard arrangement of buildings is resolved into a reflection of the basilicas in the Roman Forum on the opposite side of his redesigned Palazzo Senatorio (for which he redid the facade). He radically refaced the Palazzo dei Conservatori and proposed doubling it across the piazza (that building would be realized a century later). The Conservatori and Palazzo Nuovo shape a piazza wider toward the Senatorio, narrower therefore toward the ramped ascent from the center of Rome. The visually compressed space of his Campidoglio piazza revolves around the sculpted figure of the emperor Marcus Aurelius on horseback atop his swelling pedestal, ringed by a radiating network of lines in the pavement, which are tautly contained within an oval pattern contained by the trapezoidal outdoor room. The pattern, much more than simple geometry, creates a doubly symbolic allusion: to the shape of Homer's shield of Achilles, which had been adopted by Alexander the Great and then the Roman emperors as their emblem, and to Apollo's sun crown. Like a superdense star collapsed in space and time, the Marcus Aurelius is a focal point in a mythical cos-

mic symbol of Achilles, Alexander and Apollo, all of it perched
atop the crown of the hill that according to medieval legend was
the site of the omphalos or *umbilicus mundi*, the naval of the
world (which had supposedly been transferred there miracu-
lously, in Roman times, from the sun god's shrine at Delphi).[43]
According to the Pythagorean model of the heavens, the earth
was the center of the universe; since Rome was the center of the
earth to Renaissance humanists and the Capitoline hill was the
center of Rome, the Campidoglio piazza was thus the center of
the universe. The fifteenth-century Florentine chancellor and hu-
manist Leonardo Bruni in his *Praise of the City of Florence* had
said about his own city and *its* "umbilicus,"

> Indeed just as in a shield, bounded by a series of concentric cir-
> cles, the innermost world closes in at the umbilicus, which is the
> central place of the entire shield: In this same manner we see the
> regions of the city, like those rings enclosed and encircled one
> inside another. This city is the first of those rings, like the um-
> bilicus which lies at the center of the whole circuit.[44]

Since Michelangelo's personal universe was rooted in con-
temporary Tuscan culture, he also makes his Campidoglio a
variation on the theme of the fifteenth-century piazza at Pienza,
near Siena (to be discussed in chapter 4). The Roman Campi-
doglio is similarly trapezoidal and opens toward the Palazzo
Senatorio in the same manner as the Pienzan piazza opens to-
ward its church. Yet whereas the small Tuscan town's whole
communal life is summed up in its compact piazza (see map
4.1)—since it accommodated church, town hall and princely
palace—Rome's multiple political and religious foci (the pa-
pacy, sites of Christian martyrdom, ancient monuments, papal
family residences, the Vatican itself and so on) were instead lib-
erally dispersed throughout the urban fabric. The Capitoline

had only one purpose, as it had in antiquity—as the *symbolic* political head of the city. So the Roman piazza's homogeneity of function precluded the formal and functional variety of Pienza. Michelangelo could still, however, invest the rhetorician's *varietas*, or variety of rhetorical style, in his composition by means of an overlaying of architectural elements and systems drawn from the common classical repertoire—major and minor columnar orders, alternating triangular and segmental window pediments and so on. And his piazza, like the one in Pienza, is similarly charged with dynamic movement. The path begins along the ascent via the *cordonata*, or ramped steps, and past the Roman statues of Castor and Pollux that crown the balustrade, then is forced right or left around the Marcus Aurelius pedestal, running either along or under the loggias, ultimately to ascend to the *piano nobile* of the Palazzo Senatorio, but only after glimpses left and right out toward the ancient forum beyond (again not unlike the views in Pienza to the green Val d'Orcia below). The whole experience is like a great theater of the world that weaves together ancient and modern elements, a grand public stage perhaps unparalleled anywhere on the globe.

But the Campidoglio has another kind of rapport with its ancient sources. Its splayed shape opening toward the Palazzo Senatorio inverts the similarly arranged Basilicas of the Forum, two prominent flanking buildings that open toward the ancient Tabularium, substructure of the Palazzo Senatorio.

What Michelangelo seems to have done is to make the Senatorio–Tabularium building a hinge between the ancient and modern city, the heart of the former opening toward the south while the latter had grown toward the north (and toward St. Peter's). In so doing he literally "reflects" ancient achievement in his new piazza, whose colonnades not coincidentally also employ a variant of the Ionic order derived from the nearby Temple of Saturn in the Forum. The past in this remarkable public space

Map 1.1 The Campidoglio and
the Roman Forum:
A. Palazzo dei Conservatori;
B. Palazzo Nuovo;
C. Palazzo Senatorio–Tabularium;
D. Basilica Julia; E. Basilica
 Aemilia; F. Temple of Saturn;
G. Sta. Maria in Ara Coeli

is mirrored and transformed at the same time, an act both historically deferential and triumphant in form and meaning. A more intricate, knowing and nuanced approach to building upon one's cultural heritage is hard to imagine.

Michelangelo has been romanticized in our day into a kind of mythic, lonely self-referential *genius*—a dangerous term, one that implies for us someone who's ideas are far ahead of their time, and are at the same time wholly his own, with no reference to the past. This is, in Michelangelo's case, patently untrue. His friend and biographer Giorgio Vasari said about the great artist that he borrowed ideas from the past like anyone else but completely transformed his sources and made them unrecognizable. We shouldn't forget that in his early career as a sculptor Michelangelo made his name by forging an antique cherub, which he went so far as to bury and have "discovered" by someone else; only after it had been sold as an antique did he claim its authorship. The past for such an artist was not a straightjacket but an inexhaustible font of ideas and forms from which to learn. And no greater work of art demanded such confidence combined with humility than the making of cities, especially the making of Rome. To the humanist mind cities needed continuity with their past, between buildings along a street or around a piazza, even across a river, to be harmonious like the universe and memorable like the cities of our imagination. The classical style and humanist culture, passed along and transformed through centuries, provided a firm grounding that allowed buildings and artists to speak to each other across space and across time. Michelangelo simply embodied these ideas more completely and deployed them with greater power than anyone else of his day.

Off the via della Lungara (a street in Trastevere about which we will learn more later), connecting the Vatican with Julius II's uncle's bridge, the Ponte Sisto, the Sienese architect and painter Baldassare Peruzzi designed the Villa Chigi (now known as the

Villa Farnesina) circa 1505 for his fellow Sienese, Agostino Chigi. Perhaps the wealthiest man in Europe in the first decades of the sixteenth century, as papal banker, Chigi was also an intimate of the Vatican courts of popes Julius II and Leo X and employed many of their best artists, including most spectacularly, Raphael. Indeed he is remarkable in that, with all his wealth, he preferred to commission new work (and almost exclusively painting) rather than purchase the antiquities that were turning up regularly in Rome in those days.

Soon after the villa's completion multitalented Peruzzi was frescoing its facade with mythological subjects that were no doubt suggested by his patron's personal iconographer—probably a professional humanist like many in the employ of any self-respecting cardinal or person of means. As is usual for the period, the frescoes are at once decorative, learned, personal and allegorical, and they are intended to comment on Chigi's interests and character while being "generic" enough to provide scope to a treatment of broader cultural themes that avoided obvious egoism. The probable thematic undercurrent behind the now almost completely faded exterior frescoes was a representation of the "Loves of the Gods" (given the amorous history of the gods, a wide and yet potent source of images for the large expanses of wall to be painted). Inside Raphael painted one of his most elegant frescoes, the *Galatea*, and later designed the sophisticated fresco cycle for the main loggia around the story of Cupid and Psyche.

When the villa was purchased by the Farnese family later in the sixteenth century, the new owners, who had already engaged Michelangelo for the completion of their imposing family palazzo immediately across the Tiber River, solicited the artist-architect's advice on their recent acquisition. He proposed the bold scheme of linking their new suburban villa to their urban palace with their own private family bridge, dramatically taking possession of

both sides of the river. The project was as expensive as it was in-
spired and came to (almost, as we shall see) nothing.

In 1595 the great fresco painter Annibale Carracci and his
brother Agostino arrived in Rome from Bologna. In the Emilian
city they, along with cousin Ludovico, had established an acad-
emy for young artists that trained the students in the best of the
tradition they had inherited, from antiquity to Raphael and
Michelangelo. When Annibale (Hannibal, in Italian) was called in
to fresco the Palazzo Farnese's recently glazed loggia overlooking
the Tiber, he was acutely aware of the great artistic precedents
across the river in the Chigi villa, by then known as the Far-
nesina—as were the Farnese family members themselves, no
doubt still haunted by Michelangelo's project for a "Ponte Farne-
siano." The learned Farnese, their humanist advisors and the Car-
racci brothers designed a dense programmatic theme for their
new frescoes identical to that of the facade of the Farnesina,
thereby "bridging" thematically what they could not physically.
The theme of the palazzo's Gallery, "The Loves of the Gods," is
the same as that painted across the river by Peruzzi in grisaille; it
is also related to the story of Cupid and Psyche told in the Far-
nesina's loggia as frescoed by Raphael. *"Il dominio universale di
amore"* (the universal domination of Love, or Cupid), if it refers
to a cataloguing of Cupid's triumphs, can be seen as a prelude to
the story of Psyche painted by Raphael.[45] The painter's source for
the story was Apuleus and his bawdy late Roman novella *The
Golden Ass*; the wedding of Cupid and Psyche that culminates the
story puts the god of love's conquests in the past. So the events de-
picted in the universal domination of Love happen before Psyche
comes on the scene. In that sense the Carracci frescoes are defer-
ential to Raphael's, because they allow the Farnesina, which was
painted first, to read like the culmination of their narrative cycle.
Annibale and his brother Agostino also borrowed heavily from
the Farnesina's stock of figures, setting up the villa as a kind of

museum in the same relationship to the palazzo as the Vatican *cortile* was to Raphael's *Parnassus*. So for the educated visitor to the Palazzo Farnese's Gallery the connection to the villa was just as profound as if there had been a way there by foot. Indeed more so, since the connection was one of learning, of taste and aspiration: It linked not only two physical places but two eras, that of the golden age of High Renaissance popes Julius II and Leo X with that of Clement VIII. The beginning of what became the Baroque epoch represented by the Carracci referred to the Renaissance era as the latter had called upon antiquity, while the palazzo and the villa bridged the city and country by means of a common humanist culture. No better bridge could have been built, certainly none more private and poetic.

We have seen some Roman bridges, mostly imaginary, that make their connections via their users' knowledge and experience—some of it admittedly esoteric, but some of it based on popular common knowledge (or popular myth). But to the great patrons who tried by every means to link together what was still in the sixteenth century a very fragmented city fabric, another potentially more memorable way to reinforce the narrative structure of the city (like the memory palace of Hadrian's villa, linked together by the emperor's wandering along his mnemonic route) was by public processions, where the route chosen, the temporary structures erected along the way and the theme of the procession could turn the entire city into a great stage upon which the narrative drama could be played out and made memorable. The city became a *teatrum mundi*, a grand theater of the world.

Shakespeare's well-worn lines from *As You Like It*, that "All the world's a stage, And all the men and women merely players," in fact repeat a commonplace of his time: The world is really a great theater.[46] And since by analogy the theater is a small world, it is no coincidence that Shakespeare's own London theater was called The Globe. The City and Theater also have many affinities,

and during the extended Renaissance in Italy their analogies were made explicit in both the designs of theaters and designs of cities. (We can think of the sixteenth-century architectural theorist Sebastiano Serlio's designs for the Comic and Tragic stages, where in the former a city composed of a grab bag of architectural styles is contrasted with the classical coherence of the latter: The urban order and architectural character of the stage reflect the nature and seriousness of the drama.) Their deepest analogy lay in that both were in their own ways microcosms of the larger *teatrum mundi* that encompassed not only the earth but the heavens above—the universe was the stage for the drama of Creation, the Fall and Redemption, as Milton would have it. Earth and Universe were supposed to resonate with the *harmonia mundi*, the Music of the Spheres that humanists believed emanated from the planets, sun and moon orbiting the earth. The theater and drama itself became important metaphors for life, and the Italian word *teatro* was used almost interchangeably for any urban event.

> *Teatro*, in fact, is a favourite term used by Alexander [VII, pope from 1655–1667] and his contemporaries to designate grand architectural designs. "Teatro dei portici attorno a Piazza S. Pietro"; or "quel gran teatro intorno la piazza"; or "la fabrica del nuovo teatro . . . "; or simply, in a late diary entry of Alexander's, ". . . piazza del teatro di S. Pietro" occur over and over to refer to Bernini's colonnades. Similarly, Alexander speaks of the "Teatro della Pace," meaning the prospect of the church of S. Maria della Pace jointly with the small five-sided square in front, enveloped as it is by palatial façades concealing very ordinary houses [*sic*—one of them is actually part of the German college of Sta. Maria dell' Anima]. . . .
>
> After all, *teatro* in the sixteenth and seventeenth centuries did not refer to only the shape of ancient amphitheaters or theaters or to their spectators' area. From the start the term referred to

the stage as well. Chantelou, Bernini's Boswell in France, in re-
counting an anecdote told by the latter, calls the stage *le théâtre*.
At the same time *teatro* means not only the stage but what hap-
pens on the stage: the action, the performance, the spectacle.[47]

Pope Alexander VII had a wide and deep impact on the land-
scape of Rome, employing the architectural triumvirate of
Bernini, Borromini and Cortona in every artistic media to radi-
cally transform the visitor's experience of the city. A sketchbook
in the Vatican library records his collaborative working process
with Bernini, clear evidence that he not only commanded, he de-
signed. His most recognized project is the piazza of St. Peter's,
but his twelve-year reign had an enormous impact on the whole
city fabric, and he thought specifically about the procession
through the city of both important visitors such as Queen
Christina of Sweden and ordinary pilgrims. The experience of
the city for queens and pilgrims started at its northern gate,
where Alexander initiated a substantial urban intervention.

If walls often stood for the Idea of a City, the city gate carried
with it multiple allusions of its own. When Leon Battista Alberti
claimed that a city was nothing other than a large house, and a
house a small city, he had in mind all the analogous features that
could be transposed from one to the other (for example, streets
as halls or piazzas as rooms).[48] The city gate was an obvious
point of coincidence, with all the ceremony attendant on the
front door of the house in classical Mediterranean culture (like
the ceremonial oblations to the gods offered there, for example)
magnified in importance and scale at the gate. It was also a
boundary between city and countryside, where its Janus-faced
condition embodied the moment of transition from one realm to
the other. The ancients, however, had said that the gates could
not be consecrated like the walls, since the ceremony of tracing
the position of the walls lifted the plough at those points where

gates would happen. In Christian iconography, though, the gate was a common topos, from Revelation's Heavenly Jerusalem and its twelve gates to Christ trampling on the gate of Hell to the Virgin as both the closed garden gate and the gate of heaven.

The most important gate in Rome was arguably the northern gate—the Porta del Popolo—which was the beginning and end of the ancient via Flaminia. It was the way into the city for virtually all travelers arriving from northern Europe. Inside the gate a longish funnel-shaped piazza led to a trident of streets opening into the city: the central street, the modern via del Corso, had existed since ancient times, when it was the via Lata; the left leg of the trident, the via del Babuino, and the right leg, the via di Ripetta, were modern additions.[49] The trident form had first been tested in Rome at the foot of the Ponte Sant' Angelo in the fifteenth century; the piazza del Popolo acquired its trident in the sixteenth century. In each case the form was more than a serendipitous accommodation of diverging streets: It inevitably called up images of the Trinity, making the city map a microcosm of heaven. As the three streets departed from the piazza del Popolo, the two wedge-shaped urban plots between them became prominent foci of attention, and the streets began to look more and more like stage scenery after the classical theater was revived in Vicenza and elsewhere in the late sixteenth century. When Bernini's pupil, Carlo Fontana, was called in to assist his master's rival, Carlo Rainaldi, in the design of the two churches that would ideally crown these two prows of land (as had been decided), he brought with him Bernini's sensitivity to awkward existing conditions and his concern for the poetic conceit underlying a project. The sites, while apparently equal, were in fact asymmetrical, because the two outer streets did not depart from the piazza at the same angle. To mask this discrepancy the churches were designed with identical temple fronts in front of slightly different domed spaces, one circular, the other oval.

Both churches were dedicated to Mary, just like the Pantheon (Sancta Maria ad Martyres), and were obviously derived from their ancient prototype.[50] A common inscription at church doors was *Haec est Porta Cœli*—"this is the gate of heaven"— and it was Christ, the fruit of Mary's womb (the closed gate), who opened the gate of heaven. Mary, as Queen of Heaven, was prominently represented in church dedications in Rome (most notably the ancient Santa Marias in Trastevere and Maggiore). The via del Babuino was the beginning of the pilgrim's route to Santa Maria Maggiore. The via del Corso, now aimed at the lumbering Victor Emanuel monument, until the late nineteenth century was visually terminated by the lofty Santa Maria in Aracœli, while the via di Ripetta was the shortest route to the Borgo Vaticano (where the fifteenth-century pope Nicholas V had envisaged a "Most perfect paradise"[51]).

With these inherited ingredients the architects of the piazza del Popolo made a complex vestibule to the city that was the goal of so many pilgrims (both religious and cultural). Far from limiting or frustrating, the standard iconography of gates and churches or the awkward conditions of disparate sites, when overlaid in the first case and exploited in the second, generated an introduction to Rome that was, simultaneously, a preview of antique treasures such as the Pantheon contained within the city's walls; an appropriately theatrical entry to the grand *teatrum mundi* that was the modern city; a suggestion of Rome's image of herself as the *civitas dei*; a window onto the multiple options offered everywhere by the city fabric, where choices of direction might suggest so many narratives; a trident of streets with overt allusions to the Trinity; and a double reading of the Marian churches as framing gates to the streets and as "closed gates" themselves. The picture these churches presented to any visitor was dramatic, beautiful and memorable; the picture they presented to an informed visitor was charged with a world of

meaning. And the meanings were made most explicit when the city functioned as a great stage set.

Public spectacle, often in the form of elaborate processions, turned all of Rome into a dynamic theater space where sacred and political dramas were ritually played out; the dramas could be evocatively popular or spectacularly papal. The papal processions naturally had the greatest impact on the permanent urban fabric and evolved through centuries according to rigorous formulas. The earliest preserved ceremonial book outlining papal processional routes in Rome is that of Benedictus Canonicus (author of the *Mirabilia*, compiled 1140–1143), written at a time when the popes resided at the Cathedral, San Giovanni in Laterano, but made the long procession (known as the *Possesso*) to San Pietro in Vaticano for coronation. St. Peter's, evoking the memory of Peter, the first pope, being set over his venerable tomb, was from its inception the most popular destination of the seven pilgrimage churches. It therefore spoke loudest both *urbis* and *orbis*—that is, to the city and the world. But San Giovanni remained the cathedral, and any official confirmation of a new pope had to happen there. Before the popes returned to Rome definitively from Avignon in the fifteenth century, the procession would begin at San Giovanni where they were usually in residence. Bidirectional in nature, the pre-Renaissance *Possesso* route was markedly different going to St. Peter's and returning to the Lateran. The way to the Vatican avoided such places as the Colosseum, the Roman Forum and the Pantheon but returned to San Giovanni by way of the via dei Banchi Vecchi and the aforementioned ancient landmarks—indeed by much the same way as the later Renaissance and Baroque *Possesso* path would. The conscious evocation of antiquity on the journey back to San Giovanni represented the papal inheritance of the symbolic empire that was Rome.

When the popes returned to Rome for good from their "exile" in 1443, they did not return to San Giovanni but to San Pietro,

acknowledging both the latter church's greater international stature and its proximity to the vastly diminished inhabited part of the city, known as the *abitato*. San Giovanni remained officially, however, the home of the *cathedra* (or Bishop's Chair), necessitating a "bridge" between the dual aspects of the pope's rule, as bishop of Rome and shepherd of all Christendom. The *Possesso* procession evolved then as a solution to the bifocal nature of papal power, functioning at the beginning of each pope's reign as a memorable link between two important loci at either end of the city and evoking specific memories from Roman and Church history along the way.

Following his coronation at St. Peter's, the pope would go to the Lateran where he assumed control of his episcopal seat and was invested with his temporal power. The Lateran palace symbolized the pope's imperial powers that were believed to have been transferred to him through the legendary donation made by Constantine. When he appeared at the Lateran, he did so as both priest and king.[52]

The *Possesso* route as a memory path served a specific evocative function, represented essentially by the ceremonial roles of the two churches where the procession began and ended; but spots along the path itself evoked deliberate memories of the papacy's role in Rome (such as Castel Sant' Angelo, the via del Governo Vecchio, the Capitoline, the Colosseum, the Arch of Constantine and so on). It was in fact a route that *recalled* ideas and events, each important locus along the way being recognizable, discrete and mnemonically "loaded." Grounded in the notion of the procession as progression, it was at once a protracted revelation and recollection (and, like the procession along the nave of a church toward the altar, a path toward fulfillment or culmination).

Joseph Connors has pointed out the aspect of choice involved in the progress of the processional route.[53] In Renaissance gardens

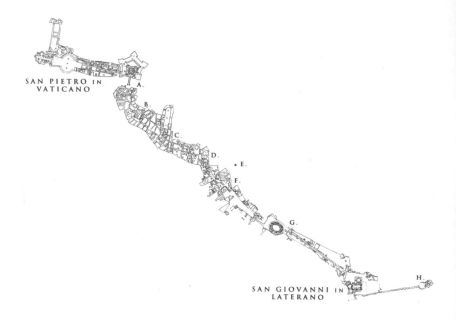

Map 1.2 The *Possesso* route through Rome (based on G. B. Nolli's map of
1748): A. Ponte and Castel Sant' Angelo; B. Orotorio dei Filippini; C. Sant'
Andrea della Valle; D. Gesù; E. Column of Trajan; F. Campidoglio; G.
Colosseum and Arch of Constantine; H. Sta. Croce Gerusalemme

a common *topos*, or theme, was the allegory of "Hercules at the
Crossroads." Having just fashioned his club, the mythical hero is
visited by two female figures representing Virtue and Vice. Virtue
points the way to Fame via a rocky uphill path, whereas Vice of-
fers him a life of ease in a shady grove; good hero that he is,
Hercules chooses the difficult path, and thus embarks on his fa-
mous twelve labors. Like Hercules, the Papal procession, taking
full symbolic advantage of the complicated network of streets in
the Campo Marzio neighborhood, marked specific places where
paths diverged along the route as symbolic places of choice be-
tween right and left, choices that could be loaded with icono-
graphic meaning. At Antonio da Sangallo's gently curving facade

of the Banco di Santo Spirito, for example, the route diverged left down the dark tortured path of the via del Governo Vecchio and past the imposing Orsini family stronghold of Monte Giordano— a castellated symbol of the chaos of medieval Rome ruled by its warring baronial families.[54] Indeed this early leg of the route deliberately took the pope through hostile territory, and that baronial, medievalizing antipapal connotation contributed to the later preservation of the winding configuration of the street even as the patrons of individual buildings along it transformed their outer facades into an ordered Renaissance of antiquity (such as the Palazzos Caloni, Nardini or Turci).[55] For the spectator it was as if the city were being read by the *Possesso*, and the pattern of streets was the plot of the story. Its readers were conscious of every nuance of the narrative as they would be with a book; choices of direction, whether urban or narrative, were the most significant moments of tension for both kinds of readers. As Umberto Eco remarks in his book on reading and writing, *Six Walks in the Fictional Woods*, "In a narrative text, people are forced to make choices all the time. Indeed, this obligation to choose is found even at the level of the individual sentence—at least, every time a transitive verb is used."[56]

The *Possesso* story began to acquire other kinds of meanings as it penetrated deeper into the heart of the *abitato*. Farther along the route was the weathered antique statue of Menelaus, known popularly then and now as the *Pasquino*. Thought in the Renaissance to represent Hercules, the sculpture was accorded the peculiar distinction of being regarded as one of three "speaking statues."[57] At this "Hercules," located at the corner of another Palazzo Orsini, the procession veered right toward the distant Capitoline hill (once again perhaps like the "Choice of Hercules," choosing between the path of virtue and the path of vice), which represented the heart of the ancient city and whose ramped approach could be dressed up as an allegorical

ascent.[58] The procession would use the city's history and the urban fabric that displayed it as the stuff of metaphor. Midway between those two Herculean choices of direction Francesco Borromini's seventeenth-century clock tower at the Oratorio di San Filippo Neri conspicuously marked the time of day. Perhaps it also alluded to a moment of change in the temporal or historical narrative—as, for example, the papacy's triumph over Rome's factional family politics. (It may also refer to the seventeenth century's obsession with mapping longitude—or position in a general allegorical sense—by means of either a near-perfect clock or the stars, which are also in evidence next to the *orologio*.) It brings to mind that the earlier appearance of clocks on communal palazzi towers around Europe signaled a change in understanding time, from that which had been *rhythmed* by the ringing of religious "hours" to that which was mechanically *measured*.[59] The Oratory tower, for an urban "monastery" of lay brothers, would have done both. As the city was slowly being stitched together throughout the papal procession, we might be reminded too of the appropriation by the popes of the imperial title Pontifex Maximus, literally "Great Bridge Builder." The Roman high priest was overseer of the auguries for construction and also built a "bridge" between earth and heaven. The entire *Possesso* route, celebrating a new papal Pontifex Maximus, can be poetically understood as an extended bridge across space and time.

Although new construction along the *Possesso* route happened for centuries, the importance of this particular street network indeed tended to focus architectural attention there. The basic continuity of the path from the fifteenth century onward privileged sites along it over those along other streets and squares around the city. While the route described here was essentially the same throughout those centuries, many of the buildings we encounter did not exist when, for example, Leo X

staged his dramatic *Possesso* in 1513. It is almost as if those who contributed some of the most significant monuments along the way embellished the bones of a narrative the given outline of which guided their actions. Two examples may suffice to make the point: They come from the two greatest preaching orders of the Baroque era, the Jesuits and the Theatines, both products of the late sixteenth century. The chosen site for the Jesuits' church marked the spot where the *Possesso* made a marked shift toward the heart of ancient Rome (the Capitoline), and Giacomo della Porta's facade of the Gesù (1575–1584) was a prominent, dramatic visual terminus to the route after it had emerged from the heart of the medieval *abitato*. Indeed it was specifically the opportunities afforded by this crucial crux of the papal coronation path that drove the Jesuits to generate one of the most influential church facades in history, which today gleams again after a thorough restoration. The Theatine order is less well known these days, but just as the Jesuits' headquarters are still at the Gesù, the dwindling Theatine order remains headquartered at the spectacular Sant' Andrea della Valle (better known perhaps as the scene of the opening act of *Tosca*). Sant' Andrea has the privilege of sporting the second-largest dome in Rome after St. Peter's. The Jesuits' great rivals for papal favor lost no opportunity to have their church—whose site marks another hinge point in the *Possesso* after it had veered away from the Pasquino—celebrate their patron Andrew, who was none other than the brother of Saint Peter. Their dome is still a prominent feature in the Roman skyline, and while we have been focusing on the ground-level experience of the city, the skyline shouldn't be ignored as an equivalent sign of the city's self-image.[60] Indeed Bernini had skewered the Parisians for their jagged skyline, which he described as resembling a carding comb: It was all chimneys and spiky spires to him, whereas Rome's graceful skyline of domes was an eloquently appropriate testimony to the

city's values. Sant' Andrea's dome therefore derived potent
meaning from its size: It made of the Theatines' church a "little
brother" to St. Peter's, establishing a familial bond with the pa-
pal basilica, reinforced by the fact that Andrew, like Peter, also
had been crucified and, like Peter, chose another kind of cross
(the diagonal) to avoid equation with Christ's. The Theatine
order drove home the latter point with Mattia Preti's monumen-
tally scaled frescoes in the apse, powerfully depicting the cruci-
fixion of Saint Andrew.

Seeming therefore to deliberately pass these two churches
dedicated to the great Baroque preaching orders, the papal pro-
cession eventually reached the foot of the Capitoline hill. From
here a glance left through the urban fabric revealed Trajan's col-
umn topped by a statue of Saint Peter (a symbol of the triumph
of the Church over paganism, and perhaps a reference to early
stylite monks). This glimpse of Peter supplanting Trajan was a
prelude to one's mounting the Capitoline hill. Until the modern
piazza Venezia was excavated from an existing dense matrix of
buildings, the elevated Capitoline piazza literally rose out of that
density as not merely a place but an important destination.
Made most explicit by the *Possesso* route, the Capitoline
marked a significant spot in the Roman cultural topography, a
hinge point between the ancient and modern city. Michelan-
gelo's plan, as we have seen, cleverly converted a haphazard
arrangement of buildings into a mirror of the ancient Forum on
the other side of the Palazzo Senatorio. His new Palazzo dei
Conservatori and Palazzo Nuovo inverted the locations and ori-
entations of the Basilica Aemelia and Basilica Julia and inflected
in the same way toward the former Tabularium (with modern
Ionic capitals reflecting the capitals of the ancient Temple of Sat-
urn). The Campidoglio we know today is perhaps one of the
most poignant spots in Rome, a place that, as twilight overtakes
it, can leave one with a deep, silent sublime melancholy, some-

thing beyond the romantic or nostalgic, the kind of feeling that inspires true reflection (as it had for Petrarch). It is a feeling deliberately drawn out by the architecture—an architecture of intellectual references, an architecture of the mind, but of a Mind that for humanist culture was not a long way from the Soul.

Pope Urban VIII emphasized the drama of Michelangelo's ramped ascent to the piazza in his *Possesso* celebration by flanking the path with five pairs of allegorical statues of Virtues that symbolized the new pope's personal qualifications to make that ascent. In a brilliant conceptual bridge Pietro da Cortona's later ceiling fresco for the *Salone* of Urban's family palace, the Palazzo Barberini, repeated and amplified those qualifications so that the visitor to the *Salone*, having climbed the circular stairs to the *piano nobile*, is meant to metaphorically continue that upward spiral and be literally assumed up into the ceiling, joining in an apotheosis of Maffeo Barberini—poet, philosopher, pope.[61]

The *Possesso* route continued after the Capitoline through the ruins of the Roman Forum, past the so-called Temple of Peace (the Basilica of Maxentius and Constantine), through the Arch of Titus (commemorating the Sack of Jerusalem), under the Arch of Constantine (as the first Christian emperor, Constantine was the embodiment of the resolution of state and church functions into one entity), around the Colosseum (the revered site of Christian martyrdom and an eventual model for Bernini's Piazza San Pietro), and down the long via San Giovanni toward the Lateran basilica—which had been given to Pope Sylvester by Constantine as the Church's first *Cathedral*, or bishop's seat.

At this last stage the route was pointed toward the Lateran palace and the obelisk in front of it, not toward the basilica itself. At the piazza the procession was therefore compelled to enter the church building through one of the side transept doors,

which effectively made that entrance ceremonially more significant than the actual front door. Indeed one of these three transept doors was considered a *Porta Santa*, opened only at holy years and claiming special indulgences for those entering through it. This explains the substantial decorative attention lavished on the interior of the transept and the chapel just inside.[62] The primacy of the transept door was also attested to by the presence nearby of the Lateran Baptistery, suggesting almost a ritual baptism for all who entered the church from this side. Finally taking his seat at the altar, the new pope only now assumed his role as temporal and spiritual leader *Urbis Et Orbis*, whose complex relationship to the city and his office had been laid out all along the route through Rome.

Other processions in the city, following the rhythm of the yearly religious calendar rather than the cycles of papal politics, regularly marked the sacred functions of the Church's saints and sacraments. One of the most important of these was the Corpus Domini (Body of the Lord) procession, which was celebrated in cities throughout Italy on the first Thursday after Trinity Sunday. Rome's version began and ended at St. Peter's.

> At eight o'clock the members of the procession were required to meet at the "prima porta," the portal leading into the [papal] palace. When they were all gathered into the forecourt, they were arranged by the Cardinal Chamberlain in hierarchical order and sent off two by two on the circular route through the Borgo under a canopy strung over tall, slender poles. . . . The canopy was very similar to the device used in the Venetian Corpus Domini procession.[63]

The pope's involvement in the Roman procession conferred the greatest significance to the route enacted in the Eternal City. The processional path precisely traced the outline of the Borgo

Leonino, the neighborhood around the Vatican in which popes such as Nicholas V would invest so much energy. The Eucharist, raison d'être of the procession, was ceremonially carried in front of the processors. This procession's focus on the Eucharistic body recalls Raphael's semicircular array of Church Doctors in his *Disputà* fresco in Julius II's private library, which is adjacent to his painting *The Muses and Apollo on Mount Parnassus* and opposite the more famous *School of Athens*. Raphael in his *Disputà* painted what is in effect an apse-shaped "architecture" of frescoed figures, saints arrayed in a heavenly auditorium, or *cavea*, apparently in solemn discussion and all focused on the elevated host upon an altar. The fresco's architectural arrangement of figures, we will see, presages Bernini's figurative architecture of the Piazza San Pietro. The Corpus Domini procession through the Borgo organized the members of the Vatican Curia into a hierarchical array like Raphael's, but in the procession the Curia moved linearly through and around the urban fabric, creating a more active or dynamic engagement with the Eucharist than the static reflection and discussion going on in the painted scene. The Corpus Domini procession gave the Borgo a privileged significance as an especially sacred bit of urban fabric within the wider Roman topography.

It was the fifteenth-century pope Nicholas V who perhaps deserves credit for imagining, if not necessarily realizing, the idea of conscious urban planning in Rome, especially in his projects for the so-called Borgo Leonino or Vaticano traced by the Corpus Domini procession. "Nicholas's conception was the determining factor in all subsequent physical development in Rome."[64] Born Tomasso Parentucelli in the Ligurian region near the port of La Spezia, this scholarly visionary pope gave shape during his eight-year reign to a new image for the district around St. Peter's, while he also encouraged humanist culture at the papal court (his library formed the basis for the Vatican

Library). The architectural historian Carroll William Westfall's *In This Most Perfect Paradise* lays out the program of Nicholas's projects, and in that often symbolic program this humanist pope's real significance lies.[65] Apart from an antiquarian's interest in the classical planning principles of the ancient city, which his advisor, Leon Battista Alberti, was happy to inform him about, Nicholas dreamt of the Borgo as a kind of mini–New Jerusalem, an opportunity to create, outside the unyielding fabric and tensions of the densely packed neighborhoods on the other side of the Tiber, a vision of an ideal, celestial urban architecture: Augustine's heavenly city counterpoised to the all too earthly city across the Ponte Sant' Angelo. In this vision Nicholas brought to the city a dream that later architects and patrons would strive to realize (a dream charged with celestial vision should not be underestimated as a planning tool). Two centuries later the latent symbolism of the urban fabric in front of St. Peter's would be made manifest in the colonnaded piazza designed by Bernini, who described his design thus: "[T]he colonnades [are as the] arms of the Church 'which embrace Catholics to reinforce their belief, heretics to re-unite them with the Church, and agnostics to enlighten them with the true faith.'"[66]

This is Bernini's formal *giustificazione*, a written justification, or description, of his design for the oval colonnades of St. Peter's piazza. Perhaps the finest artist of the seventeenth century, Bernini was without a doubt that century's most successful and prolific one. Trained early on by his sculptor father, Pietro, in stone carving, Gianlorenzo's precocious prepubescent promise was nevertheless exceeded throughout his life. Directed toward architecture by a series of popes who desired that he become their very own Michelangelo, Bernini virtually redesigned the city of Rome during his immensely productive career. Deeply spiritual later in life, he saw all his work as divinely inspired. He

was also firmly convinced of the need for an artistic project to spring from a *concetto*, a poetic conceit or idea that embodied the core meaning of the commission. The *concetto* would guide all the decisions about form in the design process, whether the project was for a painting, a sculpture, a work of architecture or best of all, the three arts combined into what he called a *bel composto*—a beautiful whole.[67]

The Corpus Domini procession, as we have said, ceremonially defined the limits of the core of the City of God that was Rome's Borgo district within the larger City of Man that Rome as a whole represented. But Bernini's written *giustificazione* of his figurative *concetto* in the Piazza San Pietro leads to some profound implications for the Borgo's meaning. The notion that the traditional form of the Latin basilica-with-transept represented the cross, and therefore also the figure of Christ crucified, is of very early origin. (The Renaissance theorist Francesco di Giorgio's diagram of this Figura Dei overlaid on an ideal basilica plan is perhaps one of the most deliberate articulations of the theme.) If we accept Bernini's description of the colonnades as embracing arms, then the basilica itself must become the head (and we know that Michelangelo conceived his dome to represent the Divine Mind, which only confirms this interpretation) And so we are left with the Borgo's urban fabric to represent the slightly *contrapposto* body of the welcoming church (or Peter or Christ?). In other words Bernini has extended the long-standing symbolic relationship between the form of the basilica and crucifixion into the urban realm. His project produces a form of *città figurativa*, or figurative city, not entirely without precedent in European thought (as we will see in Siena) but in this case more overt and ritually reinforced than any other anthropomorphic urban plan in existence. And given the fact that Saint Peter was actually martyred upside down, this primary reading of the plan of all Latin cross churches as diagrams of the crucifixion of

Christ is overlaid with a secondary one for this particular church as representing Peter crucified. The Basilica of St. Peter is oriented not to the west, as is canonical, but toward the east—that is, upside down. All of these allusions to crucified bodies, to Peter's but especially to Christ's, make the Corpus Domini procession's tracing of the outline of the Borgo district not merely a ceremonial walk around the neighborhood but a reading of the urban realm as sacred and meaningful. This may have been a deliberate affirmation of the theological doctrine of transubstantiation and sacrificial martyrdom, but it also laid out for the faithful the mystical role of the Eucharist as the Body of Christ in the very fabric of their city. Francesco di Giorgio had stated the city–body relationship explicitly. "Given that cities bear the same logic, measurements and form as the human body . . . it is likewise important to note that the body possesses all the articulation and members observable in the city and its buildings."[68]

We can't appreciate fully these themes today because the whole Borgo area was insensitively transformed in the mid-twentieth century.

The modern boulevard that now leads to St. Peter's, known as the via della Conciliazione, is really an abrupt fissure in the fabric of Rome imposed by Mussolini's planners, Piaccentini and Speccarelli, beginning in 1938 with the demolition of the *Spina*, the blocks of buildings between the old streets known as the Borgo Vecchio and the Borgo Nuovo.[69] Borgo Vecchio, the older of the two, was a gently curving street roughly directed at the facade of St. Peter's; Borgo Nuovo was a straight street aimed at Bernini's Scala Regia (the grand stair to the papal apartments and the Capella Sistina). These two paths diverged from a small piazza to the left of the Castel Sant' Angelo after one had crossed the Ponte Sant' Angelo. The Piazza San Pietro formed a dramatic contrast to these narrow shaded streets, both psychologically and intellectually; the two Borghi represented

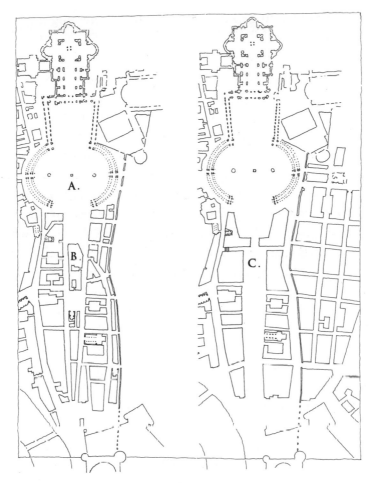

Map 1.3 The Borgo district pre–1938 (*left*) and today (*right*):
A. Piazza San Pietro; B. the *Spina*; C. via della Conciliazione

the weave of the medieval–Renaissance city fabric on the other side of the Tiber, while the Piazza extended the ideal realm of the Church into its urban context. Mussolini's overwide *via* (its width greater than most piazzas in the historic center) curiously blurred this distinction between the City of Man and the City of God in the very act of commemorating the agreement that

finally divided papal and Roman territory by creating the widest boulevard within the existing urban fabric. The pre–twentieth century urban condition had recalled, perhaps deliberately, St. Paul's architectural metaphor in his letter to the Ephesians.

> For he is our peace, who has made us both one, and has broken down the dividing wall of hostility, by abolishing in his flesh the law of commandments and ordinances, that he might create in himself one new man in place of the two, so making peace, and might reconcile us both to God in one body through the cross, thereby bringing the hostility to an end. . . . So then you are no longer strangers and sojourners, but you are fellow citizens with the saints and members of the household of God, built upon the foundation of the apostles and prophets, Christ Jesus himself being the cornerstone, in whom the whole structure is joined together and grows in to a holy temple in the Lord; in whom you also are built into it for a dwelling place of God in the Spirit.[70]

As we have seen, a deliberate anthropomorphic intention was operating throughout the Borgo area, reinforced by the annual Corpus Domini procession. The via della Conciliazione intervention in effect gutted this sacred figure and lined the corpse with banal office buildings. This was neither a revitalization of the civic realm nor the sacred. The old narrow streets had continued the "Spiritual Exercises" begun for us by Bernini at the Ponte Sant' Angelo, where his figures of angels carried the instruments of the Passion of Christ and culminated in the representation of the *Cathedra Petri* in the apse of the basilica.[71] The loss of these streets breaks the chain of Bernini's story, as it eradicates the dramatic change in experience from narrow street to wide piazza.

We know enough of Bernini's thought process to imagine how he saw the poetic *concetto* operating in the Vatican neighborhood.[72] Both the Sant' Angelo bridge and the *Cathedra Petri*

projects involved links across space and time that were at once optical and allegorical. Bernini's first sketches for the *Cathedra* show it framed by the Baldacchino he had built under the dome roughly forty years earlier, compressing the distance between the two monuments into a kind of framed picture. His sculpture *Angel Carrying the Crown of Thorns* on the Ponte Sant' Angelo appears to one standing on the bridge immediately in front of the figure and its pedestal to "place" the crown it holds on the dome (that is, the head) of the basilica in the distance. Bernini saw the bridge then as the beginning of a powerfully integrated urban narrative that takes each pilgrim on a spiritual journey. It is an allegory that transports us mentally and spiritually as well as physically along a proscribed route charged with meaning toward a final fulfillment in the explosion of light and sculpture in the *Cathedra Petri*. It is therefore like a concrete construction that embodies all of the evanescent ideas we have seen in those imaginary bridges built by Bramante, Raphael and the Carracci brothers.

The broad topography of the rest of Rome was grudgingly shaped through the centuries by new streets that gave geometric logic and structure to what was otherwise a complex, winding "picturesque" medieval street pattern. One has to develop a different conceptual framework from our modern gridded city block matrices to understand how the center of Rome was changed by Renaissance urban projects. Think of the dense fabric of medieval buildings as a lump of clay, scored over time by streets that sometimes were overlaid on remnants of streets from the ancient city and sometimes took new directions by necessity or chance. The desire of Renaissance urban designers to create straight streets could mean simply correcting these existing streets, taking off an errant lump of clay here or adding a bit there as necessary. But it might be more dramatically achieved by literally carving a new street or piazza out of the dense clayey

matrix—appropriating houses, convents, even churches when necessary and slicing off errant bits or remolding their contours.

For many reasons—lack of means, lack of authority, lack of will—this process in its fullest, most dramatic forms was quite rare in the city center until the nineteenth century. Instead during the period we are visiting the results were often more of the incremental urbanism variety: A local building project would swell in scale during the design phase, wanting to improve its context by bending streets or shaping a new piazza, then contract as it confronted the reality of achieving its goal, still having had an impact greater than if the dream had not been dreamt. For this reason the most notable straight streets realized from the sixteenth century (in many ways the century of greatest urban planning ambitions) were projected onto the sparsely inhabited landscape around the edge of the built-up inhabited area (the *abitato*). And with perhaps one major exception they were all addressed more to visitors—pilgrims and dignitaries—than to the Romans themselves.

Two of these straight streets flank the Tiber and are pointed more or less toward St. Peter's. The via della Lungara and via Giulia are part of Julius II's program for reorganizing Rome and are traditionally credited to Bramante's influence. Both depend on the Ponte Sisto, the bridge built some decades earlier by Pope Sixtus IV (1471–1484) to connect the *abitato* with Trastevere, the neighborhood across the Tiber. The slightly older of the streets is the via della Lungara, squeezed between the river and the Janiculum hill, in an area of gardens and villas. Pointed directly at the gate into the Borgo Vaticano known as the Porta Santo Spirito—the gate of the Holy Spirit—its sacred role was therefore not left to doubt. It was a road for pilgrims that bypassed the tortuous urban fabric on the other side of the river. The other street is perhaps better known to visitors to Rome today. Via Giulia is named after its driving force, Pope Julius II. As nephew of Sixtus IV, Julius saw his papacy continuing the projects begun by his uncle.

He called in Michelangelo to fresco the Sistine (after Sixtus) Chapel ceiling. He augmented the Vatican Library built by Sixtus, and he gave his uncle's bridge an urban boulevard that took on the heroic challenge of making an elegant, perspectively correct straight street on the edge of the oldest continually inhabited part of the city. He hoped too that the new buildings between his street and the Tiber River would also provide an opportunity to improve flood protection in the area. Everything Julius did had a sense of urgency about it. As Ingrid Rowland says, "For Julius, Rome's renewal was neither a rhetorical trope nor an antiquarian ideal: it was a task to be realized at once."[73] Julius had grand plans for the new buildings that would develop along his new *via*; the monumental beginnings of the rustication of Bramante's unbuilt law courts attest to his almost Herculean dreams. But it took centuries for the buildings to grow up along the via Giulia, and there are still gaps along the way today that cry out for an appropriate new palazzo. Still, his graceful straight-as-an-arrow new street points the way toward future Renaissance city planning, not only in Rome but across Europe.

Near the tail end of the sixteenth century Pope Sixtus V (1585–1590), in a busy reign of a little over five years, dramatically changed the Roman landscape, while enacting equally wide-ranging reforms within the Vatican Curia.[74] His most notable urban planning efforts consisted in developing a network of streets that would link the seven major pilgrimage churches of the city, which were mostly widely scattered beyond the edge of the *abitato*. Key to his plans, and a church to which he was especially devoted, was Santa Maria Maggiore. Inside, over the venerable basilica's triumphal arch marking the sanctuary, is a mosaic that, at the arch's peak, proclaims the patron, XYSTUS EPISCOPUS PLEBI DEI—Sixtus the Bishop to the People of God—an inscription that the eminent historian Richard Krautheimer claimed "has a flavor both Biblical and classical."[75]

The fifth-century pope Sixtus III reigned from 432 to 440—that is, not many decades after Rome had been sacked by Alaric and his Visigoths. He seems to have employed a conscious policy of overt classicism in the other projects for which he was patron (such as the Lateran Baptistery), which repositioned Christianity as the cultural, as much as spiritual, successor to the defeated empire.[76] The mosaic in Sta. Maria Maggiore shows the Old Testament scene of the destruction of Jericho, a city and an act symbolized in the image simultaneously by the collapsing walls.[77] Sixtus III would reign over a city whose walls had been breached, so seeing Jericho as the old Rome would have been a poignant message. No doubt the sixteenth-century Sixtus saw his own triumphant urban policies as involving both destruction and building, which the mosaic image and its support in this remarkable arch collapses into one symbol. Sixtus V, among his many projects connected with this church, both internally and urbanistically dedicated a monumental chapel at the east transept that introduced its own minor triumphal arch into the cross axis of the nave, allowing him to be seen as refounding the church in the tradition of his predecessor.

Although he had reverential respect for his office and his predecessor, Sixtus V was equally ruthless in his emphasizing the triumph of the Church over fallen pagan Rome. It was he who had the statue of Peter placed atop the Column of Trajan (that prominent landmark along the *Possesso* route; a bronze St. Paul was also placed on top of the so-called Antonine Column in Piazza della Colonna) in order to redefine in Christian terms the column's military triumph, depicted in relief on its surface. He went so far as to destroy the famously elaborate ancient Septizonium at the southeast corner of the Palatine hill to cannibalize it for building materials for his religious projects. He had strong convictions about which historical remains merited saving and which others deserved raiding. This polemical view of history

could not be more foreign to modern conservators' line of thinking, but it deeply informed his sense of mission in stitching Rome together for the benefit of pilgrims.

This Sixtus also had something in common with Sixtus IV, patron of the Ponte Sisto a century earlier. Sixtus V is best known for the network of radiating streets he developed to connect Rome's seven major pilgrimage churches. He is credited almost as an architect as much as a patron for propagating these linear (and, not coincidentally, most of them outlying) streets, which relied on a star-shaped geometric pattern that may owe something to the complex plan of Hadrian's villa below Tivoli.[78] And perhaps in some way the intention was the same. By linking the seven pilgrimage churches, which were mostly scattered in uninhabited districts around the edge of the city, these ramrod-straight new roads became like the routes of an extensive sacred memory palace where the stories of martyrdom and triumph were continually retold across a highly charged landscape dotted with magnificent ruins. Just as the paths one took through Hadrian's villa, the sequence in which one linked these pilgrimage churches together determined a kind of personal spiritual narrative, made memorable by the beauty of the churches, the many hagiographic associations of their sites, the ancient Egyptian obelisks that Sixtus placed as markers at the end of the streets and the evocative landscape one traversed in between. Like an elaborately illustrated medieval codex, the city of Rome wanted to be remembered, recalled long after the pilgrims had gone home; the late Ivan Illich's description of reading one of these twelfth-century codices also nicely illuminates how cities could be similarly read.

[T]he illustration of books before the thirteenth century has a practical—now often forgotten—mnemonic purpose. Hugh [medieval abbot of St. Victoire, in Paris] speaks of reading as a

journey. He advances physically from page to page. The orna-
ments that line the rows of letters place the words into the land-
scape through which this journey leads. On no two lines does
the reader meet up with the same view, no two pages look alike,
no two initial "A"s are identically colored. The foliage and
grotesques in combination with the lines reinforce the power of
remembrance: they support the reader's recall of the *voces pagi-
narum* in analogy to the scenery of the road that brings back
the conversation which took place on the stroll.[79]

John O'Malley in *Rome and the Renaissance* calls the "con-
flated myths" of Rome's self-image "civic mysticism": ideas of
the city elevated to a kind of collective civic cult of Rome's des-
tiny.[80] These ideas, consciously and unconsciously endorsed,
were the glue that held together and made sense of centuries of
sporadic urban development, creating a "concordant discord"
of building fabric and public space while patrons and artists
came and went. In the end what are these Ideas that linked the
development of Rome, even in the centuries after the decline of
her empire? Here is the short list.

Rome the Reliquary of Marvels
Rome the Museum
Rome the Memory Theater
Rome the Heavenly City (or Earthly Paradise)

All of these Ideas of Rome were pieced together into coherent
stories over time. Those who added scenes to the narratives did so
with an abiding belief in the importance of what their culture
thought the city should mean: whether in Hadrian's deference
to his model predecessor Augustus' work and therefore to the
continuity of the institution of emperor that he had inherited; or
Donato Bramante's evocation of the Rome of Saint Peter's mar-

tyrdom and the Rome of Janus' protohistory, the ancient Rome of heroic architectural achievement, and the reborn Rome of the papacy and cultural renaissance he was helping to bring about; or Michelangelo's noble melancholy at the hinge point between the ancient and modern city, a powerful, brooding and yet eloquent setting for government that would be exploited in the *Possesso* route as a place of apotheosis; or finally Bernini's classically tragic image of the urban theater, a place where our spiritual journey is ultimately played out and where in the city of cities we might even glimpse spiritual fulfillment. Rome, in all these senses, was an elaborate story that left clues about how it wanted to be understood, stitched together at times not physically but intellectually or mnemonically. And that leads to a key component embedded within these ideas: the Rome of bridges, of connections made across the urban landscape, certainly across the Tiber River, but also back and forth across time, even attempting to bridge the gap between earth and paradise. And yet the core understanding, the one behind all the other ideas and perhaps the most difficult part for us to get hold of today, was the idea that the very city of Rome somehow summed up our whole human condition in body, brain and heart. The man-made world could in this view be a powerful metaphor for the life of the mind and the soul, as it was for Augustine in the fifth century. "The power of the memory is prodigious, my God. It is a vast, immeasurable sanctuary."[81]

All the senses are touched and rewarded here: Fountains, grottos, balustrades, espaliered orange trees and frescoes were endlessly exploited for their impact on our ears, hands, noses, tongues and eyes; not for mere delight—although that was surely part of their appeal—but to tap our five senses like a good rhetorician to get at our minds and souls. Humanist culture was the source of the rhetoric and style, although it was often the Church, after the fall of the empire, that provided the content. Rome practically grabs us by our collars to get our attention;

sometimes she merely seduces us, but there is behind it all a deeper appeal to our intellectual and spiritual selves. Certainly there is much of the connoisseur's knowledge underneath Rome's beauty—the knowledge the Renaissance had regained from the ancient Roman architect Vitruvius about the classical columnar orders or the artistic principles apprehended from excavation and documentation of the ruins or the philological rigor practiced by lovers of inscriptions and so on. But the real work of making Rome beautiful was driven by the desire to make her speak. It was only because there was some degree of consensus about *what* she should say that we have inherited the poignantly beautiful city that she became over time. And it was the many layered complexity of this memorable city that inspired artists and architects across Europe for centuries, as we will see in subsequent chapters. The classical idea that Memory, or Mnemosyne, was the mother of the nine Muses, who were the goddesses of inspiration, is crucial to their understanding of the power of the past to inspire the present. As Mnemosyne's daughters, the Muses were inevitably deeply moved by the image of this most complex of memory palaces: Rome was a new home for them, a new Mount Parnassus or Mount Helicon translated to the banks of the Tiber River (the new Hippocrene stream).

> The Muses leap and dance in Pieraia in Helicon, and sing praises to their father Jupiter. They turn over what is written in books, go everywhere, and circle like a chorus, praising the intellect which gave birth to them. Thus, Greek commentators declare Pieraia to be the dwelling of the mind itself, and Helicon the books through which dance the Muses, who are aspects of knowledge and opinion.[82]

From the Campidoglio to the Vatican gardens Rome evoked and even became the mythical home of the Muses.

2

Venice and the Sea

THE CITY OF VENUS

*The august city of Venice rejoices, the one home today of
liberty, peace and justice, the one refuge of honorable men,
the one port to which can repair the storm-tossed, tyrant-
hounded craft of men who seek the good life. Venice—rich
in gold but richer in fame, mighty in her resources but
mightier in virtue, solidly built on marble but standing
more solid on a foundation of civil concord, ringed with
salt waters but secured by even saltier counsels.*
> —Petrarch, *Epistolae Seniles*, 4.3, quoted in
> Kallendorf, *Virgil and the Myth of Venice*

Perhaps no city on earth so captivates first-time visitors the
instant they arrive as does Venice. No amount of knowing that
the city lives on the water prepares one for the fact of it. Read-
ing what the Venetians and their admirers and detractors had to
say about her in the centuries when the city was a work of art
in progress confirms that this has always been so. There is an

Fig. 2.1 Ignazio
Danti (1536–1586),
Panorama of Venice.
Fresco. 1580–1582.

audaciousness in the whole Venetian enterprise that has always
commanded respect, or at least envy. The Venetians themselves
had a noble sense of themselves, their government and their
economy, and used their city as a great public sign, a concrete
manifestation to the world of their own myth.

To understand something of how the Venetians saw them-
selves and their city it is necessary to put the city in its topo-
graphical context. The urban aggregate that is now Venice
began as two interlocked islands known as Venice and Rialto,
which occupied the upper middle of a salty lagoon separated
from the sea to the east and south by a chain of littoral islands.
The Venetians called the narrow openings between them *porti*,
their doorways to the wider Adriatic and Mediterranean. To the

west the two islands were bounded by an irregular coastline punctuated by several rivers, large and small, that spilled fresh water and silt into the lagoon. This sheltered yet ecologically precarious position they shared with numerous smaller islands in the upper lagoon, many of which were settled around the same time, and out of which Venice eventually emerged ascendant. The city's original island site was actually augmented by aggressive land reclamation through the centuries, pitting land and water in a struggle for dominance of another kind, and indeed Venice's relationship with its watery context was never easy or constant, but it was certainly defining.

> [T]he city's site in the middle of the water gave rise to an ideological operation displaying the image of a city constantly menaced, even attacked, by hostile waters. On the other hand, the narrative sources always presented the water surrounding Venice as protective, some commentators going so far as to prepare the way for an aphorism that became universal in later centuries, when the brackish waters of the lagoon were called the "saintly walls of the homeland."[1]

Water was the source of Venice's very image, its boundary and best defense, what buoyed its trade advantages and military might. Yet the water of the rivers flowing into the lagoon also brought silt that threatened the lagoon's stability, and the salty water of the lagoon meant that drinking water was a complex acquisition.[2] The city's watery landscape was a precarious base for the projection of their myth.

The Venetians loved to claim that they were the only truly unconquered survivors of the Roman empire. It is a myth wrapped around kernels of truth. While they were under the protection of the Byzantine empire in their first centuries after the Fall of Rome in 410, their original population indeed seems to have comprised mainlanders looking for either security or

opportunity in the marshy lagoon. Venetians were recognized by the sixth century as a stubbornly independent society who lived and traded within the lagoon basin and between the Adriatic and the mainland. Having left the mainland for the marshy islets off the coast (whether en masse in the face of Alaric's Visigothic invasion, as myth would have it, or incrementally well before the invasions began, as scant archeological evidence seems to suggest), they literally assembled their city's site out of hard-won watery terrain. This ostensible Roman survival was marshaled to sustain claims to first, autonomy and second, conquest. With their autonomy and ambition on the Adriatic coast, however, they were bound to come into contact—and conflict—with the original claimant to imperial Rome's mantle: Constantinople. Finding empire building easier or more innately appealing on the sea than on terra firma, Venice followed her son, Marco Polo, across the Mediterranean and eastward. But her sense of herself as serenely Roman was never lost, even as exotic influences poured in on ships returning from Egypt and as far away as China or Japan. It was as the rightful heir to Rome that Venice projected herself.

> The mythical origins of this state were obscure, with one legend tracing the founding of Padua and the Venetian state to Antenor of Troy, and another dating it to the time when a group of patricians fled across the lagoon to escape the barbarian invaders. This second legend fixed the precise date at 25 March 421, which has the advantage of implying the providential replacement of one civilization with another, since the year was not long after Alaric's invasion of Rome and the month and day were that of the Annunciation to the Virgin Mary. . . . [T]he decorations added to the Palazzo Ducale in the 1480's contained reliefs of shields, helmets, and other paraphernalia with such transparent mottoes as "SPQV", and the monumental

tombs of the doges from the same period began to resemble Roman triumphal arches.[3]

Whether a parallel to Rome and founded like the imperial city by refugees from Troy or by Roman refugees and therefore the only true successor to Rome after the empire's fall, Venice built a proud self-image around her presumed Romanness. Without monumental remains from her ancient past that Rome or Rimini had, the image of her Roman roots was perhaps less than clear in her architecture, the most impressive of which was mostly of the Romanesque and medieval periods such as the Ca' d'Oro or the church of San Marco. But this longing for classical legitimacy would eventually provide welcoming ground for Renaissance Romanist architects such as Jacopo Sansovino or Andrea Palladio.

Virgil's foundation myth of Rome, the *Aeneid*, by extension became a part of the Venetians' mythic sense of themselves as successors to Rome. Not surprisingly Virgil was the most popular classical author taught in Renaissance Venetian schools and the *Aeneid* his most popular work.[4]

[I]n Act II, Scene ii of Didone, a tragedy written by Ludovico Dolce and published in Venice in 1547, Aeneas is recounting Mercury's command that he leave Carthage in order to secure a glorious future for his son and his descendants. Dolce adds some lines not in Virgil, in which the descendants of Aeneas are traced through Roman history to the Venice of Dolce's day:

And their late offspring, after many a revolution of the heavens and a long extent of years, will give a most auspicious beginning to another great city amidst the waves, where peace and love, where virtue and every good custom will always be held in esteem so long as the world endures. There beautiful Astrea, with lovely locks crowned

*by the gleaming olive, will always rule, and there in con-
trary and turbulent times those in travail should find a
safe harbour.*[5]

As much as she is bound up with her Roman past, Venice is
even more powerfully entwined in a permanent embrace with her
lover, the Sea. It is a relationship as intimate and troubled as any
emotional attachment could be: The Sea gives her commerce, de-
fense and irresistible charm but at the same time threatens to
smother her under its *acqua alta*, or high water. No other city in
Italy has as romantic and troubled a relationship with nature,
with the possible exception of the one between Naples and
Mount Vesuvius.

The Venetians formally ritualized this relationship, as they
did many others. In making explicit what was implicit in their
city's watery site they, like the Romans, made mythic what
might have been prosaic or practical: Not a truce with the Sea,
their bond was more active, formal and allegorical. The wed-
ding ritual that we will explore was a promise, a bond and a
plea. The architecture of the city matched this marriage with a
similarly tender and yet decorous embrace.

Edward Muir's *Civic Ritual in Renaissance Venice* plots out
how the ritual of wedding the sea, with the doge as bridegroom
and the lagoon as bride, originated in a ritual blessing of the sea
that can be traced back to around the year 1100. This was the
sort of ritual blessing (really an appeal for calm seas) that was
common to many maritime cities whose whole existence was de-
pendent on the temperamental tides. By the late thirteenth cen-
tury the wedding ceremony, actually more of a prenuptial
contract—what each party owed the other—had become part of
the ritual. When we arrive into the sixteenth century, the whole
state mythical season culminated in the nuptial events by then
known as the *Sensa*, and it is no coincidence that the high the-

ater of it all also formally inaugurated the Venetians' theater season. For the drama of the ceremony itself it is worth quoting Muir in full.

At dawn on Ascension Day the doge's cavalier in charge of ceremonial preparations determined whether the sea was calm enough for a procession of boats; if it was, he obtained the ceremonial ring (the *vera*) from the officials of the Rason Vecchie and announced the beginning of the Sensa. After mass was sung in San Marco the doge, high magistrates, and foreign ambassadors boarded the Bucintoro, the doge's ceremonial galley decorated with figures of Justice and the insignia of the republic. As they were rowed out onto the lagoon, the chapel choir of San Marco sang motets, and the bells and churches and monasteries under the patronage of the doge began ringing. Near the convent of Sant' Elena, the patriarch of Castello, in his flat-boat (*piatto*) bedecked with banners, joined the procession of vessels, which usually included thousands of gaily adorned private gondolas, barges hired by the guilds, pilot boats (*peote*) fitted out by companies of young noblemen, and galleys manned by sailors from the Arsenal. The religious rites of *benedictio* took place on the patriarch's boat: two canons began by singing, "Hear us with favor, O Lord," to which the patriarch answered three times, "We worthily entreat Thee to grant that this sea be tranquil and quiet for our men and all others who sail upon it, O hear us"; the patriarch blessed the waters, and the canons sang an Oremus. The patriarchal boat then approached the ducal Bucintoro, from which the *primicerio*, the head priest of San Marco, thrice entoned, "Sprinkle me, Lord, with hyssop and marjoram." Next, while his boat circled the Bucintoro, the patriarch blessed the doge with holy water, using an olive branch as an aspergillum. When the party reached the mouth of the lagoon, the place where a break in the Lido opened Venice

to the Adriatic, the actual marriage ceremony took place. At a signal from the doge the patriarch emptied a huge ampulla (*mastellus*) of holy water into the sea, and the doge, in turn, dropped his gold ring overboard saying, "We espouse thee, O sea, as a sign of true and perpetual dominion." After the marriage ceremony the doge and his guests stopped at San Nicolò al Lido for prayers and a banquet that lasted until evening, others returned to feast at home, and the pilgrim and merchant galleys bound for the East, the first of the season, made their way under the protection of the bishop's blessing and the plenary indulgences received at San Marco.[6]

There is a gender ambiguity in this ritualized relationship of city and water; the doge as husband weds the sea as bride, but in mythology cities were always portrayed as goddesses and the rivers, seas and oceans as gods. The latter relationship is how things are portrayed in Veronese and Tiepolo's allegorical canvases in the Doge's Palace, with Venice as a Venus type. But Venice was both the city as a deity and the government as embodied in the doge: not exactly a hermaphrodite, but a body whose ambiguities and multiple illusions only Italian humanists could intellectually sustain. What mattered was that the body had corporeal integrity.

> In a similar way, in the republic of Venice the greatest governmental power has been given to the patrician order, as being, so to speak, the eyes of the state, while the less noble offices are given to the remaining popular orders. Thus just like a well-ordered body, the Venetians live happily since the eyes of the republic provide for not only themselves, but also all the members, and the remaining parts of the state take into account not only themselves, but also freely obey these eyes, as the better members of the republic.[7]

Venice's anthropomorphism was less literal than that operating in Rome's Borgo Vaticano, but the body–city allusion was often sustained in the city's collective consciousness as an apt metaphor for describing both social and political integrity, and for staking out loci of importance.

> [W]hereas "the divine temples [are] the walls . . . and bastion of the Catholic and very Christian republic," it was recalled that the church of San Salvador was "miraculously constructed and founded by the hand of that very blessed bishop of Altinum master Sancto Magnio (Bishop Magnus) in the middle of this very great city," . . . Reconstruction was therefore necessary "for the decoration and ornament of this famous and renowned city, since, being located in its viscera [in visceribus suis], it deserves a larger and more magnificent building to be constructed."[8]

The idea of the church of San Salvador being located in the viscera—the guts—of the city presumably gave it special prominence on the Venetian sacred landscape. No outlying neighborhood church this, San Salvador occupied a site that had accumulated other layers of civic meaning in addition to the significance of its corporeal centrality. Magnus was supposed to be the first bishop to arrive in the small settlement then being assembled out of marshy terrain in the city's earliest days, and he set out the locations of *three* churches: one dedicated to Saint Peter, another to the angel Raphael on the extremities of the new city and a third dedicated to the Savior in the very "heart" of the city. (Interestingly Homer similarly refers to the seat of courage as not in the heart but the guts of such men as Hector or Achilles.) Given that Venice was supposed to have been founded on 25 March, the feast of the Annunciation, *visceribus* in this case could be stretched to signify the womb of Mary, where the Savior became incarnate, and the city was analogously blessed.

Atop the campanile in Piazza San Marco, the angel of the An-
nunciation is in constant communion with the city below.

After Pope Alexander III had dedicated an altar in an earlier
San Salvador a new and more ornate version was soon begun
and was completed in 1209. In 1267 it acquired the significant
relics of Saint Theodore, a warrior saint of the Greek church (of
the Saint George type) who was copatron of the city with the
Apostle Mark, both represented on the columns that frame the
view from the Piazzetta di San Marco. The relics of Theodore in
San Salvador became the focus of a notable yearly procession.[9]
As central not only for the whole city but especially the area be-
tween the Piazza San Marco and the Rialto Bridge (the oldest
bridge in the city, whose name recalls the Rialto islands out of
which Venice grew), San Salvador embodied multiple meanings
that were reinforced by a public procession of the kind so typi-
cal of the Venetian use of their city as a great theater of the po-
litical and the sacred.

These public processions of Venice are notable for two char-
acteristics intimately bound up with the city's image of herself.
Venetian public ritual was perhaps more rigorously structured
and precisely hierarchical than that of any other Italian city; and
she used the city as a stage in a way more literal than any other.
The *Serennissima*'s processions generally didn't engage the whole
city in the manner of Florence (as we will see) but focused in-
stead mostly on the Piazza and Piazzetta di San Marco and the
waters of the *bacino*. For all of San Salvador's importance in the
geography of the city, every procession began and ended in the
symbolic core that was San Marco. This was only natural, given
the presence there of the Doge's Palace, the doge's private chapel
and saint's reliquary of San Marco basilica, and the great landing
of the Molo flanked by the famous columns of Saints Mark and
Theodore. As a result, significant urban design energy in Venice
revolved almost exclusively around the piazza, articulating it

with an insistent rhythm of arcades virtually concretizing the rigorous rhythmic structure of her public ceremonies, which were renowned throughout Europe for their rigor. A late-fifteenth-century visitor thus described an All Saints' Day procession.

> They all walked two and two, as I said, after the Doge in perfect order. This is very different from the practices I have witnessed at many courts, both ecclesiastical and secular, where the moment the Prince has passed all go pell-mell (as we say in our tongue *a rubo*) and without any order. In Venice, both before and behind the Doge, everyone goes in the best order imaginable.[10]

The Ducal Palace and its chapel, San Marco, emerged on the urban landscape at roughly the same time as the spiriting of Mark's body out of Alexandria in 828. Clearly the Venetians at this time were beginning to develop a substantial sense of their legitimacy. The palace was built in about 820 on land that had belonged to the monastery of San Zaccaria; it was subsequently rebuilt, along with the basilica, by a succession of doges between the end of the tenth century and the end of the twelfth. Meanwhile, the piazza was both augmented by considerable land infill and extended by the demolition and relocation farther to the west of the church of San Geminiano.[11] The Doge's Palace and San Marco from their inception dominated not only the Piazza San Marco but the whole of Venice's collective identity, and their outward appearance would shape without contest the character of the city's most important public space. Not until the sixteenth century would the piazza again receive significant injections of architectural energy. "Still, as early as the fourteenth century Piazza San Marco was generally thought of as a stage where the entire city was on display."[12]

The building that then set the tone for the rest of the piazza is the long Procuratie Vecchie palazzo, completed in the year

before the Sack of Rome, 1526. Before then the edges of the piazza were held by relatively indifferent fabric buildings, which had no pretense to counterbalancing the basilica or Ducal Palace. The Procuratie was the first instance of thinking of the piazza wall as an important contributor to the quality of the space it defined, both formally and symbolically. Its insistent arcade rhythms are like a frozen ducal procession, and its vertical hierarchies of arches like a model of Venetian society. While considered the earliest "classical" or truly Renaissance public building in the city, its marching drumbeatlike cadences are actually set by the remains of the foundations of the earlier building it replaced, which had been destroyed by fire; so much of that rigorous structure actually antedates the Renaissance rebuilding.[13] What changed most strikingly between the old and new Procuratie was the greater correctness in the employment of the classical elements of the architecture—the proportions of the arches, the moldings and so on—which suggests a change in attitude toward a conscious evocation of a mythical, antique Roman origin for the city.[14] But there is as much of continuity with the local past here as a change toward plugging into a more distant Roman one, and the effect after all is still a Venetian one of order, hierarchy and a kind of communal anonymity. Its programmatic sources, we will see, can be traced to both the state and its religion.

As Edward Muir writes, "in effect, the ducal procession *was* the constitution."[15] There was in all of this an almost literal use of the city, especially the piazza and adjacent piazzetta, as theater. The processions and rituals had a drama, a sense of a narrative being played out, that was unique to this city. That meant that the architecture, as it was being conceived, must have foreseen its role as public stage and auditorium. The basilica of San Marco, for example, was noted for its multiple galleries, which contributed to a particular kind of divided or multiple choir that

then generated a uniquely Venetian kind of liturgical music (exploited by composers such as the Gabrieli family and Monteverdi). In a similar way the open loggias of the Palazzo Ducale are in marked contrast to the fortresslike solidity of a Tuscan or Umbrian town hall such as that of Florence or Perugia. The Doge's Palace's loggias are made up of interlaced Gothic pointed arches supported on figured column capitals whose imagery represent a kind of summa of human culture and experience, and so those leaders who appeared on the loggia's balconies did so immersed in the midst of a cosmic drama of creation and history, operating almost in a virtual theater of heroic proportions.[16] No wonder they also saw their rituals in such dramatic terms: Every act of Venetian public life seemed to be played out on a stage that existed out of real time. Indeed time itself was captured and understood in two simultaneous yet distinct ways: as the transcendent mythical time through which the city floated serenely, unchanged, the way she imaged herself in paintings; and as the measured practical time of real life, of business, clocks and tides.[17] The theater is a metaphor uniquely adapted to condense and consolidate these two times. And the city herself was the greatest theater, where both the procurator and the merchant would play out their roles on the urban stage, and the Venetian state (both secular and sacred) deliberately used the city and its monuments to that end.

> The refulgent scene on Easter morning contrasted with the somber Good Friday . . . To begin the rites, canons of San Marco met the doge in the Ducal Palace, where they gave him a tall paschal candle and then accompanied him in procession to the door of San Marco, which they found closed. . . . With the singing of an "Alleluia" the doors opened, the procession entered, and the doge approached the high altar. The vicar opened the ciborium by breaking the ducal seal, and, having found the tabernacle empty,

he announced that "Christ has risen." After the chorus responded with a "Deo Gratias," the vicar repeated his proclamation of Christ's resurrection and received a "kiss of joy" from the doge. The kiss was passed from magistrate to magistrate down the entire government hierarchy to the youngest senator.[18]

This culture of the theater in this city found a strange yet telling image for itself with a project by an influential Venetian of dubious aristocratic lineage, Alvise Cornaro. His Venetian noble status never formally acknowledged, and always in search of greater legitimacy, Cornaro floated from Venice to nearby Padova, from where he inherited what wealth he had. There in Padova, on land that his father had left him, he built a Loggia and an Odeon, both prescient for their sophisticated classicism (they date to the 1530s, proving a fertile inspiration to Andrea Palladio in the following decades). His dedication to the theater and his long life that was a kind of protracted public performance were a great part of what shaped the unusual project that he proposed for the Bacino di San Marco. Already in his proposal the project is redolent of images of decay and ruin—an architecture subject to the influence of time even before it was realized.

> [A]nd it will be a very beautiful [image] and an edifice of a type that is no longer found in any other City, for where they were, they have fallen apart; [but] even thus ruined they are beautiful to look at, . . . and if, thus ruined, they are a sign of greatness, and beauty, what then will one think upon seeing it made, and made new again, when the others have been ruined.[19]

Of the three parts of the proposal for the Bacino, the lagoon—the basin of water immediately beyond the piazzetta and the Molo (or dock)—one specifically interests us. Somewhere midway in a triangle between the piazzetta, the Custom House Point and San Giorgio, Cornaro proposed nothing less than a

Fig. 2.2 Alvise Cornaro's Venetian Theater in the Bacino

new Roman theater, surrounded by water on all sides, replete with landing docks, a fixed stage (*scenæ frons*) and raked seating—a theater island where spectators would row out from the city to view spectacles that would range from Colosseumlike animal fights to military and naval exercises. It would be a place, he promised, that would be a great civic classroom, where the republic could again and again enact the myths and lessons that the public of all ranks needed to know to fully become citizens. It was, in its way, a microcosm of the city, more literally a theater than the Piazza San Marco was, but not an escape from civic life so much as a classroom for properly engaging it.

A theater *all'antica*, rising from the water, would have also stressed the link between the specific spectacular quality of the city and antiquarian culture. Not only would the theater be the site of spectacles, it would itself become a spectacular object, while its placement in the lagoon would have endowed it with phantasmagorical and "estranging" characteristics. The evocation of the ancient theater—a metaphorical space that insists upon the principle of a "spherical vision" of the cognitive universe and that encapsulates the urban chorus—is completed *more veneto*: the edifice becomes a fantastic object, a theatrical apparition that could be appreciated *commodamente* or easily from the greater "theater" of the *Serenissima*, that is to say, San Marco's piazzetta.[20]

Apart from the fact that Alvise Cornaro's fantastic proposal has roots in a real long-standing Venetian understanding of the city as a great *teatrum mundi*, there were eventually practical applications of his extraordinary project and its imagery. Cornaro was a savvy businessman and had a pragmatic side, evident both in his interest in sober, simple architectural style and his advocacy of agricultural reform. It was in these guises that a young Andrea Palladio met him in Padova and was certainly influenced by what the older man built there; Cornaro was also an avenue out of Vicenza for the architect and introduced him to a wider, cosmopolitan circle of patrons. Eventually Palladio would design temporary triumphal arches for ceremonial entries into Venice of new bishops in 1543 and 1565, enriched with sculpture and painting, just like those built in Rome for the *Possesso* processions.[21] Perhaps with his mentor Cornaro's water theater in the conceptual background, Palladio gave Venice, ephemerally at least, a classical armature upon which she could cast her Roman myth in more overt terms. At the end of his career Palladio would finally begin the most accurate recreation of a Roman the-

ater yet attempted, in his Teatro Olimpico in Vicenza, this time on solid soil. Interestingly the Teatro Olimpico marks the eastern edge of Vicenza, next to the gate that led toward Venice; it was the Vicentines' claim to some kind of cultural parity with Venice.

Alvise Cornaro's chain doesn't end with Palladio's Vicentine theater. The slightly older Renaissance architect and treatise author Sebastiano Serlio spent some formative time in Venice, and may also have been an acquaintance of Cornaro's; Serlio certainly knew Sansovino and Giulio Camillo, and Cornaro was very familiar with Serlio's treatise.[22] Author of indeed one of the most influential architectural treatises of the sixteenth century, Serlio had trained as a painter (in part under the architect-painter Peruzzi in Rome—thus the painter's experience with perspective that he would display in his treatise) and lived a peripatetic life while his architectural tomes were in progress. Venice was crucial for Serlio in part because he began his publishing activity there and partly because the experience of the Piazza and Piazzetta di San Marco and its emerging Renaissance architecture shaped his images of the ideal theater and its Tragic and Comic stages. In that sense he perceived something theatrical already there and used it to give life to renewed ideas about classical theater. Were it not for the fact that Jacopo Sansovino—whose architecture would have such a significant impact on the piazzetta and piazza—knew Serlio and was undoubtedly influenced by him, Serlio's engravings of ideal stages would have only incidental relevance to our look at the quality of these Venetian spaces, since they don't document real urban views.[23] But since Serlio had a direct impact on Sansovino, examining his ideas of the city and the theater legitimizes our pursuit of the theater as metaphor in puzzling out the ideas behind the heart of Venetian urbanism, San Marco. Moreover, the theater emerges again and again as inspiration for the ways in which Venetians approached every art form, from the composition of

monumental paintings by Veronese or Tintoretto to the music composed for San Marco by the Gabrieli family or Monteverdi to the almost too literal public masquerade that the Carnival became by the eighteenth century.

Venice was refuge to many outcasts on the fringes of intellectual legitimacy in the sixteenth and seventeenth centuries. Thus the rakish Pietro Aretino said explicitly to Doge Andrea Gritti, "Venice opens her arms to all whom others shun. She lifts up all whom others abase. She welcomes those whom others persecute."[24] One of these marginal notables was Giulio Camillo. Frances Yates in her landmark book *The Art of Memory* describes the one thing for which Camillo was most renowned during his life, and the only reason he is remembered today: his Memory Theater. Either a visionary or a charlatan, depending upon to which of his contemporaries one listens, this sixteenth-century polymath invented a famous Memory Theater in model form that purported to be a system for remembering and accessing the sum of Western thought. He had the ear of the king of France, and not surprisingly influenced directly at least one architect, Sebastiano Serlio. Camillo's Memory Theater worked as follows: It was in reality a semicircular library, with the texts—mostly in folio or even scattered notes—kept in drawers on stacked receding shelves in the shape of an auditorium. The actor onstage was therefore a reader who had direct access to works that represented the sum of human thought. One had only to reach out and open any drawer, arranged in a (to him) memorable system organized according to planetary signs and key mythological narratives, and pull out works of Cicero or Plotinus or Varro. Ideally Camillo expected that this physical act of reaching and opening would eventually be replaced by a purely mental operation, for which the experience of his theater would be the model. But perhaps only in Venice could such a theatrical idea of reading and memory have occurred to the eccentric

Giulio Camillo, and only Venice would financially indulge his fantasy while he had a scale model actually built (unfortunately it had apparently disappeared by the eighteenth century).

The theater metaphor and the concomitant ritual use of the San Marco piazza and piazzetta auditoria go a long way toward explaining the stagelike quality and rhythmic articulation of those space's edges, with their marching arcades. But there is another aspect to that space's role in the city, a symbolic one that cannot be ignored. The venerable basilica of San Marco is the most significant sacred locus on the Venetian landscape because it housed the great relic of the evangelist Saint Mark's body. San Marco, it should be noted, is not the cathedral or *duomo* of Venice; S. Piero on the small island of Castello, a church we encountered earlier with its miraculous foundation by the bishop Sancto Magnio, held that honor. But San Marco is surely the most magnificent and elaborate of all the city's churches, prominently positioned, encrusted with mosaics, built of precious marbles, sheathed in gold. It is really an enormous reliquary for the saint's body, which had been dramatically spirited out of Muslim-held Alexandria by adventurous Venetian businessmen in the ninth century. San Marco, originally dedicated to Saint Theodore before the arrival of the powerful new relic in town, was the doge's private chapel, and he became the quasi-clerical caretaker of the saintly corpus, which he was sworn to do upon his accession. Typical, however, of Venetian suppression of the *person* of the doge to his office, no doge was ever allowed to be buried in San Marco.[25] Another tier, in addition, to the maintenance of the state church was eventually created. In the twelfth century the office of procurator was created for first one then several officers charged with overseeing the fabric of San Marco. They soon became by extension the caretakers of the whole of the Piazza San Marco, and they eventually would "become the main political and financial link between the state

and the Church."²⁶ The buildings that housed their offices in
due course would mirror the architectural impact of the Doge's
Palace throughout the rest of the piazza.

Protecting Mark's body meant protecting Venice. And Mark
as patron of the city, his body intact in the most prominent church
in the most important piazza, was effectively "shown" to all visi-
tors upon their arrival at the Molo. His allegorical figure of the
winged lion crowned one of the two columns that framed the pi-
azzetta, while the domes of his church loomed behind the Doge's
Palace. The precocious ordered regularity that emerged in the pi-
azza with the first iteration of the procurator's office (something
almost unknown in any other European capital of the fifteenth
century) might be explained by imagining the piazza serving the
role of a church nave, a vast outdoor container for the precious
reliquary that is San Marco, which was positioned almost like the
altar of this outdoor church. The one building type in medieval
culture that was consistently planned with geometric clarity and
rigor was certainly the church. What other model could the Vene-
tians have imagined to guide the structuring of their most impor-
tant civic space, dominated at one end by such a venerated
container of the author of one of the gospels? Innovations in ar-
chitecture are often arrived at by analogy; when one is searching
for a solution to a new problem, a model solution from an analo-
gous problem is a fertile way to begin. Seeing the piazza as an
outdoor basilica could have spurred thinking of the walls of the
space in similar terms. The way ritualistic processions used the pi-
azza must also have suggested to those responsible a liturgical
reading of this expansive outdoor room: Since the piazza func-
tioned like the great nave to an unroofed basilica, with the mul-
tidomed basilica of San Marco serving as altar and tomb–chapel,
this "nave" began to demand the marching rhythm of piers and
arches one found inside a noble ecclesiastical building.

Paris Bordone's painting, now in Venice's Accademia Mu-
seum, of a fisherman presenting the Sea's wedding ring to the

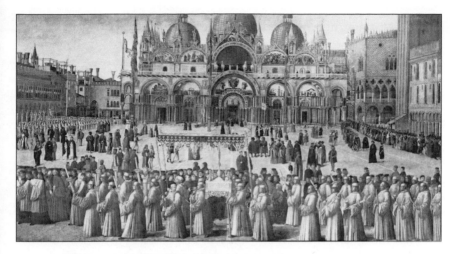

Fig. 2.3 Gentile Bellini (1429–1507), *Procession in Piazza San Marco*

Doge, depicts an event that had taken place two hundred years earlier. Using the conventions of his own time (the mid sixteenth century), Bordone portrays the doge in a fully classical environment that only notionally alludes to the actual Gothic Ducal Palace and the buildings around it. This is how the Venetians of the High Renaissance wanted to see themselves—as heirs to a great classical civilization—and they were in the process of making it real, but the actual city certainly didn't conform to the fourteenth-century reality ostensibly depicted in the painting. No matter; classical paintings are about what should be or should have been, not what is or what was, and a painting like this is more important as a vision of an ideal Venice than a documentation of an historical event in an accurate context. This architectural vision of classical arcades and colonnades—the same background we find over and over in monumental paintings by Titian, Veronese and even the sometimes wildly unclassical Tintoretto—burned a triumphant classical Venice into the public consciousness. Architects such as Jacopo Sansovino, Andrea Palladio, Baldassare Longhena and later, Giorgio Massari, would eventually be called on to make that consciousness real.

With its campanile looming large over the piazza and pi-
azzetta like the navigational marker for arriving sailors that it
actually was, it is no wonder that the urban scene evoked mem-
ories of the most famous lighthouse of antiquity, in storied
Alexandria. The ancient city's towering Pharos, named for the
island on which it stood, was one of the Seven Wonders of the
World, and Alexandria was one of the great cities of Hellenistic
culture, renowned also for its vast Library, known as the Mou-
seion (meaning a Hall or Temple of the Muses, patrons of the
arts and sciences). Saint Mark had been martyred in Alexandria,
and it was from there that audacious Venetian traders spirited
away his body—the body which, elaborately housed in the
Doge's private chapel of San Marco, made that church the focus
of the whole state religion. Haughty cities such as Venice were
accustomed to seeing themselves as competitors with the great
cities of the past (as much as the present)—quasi-mythical places
such as Alexandria, Athens, Carthage, Rome, Thebes. It is no
wonder Bellini chose a Venetian-looking setting when he was
called to paint Saint Mark preaching in Alexandria. No doubt
wanting to be seen as a new Alexandria had not a little to do
with the Venetians' ambitions for Jacopo Sansovino's Library
project.

Sansovino (born Jacopo Tatti in Florence, he later took the
name of his master, Andrea Sansovino, as many artists did)
came to Venice at the age of forty-one after having spent most of
his career in Florence and Rome. He had some early experience
with designing ephemeral processional architecture for Florence,
which served him well in Venice, but he also began several sub-
stantial buildings in Rome.[27] Arriving in Venice to oversee re-
pairs to the domes of San Marco, he acquitted himself well
enough to take over the position of *proto* (buildings superin-
tendent) to the procurators of San Marco, beginning a long and
fruitful relationship with them and the city at large.[28]

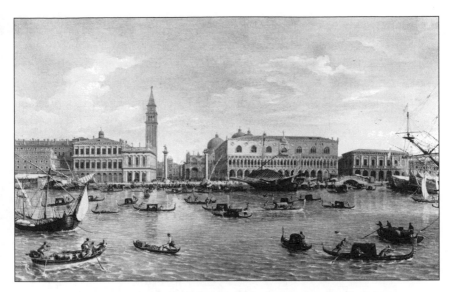

Fig. 2.4 Gaspare Vanvitelli (van Wittel) (1653–1736),
St. Mark's Basin with the Molo, Piazzetta and Doge's Palace

Suffused with the saturated culture of ancient Alexandria, the theatrical metaphors inherited from Serlio's Tragic stage, the High Renaissance humanism of Rome and Florence and the modern memory systems of Camillo, Sansovino's Library on Venice's Piazzetta di San Marco draws on the theater in ways different than Camillo's "library" did, in part because it forms part of a larger urban ensemble.[29]

Balancing the Doge's Palace across the piazzetta, Sansovino's Library acts perspectivally, like the buildings in Titian's painting *The Presentation of the Virgin*, in the view from the water as part of a group of buildings (including the clock tower beyond) that are almost too directly analogous to those of Serlio's Tragic scene. The Library facade's articulation of stacked Doric and Ionic orders also draws directly on Rome's ancient Theater of Marcellus, which was the best-known ancient theater to have survived in Italy. Like the functional inversion of Camillo's

theater, however, where actor is actually audience to the shelved resources, Sansovino turns the Theater of Marcellus inside out. His Library's facade in fact becomes, during the urban dramas that took place in the piazzetta, both like the classical stage set backdrop, or *scena frons*, and like a seating platform, or *cavea*—that is, like aspects of the internal workings of the theater, not its facade.[30] He simply turned the facade of the Theater of Marcellus into the balcony from which spectacles could be watched.

Long recognizing the value of music in ceremony and society, Venice was the nurturing ground of the early Baroque opera house, and that culture too benefited from the grand rhetoric of the Library. Specifically Sansovino's Library's deep facade bays of double columns and balustraded balconies may have influenced the later development of the seating boxes of Italian opera houses, in part because those bays often functioned as viewing platforms for the city's procurators during the frequent staged and spontaneous performances that took place in the piazzetta.[31] Indeed the procurators' offices occupied a good one-third of the so-called Library building. Internally the library portion is populated by painted philosophers, saints and allegorical figures executed by the greatest artists of the second half of the sixteenth century, who symbolically summarize the ideas contained in the book collection begun by the influential fifteenth-century Greek prelate Cardinal Bessarion. So both in its cultural and civic roles Sansovino's Library draws on and performs as both stage set and audience to those dramas—public and private, civic and cerebral—that it inspires and witnesses. In that sense and not necessarily in its style the Library is like a great summation of the themes embedded through the centuries in the heart of the Venetian *urbs*.

The Library is a key component of a radical reformation of the piazza area, for which the transplanted Tuscan Sansovino

was the mastermind. On the water side, adjacent to the Library, Jacopo designed a new mint, or *Zecca*, for the city, a project that actually predates the Library's design by a couple of years. The *Zecca*'s facade, in contrast to the ebullient Library, is a serious, robustly rusticated exercise, providing the image of a secure home for the vital function of stamping out and guarding the city's coinage. In its original form it was of two stories like the Library (a third story was added decades later), but composed of a lower floor arcade unarticulated by the classical orders. This was surmounted by a trabeated (post and beam, as opposed to arched) Doric-order second story, the column shafts of which were wrapped or engaged by bands of rusticated stonework. Given the hierarchy of the classical orders that Serlio's treatise established (from the humblest Tuscan to Doric then Ionic through Corinthian and finally Composite—that is, from simple to refined), the *Zecca* is deferential to the Library: It is rusticated and stops short of employing the more refined Ionic order like the Library does, and all the more so because its original two stories were lower in height than the latter nobler building. Still, the robust *Zecca* could inspire admiration. The architect's son, Francesco, in a guidebook written during Jacopo's lifetime described the Mint as a "Worthy prison for most precious gold."[32]

The Library and Sansovino's other great imposition on the piazza, the *Loggetta* attached to the campanile, employ figurative sculpture whereas the Mint does not. In the spandrels of the Library's arches the architect introduced reclining figures, male sea gods in the lower Doric zone and female Victories above in the Ionic (Sansovino would have seen similar Victories on the triumphal arch of Titus in the Roman Forum). Cherubs carry swags between the attic windows, and heroic worthies crown the balustrade.[33] Altogether it is a sumptuous display, rich in ornament and chiaroscuro, and holds its own in detail while deferring in scale to the Doge's Palace opposite.

A crucial decision of Sansovino's in projecting the Library was to distance it a bit from the campanile, liberating that venerable beacon from the buildings that had enveloped it on two sides not only in the direction toward the water but also along the long dimension of the piazza. Since the Library corner formed a right angle, it reestablished the southerly boundary of the piazza at more or less right angles to the basilica, thereby widening the open space by more than a dozen meters.[34] Sansovino completed his intervention with an addition to the newly liberated campanile, the graceful *Loggetta*. It is in function quite literally a stage: On days when the *Primi* (the First Ones, i.e., the leading noble families) gathered inside, the three large arched doorways were opened wide for all to see the assembly. It is not an accident therefore that the facade takes on the appearance of a classical *scena frons* (not unlike the facade of Cornaro's Loggia at his home in Padova, and a precursor to Palladio's stage at the Teatro Olimpico), nor that the bronze figures in the alternating small niches—Pallas Athena (Minerva), Mercury, Apollo and Pax—might be understood as models or mirrors of the living, breathing *Primi* inside. These four bronze figures allegorically refer to Virtues of the State—Justice, Commerce, Arts–Eloquence and Peace—and should also be linked with the reliefs in the upper attic, showing Venice in the context of her waters and territories (Crete and Cyprus).

If the Library was a step up from the *Zecca* in refinement, the *Loggetta* was a step up from the Library, being articulated by projecting Composite columns, which flank alternating small and large arched bays. Serlio first named this columnar order, describing its genesis as a quintessentially Roman invention.

Perhaps because the Romans were unable to surpass the invention of the Greeks, who discovered the Doric column based on man, the Ionic imitated from matrons, and Corinthian derived

from virgins, they made from Ionic and Corinthian a composition . . . , and this they used more for triumphal arches than for any other structure.[35]

Serlio is right in linking this order with Roman triumphal arches, and the Arch of Titus that Sansovino references with the Victories on the facade of the Library might have provided the model here too. Venice saw herself therefore as exceedingly triumphant, over Rome both ancient and modern, over Alexandria, Constantinople and indeed any rival claimant to the throne of the *Serenissima*. The message was generally available to any visitor, but its deepest allegories were comprehensible only to the most educated of the city's guests.

There are two additional components to the piazza that visitors will recognize today, and they point out two telling attitudes to the meaning and form of that great space. They postdate Sansovino's Library, one by decades, the other by centuries. To the west of the Library (that is, heading away from the basilica), the procurators intended in the late sixteenth century to add a new wing of offices, and the debate about their volume and articulation was hotly contested. On one side were those who would want to continue Sansovino's facades around the square (apparently the architect himself had intended the same, his nephew claiming he would even have wrapped them across the Procuratie Vecchie all the way to the Orologio). On the other side were those lined up behind Palladio's successor, Vincenzo Scamozzi, who opted for "correcting" the Library's ornamental excesses with greater classical rigor in the new work but were also opting to add an additional story to the Library itself to align with the three-story "addition." Powerful civic leaders gravitated to either camp, and the debate seemed to have resonance for the very future of the city's image. On the side of the Sansovinans, the most cogent argument confronted the very

nature and purpose of the space; the historian Manfredo Tafuri summarized the original program statement as follows.

[T]he entire space of the new Piazza was called upon to exalt the church of San Marco, which was, as we have seen, an emblem of the Republic's autonomy. The formal transformation was thus not supposed to attack, but to reinforce meanings that had become mythical.[36]

The debate effectively hinged on who best created the proper frame and context for San Marco, with Scamozzi the rigorist arguing for greater adherence to the "rules of art" than had Sansovino. In the end Scamozzi won the day, while he would lose at the Rialto Bridge (where a more "practical" design had been chosen). His contribution to the piazza, the last before the fall of the republic, now appears an inevitable piece in a subtly varied ensemble of Procuratie, old and new, and Library.[37]

The Sansovino Library is also a theater of the mind, a likely destination of an educated visitor to the city, and the painted philosophers and allegorical figures are like the audience for the life of scholarship that the place represents and for which Venice herself provided a stimulating home and refuge. It once again consciously placed Venice in the league of great cities famous for their learning.

Libraries are often used to celebrate and add special lustre to well-founded cities. . . . Therefore, when the former Most Reverend Cardinal Nicenus who was so gracious to our republic gave, now some time ago, to our government the gift of about 800 Greek and Latin books of great beauty and value, we deemed there was no place in our city which could [accommodate] a gift of such great splendor. But now it is at last fitting to erect [a building] to hold this most precious treasure which has

been almost hidden from the vicissitudes of time, especially since the Procurators of our Church of San Marco have willingly donated a place in the piazza itself for the new structure. There could be no lovelier location in this city, nor one more convenient to the learned [community]: because once the library has been finished, it will be a perpetual monument to our heirs and the mirror and light of all Italy.[38]

This Cardinal Nicenus is perhaps marginally better known today as the aforementioned Cardinal Bessarion, and the vicissitudes of his life and his book collection are metaphors for the relationship, sometimes adversarial and sometimes affectionate, between Mediterranean east and west, between Constantinople and Venice, rival claimants to the mantle of Roman civilization. By the fifteenth century the Byzantine city had been in decline for decades if not centuries, and its fall seemed inevitable for years. To a certain extent Venice had hastened its fall by protracted competition and even brutal sacking during the fourth crusade, while at the same time she was eager to emulate her rival's greatest glories. The bronze horses atop San Marco, for instance, were booty from the (albeit short-lived) Venetian sack and occupation of Constantinople during the fourth crusade Bessarion was an eminent Greek prelate who went over to the Roman church to guarantee a refuge for what he could save of his imperiled homeland's intellectual and cultural treasures. In naming Venice the heir to his book collection, to be rescued from the imminent destruction he feared for his native city and its riches at the hands of a Turkish invasion, Bessarion touched on an aspect of familiarity he felt about his library's new home.

Though nations from almost all over the earth flock in vast numbers to your city, the Greeks are most numerous of all; as they sail in from their own regions they make their first landfall

in Venice, and have such a tie with you that when they put into your city they feel that they are entering another Byzantium.[39]

Venice thus became home to one of the great book collections of the Byzantine world and the accumulated Greek heritage it contained; but the city was also home to one of the great humanist presses of the time, the child of publisher-scholar Aldus Manutius. He was not alone. "At the beginning of the sixteenth century Venice had between one hundred and two hundred print shops. The overall number of volumes produced during the two final decades of the fifteenth century has been estimated at 1,125,000."[40] As a city of commerce, Venice appreciated the value of rare goods such as manuscripts, but it also was alive to the potential of a new technology such as the printing press to reinvigorate and disseminate the ideas contained in those elegant old tomes. Notably Manutius produced the finest editions in Greek of his time; he also took the calculated risk of printing a poetic, obtuse romantic allegory called *Hypnerotomachia Poliphili*, probably written by a lovelorn monk from the Veneto named Francesco Colonna. It is a strange and beautiful book, as much for its appearance—the elegant typeface and seductive woodcuts—as its evocative text, written in a macaronic Italo-Greco-Latin that was meant to call up ancient spirits with the esoteric sound of its phraseology and pseudo-antique neologisms as much as its content. Like Venice herself, the Aldine press was at times rigorously scholarly and occasionally exotic and romantic; the particular character that makes up the Venetian Renaissance comes from just such a conjunction of seeming opposites. The city was a naturally mediating culture, whether as an intellectual refuge for exiled scholars or as a mercantile ambassador between East and West, both rooted perhaps in its very existence, balanced between water and land.

Owing to the nature of how Venice's "ground" was assembled through centuries from scattered marshes and rafts of pil-

ings, the kind of "doughy" urbanism that we encountered in Rome—that is, blocks of buildings carved away to reshape streets and squares by papal intervention—was virtually impossible here. The Venetians never really allowed themselves to be fooled otherwise. The kind of res publica space shaping of the Campidoglio or Piazza di San Pietro instead was reserved in Venice for the Piazza San Marco and what could be viewed from its Molo (that is, the churches of San Giorgio and Sta. Maria della Salute or Cornaro's imaginary water theater and so on). This left the bulk of the urban fabric to be modified in subtle ways by local interventions, almost exclusively by churches and the charitable confraternities known as *scuole*, which had little urban influence beyond their small *campi*. And this therefore resigned the rest of that fabric in between to labyrinthine patterns that continue to simultaneously stump and seduce nonlocals. Even in these murky patterns, though, one can still read something of the organization of the state.

> Perhaps the relationship between the [overlapping] councils of government is better compared to the city of Venice itself, to the winding alleys and canals that always seem to bring the wanderer back to a familiar *campo*, although seen from a different perspective and entered by a different approach—a maze whose order only emerges from observing the passage of others through it.[41]

For a city conscious of both its historical mission and the day-to-day rhythms of the marketplace, a clock was a crucial component for the center of public life. The Orologio, or Clock Tower of the Piazza San Marco, not only marks time, the seasons, the zodiac and religious feasts, it also marks the transition from San Marco to the principal street called the Mercerie that stretched out from the piazza toward the Rialto Bridge, passing the church and convent of San Salvador in the viscera of the city. *Mercerie* means "markets," and we note therefore also a

transition from the urban image of state to the image of commerce. This was not an image as calculated as the one articulated by the Procurate Vecchie, but even that is in itself a message or an image, suggestive of the hurly-burly, barely regulated competitive world of trade.

Imagining ourselves having arrived at the piazza by water, passing San Marco and under the Orologio, and continuing on to the Rialto, we would have experienced two radically different kinds of urban space: open, ordered, splendid and dramatic in the piazza; narrow, chaotic, maybe a bit shabby and unorchestrated on the Mercerie. We would therefore, after the latter experience, find the revelation of the Rialto and the Grand Canal that it spans as a welcome relief, with a spectacular vision of refined *palazzi* extending in both directions on a generous body of water, plied by boats of all sizes and uses. We would have first noted the Grand Canal extending off to the left on our arrival at the piazzetta, and so finding it again would begin to help us form a diagrammatic map of the city in our mind (realizing the canal is shaping itself into a reverse S, slicing through the fibrous tissue of the city fabric). The Grand Canal is therefore perhaps the only place away from San Marco where the city has an opportunity to "present itself" again in a coherent extended way; but in this case the opportunity was ceded to private interest along most of its length, with one significant exception.

At the second bend in the Grand Canal (assuming we have come from the port at San Marco; the first bend begins at today's Accademia Museum) was the city's teeming market; it clustered mostly on the island of Rialto, at the farthest extent of cargo shipping up the Grand Canal. For a mercantile city the market was as much a defining focus as the great basilica. To visitors and natives Venice's market seemed to be "the richest spot in the world."[42] If butchers had been the earliest to ply their trades in the area, it soon became the hub for buying and

selling the finest, most expensive goods, something in fact encouraged by city ordinance. In the venerable church of San Giacomo, around which the market hummed, were painted frescoes of views and maps, fixing in the imagination, if it were necessary, the "global" nature of the market—the world and its goods came to trade here. It was also the site where the city was born, mythically at least; the first settlement supposedly emerged here. The Campo San Giacomo housed the *bando*, a column with a platform from which laws were publicly proclaimed; the laws were not considered in force until made public in this central forum. The commune initiated numerous public works projects to enhance the appearance and effectiveness of the area's squares and buildings, both for the good of the citizenry and for the image it projected to the world. Elizabeth Crouzet-Pavan says pointedly that, "As with the shoreline of San Marco, aesthetic needs determined urban policy and practical choices."[43] After all, the image of the city was part of its attraction for traders and spoke to its vitality; the ephemeral abundance of goods, ships and people gave the market and its city a reputation as a world in miniature, a cornucopia of commerce. It is no wonder this attitude manifested itself in buildings and art, as the whole scene must have seemed an ever-changing tableau begging for permanence.

Apart from the more prestigious buildings of commercial purpose around the market such as the Fondaco dei Tedeschi, the majority of the impressive urban wall along the Grand Canal was defined by the great families' private *palazzi*: the medieval polychromed Ca' d'Oro; the Renaissance's Palazzos Corner and Dolfin-Manin with a far greater proportion of window to wall than their predecessors; and the exuberant Baroque jewels of Palazzoes Pesaro, Rezzonico or Labia (private palaces whose glittering Murano chandeliers would have illuminated their frescoed *saloni* for all to see in the evenings from the water).

Venice had notably strict sumptuary laws regulating the dress of the city's nobility (and they were strictly enforced, unlike those of Florence or other Italian cities). Unless demanded by the necessities of office, male nobility were required to wear the *toga*, the long black gown so ubiquitous in Renaissance portraiture. But what was forbidden in attire was licensed in architecture: Display at the level of fine building was perceived to be a public benefit rather than a sign of corruption or excess. Architecture that contributed to the image of the city was a permanent contribution to the city's prestige in the eyes of foreigners, and, one would like to believe, to the pleasure of the ordinary citizen going about daily tasks on public thoroughfares. Private architecture in the public realm thus had a double function, and given that much business, commercial and political, went on behind the facades of the great Ca's and Palazzos, patrons saw their homes as mediating the res publica and res privata in a way only possible (and desirable) in an urban context.

Off the Mercerie and behind the facades on the Grand Canal Venice seemed then (and today) a vast labyrinth designed to frustrate attackers, both military and touristic. The image is only partially intentional. Now the city fabric seems threaded by a series of watery streets, but in earlier times one would have been more conscious of islets floating densely in a lagoon, today's canals the boundary between one islet and the next. As more and more land was claimed by rafts of wooden pilings and landfill, those thin slips of watery boundaries were preserved as essential routes of circulation, their haphazard pattern a convenient memory of the natural context from which the city was born. In recognizing the genesis of Venice rising from the water, less evident in the labyrinth at first glance but most deeply embedded there, the city's iconographical association with Venus makes the most sense. Venus, who was born from a sea fertilized by the genitals of the castrated Uranus, according to Hesiod,

was the patroness of Aeneas during his odyssey in search of Italic shores. Venus literally emerged from the foam of the sea—seawater become woman—and only she could sway Neptune to still his fury. Venice too emerged from the water; she made terra firma where none existed, and the city still seems frozen in the act of rising from the gentle waves of the lagoon.

The labyrinthine nature of most of Venice did tend to preserve a certain neighborhood identity and autonomy. Local churches, the wells providing essential drinking water in an otherwise salty marsh, the confraternities known as *scuole* who administered many of the social needs of the community, the fact that the *campi* once served as local cemeteries—all helped to reinforce the coherence of the neighborhood. But one can point to little deliberate formal urban planning in Venice's neighborhoods analogous to Rome's Borgo Vaticano, the Sistine street network or piazzas such as Sta. Maria del Popolo and S. Ignazio. In part because land was so hard won that it frowned on formal interventions without practical purpose, and partly because no civic authority existed with the will and power of a pope, conscious urban design of a formal kind was reserved for San Marco, where the practical purpose was indeed largely the image itself.

And a Venetian's neighborhood identification was rather fluid. Mobile at the scale of global trade, the city's inhabitants were also likely to move from parish to parish in their lives, often for reasons of work. The great numbers of arsenal workers commuted there daily, merchants and craftspeople clustered around the streets dedicated to their trades, sailors would disappear on years-long journeys returning home perhaps destitute or rich, necessitating a change in locale in either case. And the city did its best through ritual, architecture and governance to create a collective Venetian identity at the expense of neighborhood loyalties; one was probably more often closely identified with

one's caste—*nobili, cittadini, popoli*—than with one's neigh-bors. Neighborhoods themselves were therefore socially poly-morphic, with the various castes squeezed in cheek by jowl, and powerful attractors such as the charitable *scuole* or major churches provided dispersed public foci for the entire city.

The unique intellectual polymorphism manifested by Venice's tense suspension between the evocative or exotic on the one hand and the rigorous and archaeological on the other is clearly evident in the buildings that surround the Piazza and Piazzetta di San Marco. Because of that polymorphism these two spaces composed themselves into charmingly compelling views long be-fore Canaletto would paint them in the eighteenth century. The piazzetta, as we have seen, was to be both looked at from the water and looked out from. The winged lion representing the evangelist Saint Mark sits atop one of two columns that frame the water view, and Mark's symbolic role for Venice's self-image is intriguing, eccentric and powerful, just like the Virgin's role as patroness of Siena. The experience of looking at Venice as a tableau, a canvas, easily translated the city into the subject of view paintings, but it also had a poetic connection with the printed book and the drawn image. Sebastiano Serlio was influ-enced by and influenced the stage set quality of the piazza in his architectural treatise and his discussion of the classical theater.

In concrete terms Andrea Palladio's two Venetian churches compose themselves from a distance almost like two-dimen-sional drawings of facades. San Giorgio Maggiore, the monastic church on its own island so magically visible from the piazzetta, and the Redentore, proudly presenting itself from the Giudecca island toward the wide Dorsoduro quay known as the Fonda-menta delle Zattere, are two churches that were the foci of pil-grimages and processions, approached with great solemnity from a distance. The former, part of a large, ancient monastic complex, housed some of the city's most important relics; the

Fig. 2.5 Anonymous eighteenth-century (?) view
from the Piazzetta di San Marco looking toward
San Giorgio; the Doge's Palace is on the left

latter was dedicated to the Redeemer in fulfillment of a vow af-
ter delivery from the plague of the years 1575–76. San Giorgio
had the advantage of being seen from the piazzetta, but access to
it across a wide expanse of lagoon was inevitably by boat. Its
dedication to Saint George, like the island on which it sits, al-
lowed it to be seen as the third element in a saintly triad along
with Saint Mark and Saint Theodore (atop their columns). The
Redentore was visited annually on the third Sunday in July, the
Feast of the Redeemer, by a grand ducal procession that pro-
ceeded to the church on foot across a temporary platform of
boats. In a city where the dense labyrinth of streets and small

canals largely frustrated any chance of the long dramatic approach exploited by Rome's popes, moments of real distance—such as along the Grand Canal or islands such as those seen from the city edge—were naturally taken advantage of for maximum effect. They lent themselves to the creation of frontal "picture" facades such as those Palladio gave to San Giorgio and the Redentore.[44] Indeed it may be the expansive distant view afforded across the open watery topography—whether looking out from the city toward San Giorgio or looking back toward the piazzetta from the water—that spurred the flowering of view painting here as in no other Italian city.

Palladio, however, was not simply content to define a compelling silhouette from a distance for these churches; rather he invested the quasi–two-dimensional facades with peel-away layers of complexity. There are many ways one can "read" these compositions as abstractions. Alexander Tzonis and Lianne Lefaivre in their book *Classical Architecture: The Poetics of Order* assigned the jargon of rhetoric and music to the compositional devices Palladio employed in his church facades. They use words such as *analogy, alignment, aposiopesis, abruptio* and *epistrophe* to describe the ways in which elements of the classical vocabulary appear across the buildings' faces.[45] These devices, having to do with the classical rhetorician's strategies for creating emphasis or allusion within his argument, allow us to see these compositions as "arguments" themselves, which depend on calculated variety and connections to stress and enrich the classical structure that holds them together. Whether or not Palladio himself thought in precisely those sorts of rhetorical terms when designing these facades, he certainly exploited the rhetorical potential of architecture in order to proclaim the role and dignity of public buildings in the city.

So much of urban energy in Venetian history is concerned with how the city meets the sea; it is fortunate that she saved the

best for last. The crowning jewel of Venice's image from the water is the graceful, picturesque double-domed church of Santa Maria della Salute, vowed for relief from the plague (*salute* means "health"). A product of the mid seventeenth century, already past the city's political heyday, it was built more than a hundred years after Sansovino's waterfront buildings of the Library and Mint.

While it is the church's dome hovering over the glistening white building that settles into the memory, there are several unique aspects to how the Salute presents itself. The octagonal church's six radiating chapels (the other two sides are dedicated to the entry and connection with the sanctuary) emerge on the exterior almost as miniature structures seemingly tacked onto the domed drum. They suggest that we could read the eight-sided space around which they cluster as a sort of roofed piazza, something reinforced in the interior by the way the chapels are each framed by the arches that define the central space. Longhena's dome was no doubt partly inspired by Palladio's unbuilt first project for a centrally planned Redentore (also dedicated in relief from the plague), but he may have also had in mind an idealized civic piazza, albeit with a great ceiling.

As the Baroque architectural historian Rudolf Wittkower has shown, the Salute's architect, Baldassare Longhena, was a designer of spectacular theatrical effect, something in abundant evidence in the church's interior, where the spatial sequence is always framed and layered.[46] But Longhena's most obvious theatrical contribution to the city fabric is this great domed crown to the prow of the Dorsoduro island as seen from the lagoon. It has the unique merit of being invested with inevitability, a sense that it has always been there, or was always meant to be there, merely waiting for the right artist to come along and coax it into existence. Like his great predecessor Palladio's buildings of San Giorgio and the Redentore, Longhena's church too was the

focus of elaborate processions. Santa Maria was visited in grand style once a year by a ducal entourage, and one has a sense that only then did the building truly come alive—that Holy Mary of Health blossomed only at that moment into something even more than magical, a celestial vision, a monumental trace of processional ephemera.

Palladio's two great Venetian churches prepared the way for the Salute, and perhaps no other Renaissance buildings ever had such opportunities of distance from which they could be seen as these. Pictured almost as tableaus, they appear to anyone wandering out onto the Fondamenta promenade across the water as mirages, as haunting manifestations of the *civitas dei*. They have all the composed qualities of a fine view painting.

We are rightly focusing on architecture in our explorations of city myths, but we can't leave Venice without encountering two last great propagators of the city's image, painters who sustained and exported the remarkable Venetian Idea to a receptive European audience in the eighteenth century. Antonio da Canal, called Canaletto, and Giambattista Tiepolo staked out very different careers for themselves. The first seemingly documented what he saw in the piazzas and from the water, while the second decorated what others built with a gloriously impossible illusion of other worlds. But one could cast them in precisely the opposite roles. Canaletto's painted Venice for all its seeming accuracy is a documentary fiction generated as much by what the composition of the two-dimensional canvas demanded as what he was describing. Canaletto was not above modifying what he saw should the painting need it, but of course the final effect is so convincing that we imagine that it must be real. Tiepolo's ethereal visions, however, document all the long-standing myths of the city we have encountered elsewhere in this chapter—bride of the sea, theater of sacred dramas, home of the great and the good. In essence Canaletto artfully fictionalized reality, but Tiepolo made fictions seem real. The

latter is in the end closer to what Venice had always been about: a grand poetic fiction made real on the mud and tides of the lagoon. Tiepolo's allegorical fictions are Venice's reality.

Finally, in relating herself to other cities Venice defined herself as much by what she was *not* as what she was. The two greatest antonyms to the city's self-definition were Florence and Rome, the former a rival in the mercantile and banking world, the latter a European power and adversary in the city's claims to clerical self-determination. Florentine and Venetian humanists traded written barbs and diatribes in laying out their respective city's political and cultural prestige, and these antitheses sometimes also played out in architectural style (although the architect who brought the Renaissance to Venice, Mauro Codussi, owed not a little to the great Florentine Filippo Brunelleschi). The conflicts with Rome, though, came to a head in some cases more dramatically, the last and most telling being Pope Paul V's interdict against the city and its citizens in 1605 (it lasted until 1607). In publicly defending the Venetian cause in this powderkeg drama with Europeanwide implications, prelate and scholar Paolo Sarpi returned to the structure and rituals of the early Christian church as justification of his city's position.[47] His recourse to the past is our own return to where we began in looking at Venice's self-image. Venice through the centuries believed in her own myth of a legitimacy rooted in antiquity: as rightful heir to the Roman and Byzantine empires. Audaciously she would stake out her role in confronting Rome by claiming to have a better grasp on the early Church's principles than indeed Rome herself. This belief explains the two apparently contradictory tendencies in Venetian architecture throughout the Renaissance—Byzantine conservatism versus Renaissance classicism. Both were attempts to ground the city's urban fabric in an image that proclaimed tradition and continuity. They differed only in how far back each camp was prepared to reach to do so: to the

Byzantine Middle Ages or to ancient classical Rome. In either case by rivaling the Mediterranean's greatest cities Venice emerged from the waves as a city like no other on earth.

> [T]he task of Venetian humanism was to affirm, not challenge, Venetian culture.
>
> —Margaret L. King, *Venetian Humanism*
> *in an Age of Patrician Dominance*

Venice was the great theater of her own myth. This impacted her architecture in profound ways, especially her greatest public stages: the Piazza and Piazzetta di San Marco. The impact was at the level of both form and allusion. Whether in the architecture's rhythmic repetition of the rituals played out in the piazza or in the allusions to Rome's Theater of Marcellus at the piazzetta's Library, Venice became what she portrayed to the world—and what she portrayed to herself. In continually reinforcing her image in public paintings of both secular and sacred subjects (usually both at once) she "imaged" her form on canvas even as the actual buildings of the city strove to catch up. Indeed this is an essential aspect of all the great cities we are visiting. They had an evolving vision of their ideal well before the reality could be brought about, and the only way the reality could be as spectacular as it has become is because the vision reached so high. The trajectory of human achievement is always dragged down by the gravitational pull of practical constraints and compromise; only in aiming toward the heavens can we hit the mark of the best on earth. As Elizabeth Crouzet-Pavan observes, "The public authorities expressed an interest in urban aesthetics by proclaiming the necessity of the *pulcher* [beauty] and the *ornatus* [ornament] in their projects."[48] The Venetians deliberately put a high value on the beauty of their city and indeed required it of public projects as one of the prime proclamations of the city's mythical self.

The Venetians chose to concretize this mythic ideal by setting up comparisons with the greatest cities of the ancient world. Depending on the historical or programmatic context, Venice might want to be a new Alexandria, a new Constantinople, a new Rome, even a new Athens. Being heir to Rome's mantle meant, for example, being the stewards of that venerable culture, adopting the ancient city's foundation myth (the *Aeneid*) as their own, and even rivaling modern Rome's claim to religious authority by challenging both doctrine and clerical appointments. These aspirations took on in the sixteenth century an architectural form that was in many ways more deliberately and overtly *all'antica* than that of the Renaissance city shaped by Michelangelo's inventive genius, a form that therefore became absolutely novel for its rigor in its time and stills appears so. The gate at the remarkable Arsenal ship-building complex, the Porta Magna, built in 1460 as part of the extensive modifications to Europe's greatest industrial facility, was the city's first foray into Renaissance design. It is no accident that the work on the Arsenal and the Porta followed less than a decade after Constantinople had fallen to the Turks; these projects, one by its extent and the other by its style, proclaimed Venice's succession of the conquered classical culture on the Bosporus.

Thanks especially to Palladio, his successors and his architecture as depicted in the backgrounds of painters from Veronese to Tiepolo, Venice was an unrivaled destination for Europeans on the grand tour in search of models of contemporary classical achievement. Being more philologically correct was one of the ways the *Serenissima* staked out its legitimacy. Yet in every case, whether emulating Constantinople, Alexandria, Athens or Rome, Venice never surrendered her uniqueness. Indeed the references seem to have been sifted through a refined filter of judgment (both aesthetic and political) and combined in calculated ways to satisfy the demands of their own brand of decorum and

the genius loci. The lesson for us today might be that the rivaling, referencing and emulating of great cities of the past or elsewhere demands no sacrifice of originality but is a tried and true means of establishing high standards.

In Venice the city was essentially simultaneous with the idea and myth of the place, in a way like the *urbs* of Rome was really indistinguishable from the Idea of Rome in the ancient world. All of the city's struggles with her environment, her paradoxical engagement and secrecy, her pride and faith, were available along every canal, in every labyrinthine neighborhood and from the gateway of the piazzetta.

Venice was also the great city of cultural synthesis, where myriad aesthetic influences were subjected to a deep indigenous sense of tradition and mission. While being open to other cultures, Venice never abandoned her own, and the resulting accommodation of outside sources invigorated the local vernacular and the larger classical traditions.

Venice offers perhaps the most self-conscious example of a civic mythology, one that is reinforced spectacularly in painting, perhaps to a lesser extent in sculpture, certainly in architecture and most poignantly in urban form. This cultivated mythology—as the most serene heir to the greatest Mediterranean cities, mistress of the sea itself, a republic of stability, justice and endurance—shaped all decisions of the city. Not a gloss on an ad hoc policy, it was the a priori condition for policy, giving continuity and direction to the long-term project of city building. Venice would even exploit her position on the sea to suggest, with the twin columns of Saint Theodore and Saint Mark, an analogy to the mythical edge of the world defined by the Pillars of Hercules. Whether in politics, ritual or architecture, no city structured her position so theatrically, rigorously, consistently and consciously. After all, "In the procession, position was everything."[49]

3

Florence vs. Siena

THE BATTLE FOR PARADISE

The Pythagoreans . . . call music the harmonization of opposites, the unification of disparate things and the conciliation of warring elements. . . . They say that the effects and application of [musical] knowledge reveal themselves in four human spheres: in the soul, in the body, in the home and in the state. For it is these things that require to be harmonized and unified.

—Theon of Smyrna, A.D. second century

*F*lorence and Siena were desperate political rivals for control of Tuscany, battling back and forth for centuries before Siena's ultimate capitulation to the first Medici duke, Cosimo I in 1555. Today most of what is left of centuries of an exhausting and ultimately futile contest is, fortunately for us, spectacular art and architecture. In defining themselves as political,

military, economic and artistic adversaries each drew upon its uniqueness—of setting, history, resources and temperament—to define their special claims to dominance through building. In politics and religion especially these cities' self-images created wonderfully specific approaches to shaping the skyline, public space, public architecture and religious building that in many ways stake out the profiles and boundaries of two clearly distinct but equally appealing approaches to the building of the City as an Idea. Before we begin the exploration of these two walled earthly paradises a myth is worth recounting that brings alive the fundamental role of a city's walls—so vital to the defense of desperate rivals such as these—in defining the very identity of a city. At the same time it reinforces the role of music in the consciousness of classical humanist culture.

THE WALLS OF AMPHION

This is, I imagine, why legend had it that Saturn, out of a concern for human affairs, once upon a time appointed heroes and demigods to protect every city with their wisdom; because we depend not only on walls for our safety, but also on the gods' help. . . . The walls were therefore considered particularly sacred, because they served both to unite and to protect the citizens.[1]

Many mythical gods and heroes were city builders. Apollo and Poseidon teamed up to build the walls of Troy for its king, Laomedon.[2] Aeneas of course founded the first Rome at Alba Longa (without actually building her walls), Myceneus was the hero who founded Mycene and Cadmus founded Thebes. Since being a hero often meant taming wild nature, city building was really the ultimate heroic civilizing act. In the story of the building of the walls of ancient Thebes there is

a myth whose resonance echoes across humanist thought, both as an allegory about urban form and as an emblem of Eloquence.

Amphion and his twin brother, Zethus, were the offspring of Zeus' liaison with Antiope.[3] Exposed at birth and left to die for their mother's indiscretion, they were rescued and raised by a shepherd; as they grew, Zethus devoted himself to farming and war, while Amphion focused on music and the lyre given to him by Hermes. Meanwhile, their mother was imprisoned for years by Dirce and her uncle, Lycus, who had inherited the throne of Thebes, the city founded by Cadmus (who was, significantly, the husband of Harmony). Antiope was eventually freed by Zeus, but her sons, not recognizing her upon her return, sent her back to Lycus; upon realizing their mistake, they took revenge on Dirce and Lycus, killing them, and became rulers of Thebes themselves.

Now Cadmus had built a defensive citadel at Thebes, but evidently the walls did not encircle the whole city. Zethus and Amphion resolved to remedy this. Zethus took it upon himself to do the heavy lifting and carry stones to the city's perimeter, but Amphion, relying only on his lyre, played music that charmed the stones into place. So the city where Harmony once had been queen received walls built by the power of music. For Renaissance humanists who saw the myths as allegories this one seemed to say something about the constructive power of Eloquence and Art, and as such an allegory it is sometimes represented in frescoes. Even more, it seems to be a triumphant argument for seeing city form making as a reasoned, noble and refined art that involves coaxing rough stones into artful place. Zethus and Amphion often quarreled over the relative merits of their skills; certainly a city has need of agricultural sustenance and simple defense from aggression, but Amphion's harmonious art was what was needed to give Thebes the form it

would proudly present to the world. Music was the most perfect art to the humanist mind because it was closest in structure to pure number and the mathematical systems that they believed gave order to the cosmos. Thus the form of a city shaped by music for them matched the structure of the heavens, becoming a microcosm of the universal order. And for the Renaissance humanists its harmonious form couldn't help but shape an equally harmonious society. The twelfth-century German abbess and mystic Hildegard of Bingen echoed the Amphion legend in her song *O Ierusalem*,

Then your walls blaze
With living stones,
Who by the greatest zeal of good will
have flown like clouds in Heaven.[4]

This is in part why the subject of harmony keeps coming up again and again in early Renaissance discussions of the ideal city and state. If the city could imitate music in its formal order, it could then bring down the harmonious structure of the heavens to earth. Lofty stuff, but what did this really mean in practical terms? Sensibly humanists had a definition of harmony that could accommodate "imperfection," so there was hope it could be brought to the highly imperfect creatures that real cities inevitably were. Alberti's notions of individual perfection, for example—a balancing of opposing characteristics—still sound wise and possible even to us today, but he was too much of a political realist to have suggestions about the ideal society that would overtly challenge the patrons he depended upon as an architect. Instead he hoped his balanced and noble architecture could create a like-minded society, and his idea that "surely the most thorough consideration should be given to the city's layout, site and *outline*" was listened to.[5]

FLORENCE

*Although not attested in any ancient chronicle, it is thus
obvious that Florence was founded, erected, and adorned by
powerful, rich, strong, and valorous Roman citizens, who
provided it with beautiful buildings and a circuit of walls.*

—Giovanni Gherardi, *Paradise of the Alberti* (1425), in
Baldassarri and Saiber, eds., *Images of Quattrocentro Florence*

As we saw in Venice, a core component of a city's myth involves
how it perceives its origins, and the case of Florence is certainly
no different. The sense of that mythical origin indeed changed
periodically during the fifteenth century, the period with which
we will be most concerned (since so much of the city's wealth,
Idea and form was defined in those years). To stake out particu-
lar claims for Florence's antiquity or nobility, the myth evolved
as changing political and military situations required.[6] These
mythical variations all hover around the truth. While we know a
bit more than the authors of the fifteenth century did about the
archaeology of the city, their sources, mostly textual, gave them
a fairly good idea of when Florence was founded, by whom, and
how it related to Fiesole on the hill above. As we will see, their
mistaken attributions of what they thought were actual ancient
remains also had an enormous impact on the buildings of the
Renaissance.

Florentia, the Roman military encampment and colony laid
out during the reign of Julius Caesar, settled itself into the valley of
the Arno River below an earlier Etruscan village on the site of
present-day Fiesole on the hills above and to the north. The hu-
manists of the fifteenth century oscillated between two beliefs
about the city's origins. One bases the city in a pre–Julius Caesar
(that is, preimperial and therefore Republican) conflict with
Rome's allies known as the Social War; this history was employed

to endorse the modern city's republican government. The other belief is that the city was settled by either Julius or the triumvirs who succeeded him, including Augustus; the imperial overtones of this view accorded better with the dynastic aspirations of the House of Medici. Both views acknowledged that rebellious Fiesole was crushed and the valley site chosen to replace it. The new city was strategically sited just off the important road known as the via Cassia that led from Rome to the south onto the wide fertile Po Valley to the north. Absolutely typical for a Roman camp in its gridded street layout, the new Roman town was canonically oriented along the inevitable *cardo* and *decumanus*, the classic north-south and east-west cross streets that developed from the Roman surveyor's (*agrimensor's*) standard cardinal axis siting of all towns and military outposts. These were founded symbolically as "new Romes" in imitation of Romulus' *Roma quadrata*. First the center was established, and then the cardinal axes were laid out and the boundary defined: A *castrum* grew out from its *umbilicus* (the omphalos of the world as we have seen was believed to exist in Rome on the Capitoline hill). For a number of years historians had wrongly argued that the Roman *castrum* (from which the English get their suffix -*chester*, as in Winchester), so different in its geometric clarity from the chaotic plan of the empire's actual capitol, was the model for Roman new towns.[7] In fact the situation was precisely the opposite: Roman military encampments imitated cities or actually an idealized image of the City, or *Urbs*—that is, Rome herself. The fifteenth-century humanists who wrote on Florence's origins actually understood this quite well, and point to the fact that theirs was a founded city as evidence of its Romanness, created in imitation of an ideal type of the mother city. For the city chancellor Leonardo Bruni the Roman image of Florentia was reinforced by conspicuous architectural imitations, buildings he and others believed in the 1400s still existed in one form or another.

It seems that the settlers, inspired either by nostalgia or by love of their native country, wanted to model the city after palaces and buildings in Rome. . . . The desire to model the new city on Rome was so ardent that it led them to imitate even buildings of lesser functionality without heed for the cost.[8]

For one author at least the birth of Florence proved the industry and genius of her citizens through the years, who made of a humble site something noble, even miraculous. Writing in the mid 1400s, Cristoforo Landino, humanist teacher to Lorenzo the Magnificent and Politian (among others), describes in a letter the contrast between unpromising beginnings and glorious present achievement in vivid terms.

All these rich buildings, both sacred and profane, rising before your eyes and rendering you speechless, could not have been imagined by Sulla's soldiers when they first settled in the territory of Fiesole. The beautiful cultivated fields that you now see were once covered by Arno's dark, swampy waters, whose rapid course was obstructed by a massive rock and turned here into a stagnant pond. The ground could not be trodden by man, nor was the lake navigable; the river was not suitable for fish, nor the grass for cattle. It was not yet possible for the traveler to look at these four wonderful bridges and use one of them to cross the river without wetting his feet. Water was not yet brought to our city channeling it from distant springs. Where today the high tower of the senate rises, the fishermen built their huts; and where the holy fonts of the baptistery now stand was a marsh that resounded with the croaking of frogs.[9]

Although the Roman city camp of Florentia was walled, signs of civic prosperity and growth such as the amphitheater and theater were allowed to develop outside the original *castrum*'s

defensive perimeter, confirming the meaning of "flourishing" suggested by the town's name. The shape of the amphitheater is still preserved in the footprint of buildings just west of the Piazza Santa Croce, and was cleverly recognized as such by Renaissance humanist writers. Since it was not sited with any special regard to the orientation of the Arno River, the town spontaneously threw out roads beyond the walls, and a (probably wooden) bridge to reach and span the river. Like other similar Roman foundations such as Torino, the Florence we know today mostly preserves her ancient past in the still-gridded layout of the streets of the city center rather than in standing architectural ruins. Major modern thoroughfares such as the via del Corso still follow the route of the old east-west *decumanus*, while the via del Proconsolo follows the perimeter of the Roman walls, and its name evokes the title of the Roman governor.

Interestingly few early Renaissance writers point to the city's plan as evidence of its Roman origins. Instead looking for confirmation of their Roman roots, Florentines were convinced that remains of actual, noble ancient architecture survived in plain view. In particular, fourteenth- and fifteenth-century Florentine panegyrics point repeatedly to the Baptistery as being either a converted Roman Temple of Mars or at least built on the ruins of one. Indeed arguments have been made by historians for decades that the architectural Renaissance as it emerged in Florence under the influence of Brunelleschi was as much a rebirth of the style of Florentine Romanesque buildings (which were mistakenly believed to have a classical Roman pedigree) as it was of the architecture of the great ruins in Rome that Brunelleschi had spent years studying.

Florence's Roman origin, like a noble family lineage, was a mark of pride to Florentines and conversely an open question to the city's detractors. Humanists employed by rival cities were just as likely to cast aspersions on Florentine claims of noble

Roman origins as the Florentines were to proclaim them: Imagine a war where insults of pedigree were considered to be potent weapons.

Florence, like many Roman-founded cities, shrank in population with the waves of invaders who flooded the Italian peninsula after the fall (the Byzantines would have said the relocation) of the Roman empire; the walls shrank with the population to a smaller precinct within the original mural circuit. Within a few centuries, however, the city began to fill out its original Roman boundaries and then exceed them. In the meantime it had acquired churches that hovered around the perimeter of the city, like those of early Christian Rome. At first this occurred so as not to encroach on sometimes still pagan sentiments in the center, but also to be near the burial sites of early martyrs in the cemeteries that Roman law demanded be outside the walls. Tucked into the northeast corner of the old *castrum* was the church of Santa Reparata, dedicated to an imported Palestinian saint. Built perhaps in the sixth century, it received the bishop's chair, or *cathedra*, in the late seventh century, replacing San Lorenzo as the Cathedral (or *Duomo* in Italian, from *domus dei*, "house of God") of Florence. Old Santa Reparata was considerably smaller than the famous Duomo we know today; it is a mark of Florence's rising status on the Italian and European stage that the city had the pluck to replace the paleo-Christian and then Romanesque cathedral with so enormous an edifice. The demolition of Santa Reparata began in 1285, and the new cathedral would subsequently take a new name, Santa Maria del Fiore.

The Duomo of Florence was begun in 1296, roughly thirty years after Siena had completed its cathedral, and it was meant to dwarf the crowning jewel of its southern Tuscan rival. The architect, Arnolfo di Cambio, intended that it could house 30,000 worshipers (a little less than a third of the city's estimated population).

It says something about Florentine *chutzpah* that the building was begun without any clear idea as to how a roof would be constructed over the octagonal crossing; the building committee was certain that, by the time they had reached that stage, someone would have come along with the answer. Fortunately for them they were right. Filippo Brunelleschi, who had dedicated himself to architecture after his disappointment in the competition for the Baptistery doors (won by Lorenzo Ghiberti), was both a product of a century of classical philology in the city and a harbinger of a rebirth of classical style in the visual arts for the rest of the fifteenth century.

Brunelleschi's achievement is entirely unthinkable without the humanist culture that surrounded him, which had been until then mostly a literary culture, but one combined with an inexorable movement in all the arts toward increasing mastery of the classical past. The dome on the Duomo would eventually be proof to Alberti that measuring up to the past was not only possible but had already happened, and indeed for him Filippo had exceeded his ancient models in size and grace. A growing sense was developing that this achievement could only have happened in Florence, and a dense web of exhortations and self-congratulations on the part of the city's humanist writers inspired the nascent renaissance movement while spreading the word around the continent. Writers and artists collaborated intellectually in Florence in these years unlike ever before and perhaps never again.

The *duomo* defined most Italian cities' high aspirations. It said everything to the world at large about their political and economic power and the state of their collective souls; as the most notable building in town, the *duomo* could also become metaphorical fodder for all sorts of high-minded ruminations. Listen to Alberti in his book *On the Tranquility of the Soul* discussing some of the many connotations the Duomo of Florence suggests to him.

Certainly this temple has in itself grace and majesty; and, as I have often thought, I delight to see joined together here a charming slenderness with a robust and full solidity so that, on the one hand, each of its parts seems to be designed for pleasure, while on the other, one understands that it all has been built for perpetuity. I would add that here is the constant home of temperateness, as of springtime: outside, wind, ice and frost; here inside one is protected from the wind, here mild air and quiet. Outside, the heat of summer and autumn, inside coolness. And if, as they say, delight is felt when our senses perceive what, and how much, they require by nature, who could hesitate to call this temple the nest of delights? Here, wherever you look, you see the expression of happiness and gaiety; here it is always fragrant; and, that which I prize above all, here you listen to the voices during mass, during that which the ancients called the mysteries, with their marvelous beauty.[10]

Santa Maria del Fiore (St. Mary of the Flower), as the cathedral was dedicated, is richly polychromed outside to call out its floral dedication, while inside it is all simple sandstone and plaster, a concession to sobriety but also an opportunity for wealthy groups and individuals to decorate their own chapels. (Much of it in fact had been frescoed when the Medici grand duke Cosimo I had his director of arts, Giorgio Vasari, obliterate them and redecorate it all in a more "correct" and up-to-date mid-sixteenth-century classicism.)

Guillaume Dufay was the composer charged with writing music for the Duomo's consecration ceremony on 25 March 1436 (a propitious day, the Feast of the Incarnation; the ceremony was conditioned by sacred time, since the crowning lantern that capped the dome would have to wait for another few decades). His motet *Nuper rosarum flores* ("Recently roses flowered") took as its point of departure Brunelleschi's proportional system

for the dome, miraculously translating the musical proportions of the architecture back into the structure of the music.

> Not only do the [motet's] mensurations in its four sections have a proportional relationship of 6:4:3:2 [like the cathedral and its dome], but the number of tactus in each of the sections is the same as the number of braccia [the Florentine unit of measure] contained in the modular scheme based on twenty-eight braccia squares. . . . What is more, there are twenty-eight breves in each of the two-voice and four-voice subsections of the motet, which means that the "module" of the motet is the same as that of the cathedral.[11]

If the "concordant discord" of the music restated the harmony of the building, it was all to a purpose—not that architecture borrowed the proportioning systems of music, but rather that both arts tapped into the heavenly music that ordered the cosmos. Each was a microcosm of the systems that governed all of nature. The purpose was for Florence herself to be made harmonious, certainly in form but also as a society, so that the citizens and the city would be shaped by the same concord. Florence truly believed in the affective power of architecture and music: Here was urban renewal being carried out by a Renaissance motet.

One attendee at the consecration ceremonies wrote a letter describing the events but began first by analyzing the building. Lapo da Castiglione, a friend of Alberti, saw in the cathedral the form of an ideal human body, so that also in this anthropomorphic way the building participated in nature's design.

> After repeated examinations, I have decided that the wonderful edifice of this sacred basilica more or less takes the shape of a human body. . . . If, then, the form of our church is like a human

body, no one of sound mind can deny that it has been endowed with the most noble and lovely appearance possible, since it is obvious that the human body is superior to all other forms.[12]

The human body therefore did just as much to bring mathematical harmony to the Duomo as did musical proportion. As Anthony Grafton notes, Lapo "clearly understood the building as a text written in the languages of arithmetic, geometry, and ornament."[13] So too by extension could the city be read and written, and the echoes of music and the body in each resonated in the patterns of ceremony and daily life. Indeed the Florentines lavished as much attention on the ceremonial route from the Dominican church of Santa Maria Novella (where the pope was then in residence) as they did on the church itself. A causeway was raised over the connecting street so that "whether onlookers walked on the causeway, or ambled along the street, or wandered through the basilica itself, they were stimulated by delights of all sorts, seeing and *smelling* at the same time, and were filled with many kinds of pleasure."[14] In Dufay's motet the Virgin and Florence are conflated (*Tuus te Florentiae*), and the people entreat her "with mind and *body*" (*mente et corpore*) to solicit her protection. Both mind and body need to be moved by the building; Dufay and Brunelleschi were after much more than cerebral pleasure. In humanist culture the order of our physical environment transcended aesthetic delight; it literally made sense of human experience and action. Every civic building therefore had a tremendous communal responsibility that extended beyond its practical usefulness.

Like most Italian cities, Florence's Duomo has a freestanding bell tower, the towering Campanile, where bells tolled music the whole city could hear; polychrome like the cathedral, the Campanile was designed by the great painter Giotto, his only known foray into architectural design. That the conservative Florentines

would entrust such a prominent monument to an effective ama-
teur is significant; evidently they saw its technical challenges as
minor compared to its major mission, which was all about
imagery and iconography. The iconography of the Campanile is
not unusual for the late Middle Ages, but it is remarkable for
the scope and quality of the reliefs that wrap its lower ranges. At
the most general level the reliefs use the arts and sciences to de-
scribe the full range of human experience, and these are seen as
almost steps in a ladder toward redemption. Using the medieval
scholastic's categories of *Necessitas, Virtus* and *Sapientia,* hu-
man endeavor at the level of necessities (mechanical arts), virtues
(the arts relating to familial, social and political life) and wisdom
(the "liberal" arts, as Cicero would have it, those that make us
"free" citizens) is represented in each case by a single figure from
the Bible, history or mythology.[15] Every Florentine could there-
fore find him- or herself represented somehow, in the guise of all
the trades who operate in the city, from the clerical to the man-
ual; and not a little of this, it should be noted for this Christian
landmark, depends on pagan imagery.[16]

The Campanile is ultimately a celebration of work, craft and
knowledge. As we will see in Siena's town hall, the labor involved
in keeping a medieval commune humming was not taken lightly
but was rather promoted and celebrated. Labor was not just
work, it was skill; Florence was a vital hinge pin in the great Eu-
ropean wool trade mostly for the *quality* of what she produced—
dyed wool unmatched elsewhere for beauty and permanence.
Portraying the city's artists and artisans on her towering Cam-
panile was good business, but it also dignified labor as an ulti-
mately sacred act, offered up to God from the launchpad of this
spectacular marble gantry. Our scarce respect today for the dig-
nity of human craft and labor goes a long way toward explaining
why we suffer the lack of such nobly extravagant achievements as
the Duomo and Campanile, or indeed of the Renaissance itself.

Florence had developed substantially in the years between the building of the first Santa Reparata and the start of construction, around the year 1300, of the current Duomo. The new walls of the city that were rising at the same time as the great cathedral enclosed an area roughly twenty-four times the size of the original Roman city (480 hectares, or 1,150 acres, in place of the original 20 hectares). The walls had seventy-three equally spaced towers and fifteen gates, all unique in form and decoration.[17] This vast circuit of imposing walls does not mean that the area they enclosed was all inhabited. On the contrary, substantial intramural tracts were devoted to the holdings of the monastic orders, who established their large churches on open land away from the city center and outside the previous circuit. These orders, specifically the Dominicans and the Franciscans, were effectively self-sufficient, self-contained communities with gardens, orchards and livestock. There was additional space dedicated to small, private agricultural holdings within the perimeter, and in case of attack these sources of sustenance would come in handy should the farms in the vicinity outside the walls be laid waste—a standard first jab of a marauding army at a besieged city.

But clearly Florence had grown from her modest roots. Sober Florentine businessmen and bankers plied their trades, from the wool industry to money lending, in cities across Europe from Barcelona to London. The money that flowed into the coffers of guilds such as the wool guild could be used to build symbols of Florentine status such as the Duomo. But as the city grew in size, it grew in governmental complexity and power, and the other great symbol of the numerous communal republics that dotted Tuscany and Umbria in the Middle Ages was the town hall, or Palazzo Comunale.

Florence's town hall, known today as the Palazzo Vecchio, succeeded an earlier building to the east, a looming structure

that later became a prison, now known as the Bargello. The town hall that replaced it was sited to great effect on what would become known as the Piazza della Signoria. The open space of the piazza had been created by confiscating and tearing down the houses of a family of the wrong political sympathies at the time (the Uberti family). The building itself replaced other houses, bought in this case from the Foraboschi (although the campanile supposedly absorbs the family's old defensive tower).[18] Private interest, politically incorrect in the first case and legitimate in the second, was sacrificed to the common interest, and the great bulk of the Palazzo Vecchio canceled forever the chance of a return to that particular private landscape.

The piazza occupies a unique historical position in the city fabric. The buildings that define it to the north mark the south edge of the original Roman city fabric, and the piazza splays out from there, pie-shaped, toward the street network oriented toward the river. It is a hinge between the city's oldest imperial foundations and the newer post-Roman development. The via dei Calzaiuoli marks a straight line through the old *castrum* from the facade of the Duomo to the western edge of the Piazza della Signoria. The Palazzo Vecchio and the Duomo therefore occupy similar positions with respect to that street, making them effectively counterweights, the two poles of authority in Florentine life, a relationship most clearly expressed in the city skyline that we can appreciate from the hills beyond the city gates.

Whether coincidental or not, the Palazzo Vecchio sits above the site of the old Roman town's theater. With a spectacularly inaccurate politicized interpretation the fourteenth-century Florentine writer Giovanni Villani described Florence's Roman theater

"as a place for speeches, intended for holding public assemblies [*fare suo parlamento*]." The substructures for the tiers of seats and the central platform are transfigured [in his description]

into a marvelous structure "built in the round . . . with a piazza in the middle[!] . . . where the people came together for their public meetings [*a fare parlamento*]."[19]

In doing so he drew on a long medieval tradition of interpreting Italy's surviving Roman theaters and amphitheaters as urban public spaces and their undercrofts as mysterious labyrinths. Indeed Lucca and Rome built piazzas over the remains of an ancient amphitheater and a stadium, respectively. It is no wonder that, as that same medieval culture approached the building of piazzas and civic buildings, they thought of them in suggestively theatrical terms.

To grasp what the architecture of government meant in practical terms to a medieval citizen of a city such as Florence or Siena we need to let go of some of our modern notions of what a town hall is. Rather we must expand our notions of how the center of government functioned in those times. Most important, the Florentine Palazzo Vecchio was called that because it indeed functioned as a palace. It literally housed, day and night, the leaders of the city government—the so-called *signori* (who gave their name to the Piazza della Signoria)—while they were in office, including their staff, security and entertainment. (It is now called *Vecchio*, or old, because the eventual duke, Cosimo de Medici, lived there upon establishing the dukedom, beginning in 1540, and then soon after moved to the Palazzo Pitti across the river, making that the "new" Palazzo.) Around 1410 the merchant Goro Dati composed a *History of Florence* that gives a remarkably precise and evocative picture of the structure of Florentine government and life in the Palazzo della Signoria.

> Each member of the signoria is assigned a room in the government palace according to his rank and the district from which he comes; the best room is reserved for the standard-bearer. All

the signori have a servant who helps them with whatever they may need in their room, during meals and so forth. . . . Each member of the signoria, moreover, has two subordinates whom he sends to act as legates. Altogether, the signoria has a hundred subordinates in its service. . . .

No one sits at the table of the signoria except the signori themselves and their secretary. Guests, foreign authorities, or ambassadors of foreign lords and communes are [however] sometimes invited to dine at the table. On special occasions, such as religious feasts or the welcoming of important guests, the rettori and certain city officials are allowed to have lunch with the signoria, whose table is said to be well appointed, elegantly served, and orderly, as befits the highest authorities of government. . . . They also enjoy the company of the commune's fifers, musicians, jesters, jugglers, and all sorts of entertainers, though they can rarely indulge in such activities, being continually summoned by the proposto to discuss the needs of the state. They never lack for things to do.[20]

Dati goes on to enumerate the many councils of citizens elected to advise the signori: the *Dodici buoni uomini* (Twelve Good Men), the *Consiglio del popolo* (People's Council), the *Dieci di balìa* (Ten of Power–Authority) in times of crisis, the *Otto di guardia* (Eight Guardians), the *Dieci di libertà* (Ten of Liberty) and various other officials for specific tasks. So we are not talking about a simple bureaucratic office building. City leaders actually took up residence here for terms that could range from months to even years (in the case of a despot), making of it literally a palace of the people. They constantly engaged in dialogue here with other civic counsels and officials who would come as visitors or guests. One of the principal reasons they lived here, and one reason it looks so defensive, is that this was the only place the commune could guarantee the safety of

their elected officials. Moreover, its symbolic role, its public image, was at least as important, if not more so, than its actual functioning; this is something one could say also about any private Renaissance palazzo, but it is especially true of a public one. In Florence until the later fifteenth century this image was primarily conveyed by the height and bulk of the Palazzo dei Priori (Palazzo Vecchio), and its looming campanile; frugal Florentine *signori* seem to have spent little on internal decoration (perhaps because of their residential impermanence it was never a priority). As the historian of medieval and Renaissance civic life Nicolai Rubinstein writes,

> By the beginning of the fourteenth century, it was becoming customary for town halls to be decorated with paintings. By far the most magnificent example of such early decoration of public palaces is provided by the Communal palace of Siena. Constructed almost exactly at the same time as the Palazzo Vecchio [of Florence], the Palazzo Pubblico must have had its council hall decorated from the moment it was completed: a document of 1314 refers to earlier paintings on its walls, and probably in the following year Simone Martini began to cover almost the entire space of one of them with his fresco of the *Maestà*. . . . In contrast to the wealth of Siena, no mural pictures from that century have survived in the Palazzo Vecchio.[21]

Adjacent to the Palazzo dei Priori the commune erected the Loggia della Signoria (later known as the Loggia dei Lanzi after the hired lancers stationed there in the sixteenth century; since the nineteenth century it has been one of the world's finest outdoor sculpture museums) in the years 1374–81. It provided the kind of covered place of interchange that many smaller towns incorporated into the body of their town halls (such as the one we will visit later at Pienza). These spaces were not all that

much different in kind from those built to shelter bankers and businessmen at the markets, and no doubt politics and economics were discussed in these places interchangeably. Business and politics were just as intertwined in the Middle Ages and early Renaissance as they are today.

Florence first came to prominence on the Italian and European stage not as a cultural or military center but as a mercantile hub, a place for bankers, wool merchants and artisans. Ever mindful of her pragmatic priorities and motivated by a fiscal prudence derived from a history of calamities, for centuries she eschewed overt displays of luxury, whether in the clothing of her citizens or in extravagant public expense (with the occasional exception of churches). Florence's town hall, with only a handful of modest works of art before the mid fifteenth century, must have looked relatively austere and mean to a visiting Sienese, who was accustomed to the abundant civic murals of his or her own Palazzo Pubblico.[22] This generally conservative habit, solidly in place until the early fifteenth century, wouldn't have seemed to bode well for the remarkably generous flowering of the arts there that we call the Renaissance. What was it then that changed?

First of all, things changed on the pages of humanist writers before they changed in the salons of palaces and in the skyline. Perhaps the first of the arts that truly flowered in medieval and early Renaissance Florence was that of literature, through the pens of writers such as Dante, Boccaccio and Petrarch. Dante loved the city that had cruelly exiled him, and the *Divine Comedy* is peppered with references to the buildings and streets of the city, allying his beloved city with Paradise mostly, but its politics often with Hell. Dante still ached in his absence for the austere unsalted Florentine bread and all that it symbolized; still eaten today, it is a bread that holds up well for days, can be economically recycled into toasted *bruschetta* or dropped into the

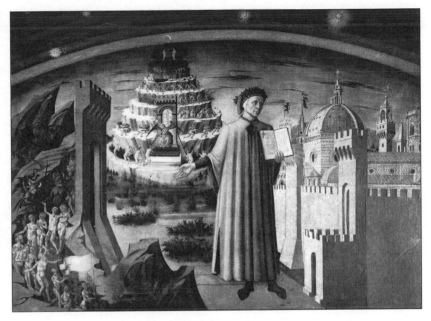

Fig. 3.1 Domenico di Michelino (1417–1491), *Dante and His Poem*

twice-cooked minestrone known as *ribollita*, and takes a discreet backseat to the peppery Tuscan olive oil. Italians, even today, are habitually identified by their birthplace, and Dante was,
throughout his years away from his hometown, always a
Fiorentino.[23] It wasn't long after his death in Ravenna, where he
is still buried, that his mother city desired its famous progeny's
return, if only bodily; his empty, marble eighteenth-century
tomb in Santa Croce still awaits. But Dante had given Florence,
by the wide fame of his epic poem, elevated status on a pan-European scale, and the Tuscan dialect in which the poem was
written became *the* Italian of the peninsula's scholars—thanks
to the humanists of a century later who took up the Dantean
banner.

Praise of Dante became de rigueur for later Florentine writers
such as Boccaccio, and praise itself—encomium—emerged as

one of the first of the ancient literary genres to be systematically and effusively recovered. Eventually this habit of praise led to a veritable humanist industry of writers—often notably civil servants—who made the city itself the subject of their most effusive praise in poetry and prose. It is almost as if all the laudatory descriptions of Florence that started surfacing in the very early fifteenth century eventually demanded an image of the city that lived up to the hype.

> I can't believe that my Antonio Loschi, who has seen Florence, or anyone else at all, who saw Florence, could deny that it is the flower of Italy and its choicest part, unless he were downright foolish. Which city, not only in Italy but in the whole world, is more safely guarded by its walls, more superb in palaces, more ornamented in respect to temples, more beautiful by virtue of its buildings, more illustrious in its porticoes, more splendid in its piazzas, cheerful in respect to the breadth of its streets; which is greater in population, more glorious in its citizens, more infinite in riches or more cultivated in its fields? Which is more appealing in its site, healthier in its skies or clearer; which has more wells, sweeter water, is more industrious in the arts and more admirable in everything? Which is more edified in villas, mightier in towns, more numerous in municipalities or more abundant in farmers?[24]

Recall that when the Florentine humanist Coluccio Salutati wrote this invective against a cranky Venetian rival around the year 1400, many of the buildings and works of art for which Florence would become so famous remarkably did not yet exist. There was no dome on the Duomo, no Hospital of the Innocents by Brunelleschi, no Davids by Donatello or Michelangelo, no Brancacci chapel nor bronze doors on the Baptistery. The reign of the Medici progenitor Cosimo was decades away; the lights of

the century such as Leonardo da Vinci, Lorenzo de Medici and Leon Battista Alberti were yet to be born. Still, there was much to be proud of, and civic pride is one of those proverbial self-fulfilling prophecies. Christine Smith in her book on the culture of early humanism and architecture claims, "As far as I can determine, this use of the built environment as evidence of national character is a genuine innovation that first appears in Florentine circles in the first decades of the Quattrocento [the 1400s]."[25]

A particular phenomenon of Florentine society is that the position of chancellor in the city government, essentially that of an official letter writer, was filled by a succession of skilled humanist poets and historians. One of the greatest of these was Leonardo Bruni; he and others wove political reality and poetic myth into a compelling picture of a society that was for them exactly what it appeared to be, where citizens and the city were one. Indeed Bruni saw specific corollaries between the very nature and setting of the city and the nature of her citizens.

> First of all, let us note the signs of its wisdom. For one, Florence has never done anything ostentatiously; it has always preferred to reject dangerous and foolish arrogance in order to pursue a state of peace and tranquility. It was not built on top of a mountain, to show off its greatness; nor, by the same token, was it built in the middle of a plain and open on all sides to attack. Instead, with the discerning prudence of its citizens, Florence attained the best of both situations.[26]

Bruni was clear to make a distinction between the civic character of a citizenry and the character of civic architecture. The former is a *civitas*, the latter, an *urbs*. For him speaking of Rimini but no doubt thinking of Florence, "even if an *urbs* were small, its *civitas* could nonetheless have been very large and powerful."[27] To a great extent the building out of the Florentine

urbs in the fifteenth century was the manifestation of an already great *civitas*, whose praise had been sung at least since the time of Dante.

The literary genre of encomium was given a Florentine flavor by humanist civil servants who vied to outdo each other with their laudatory descriptions, and again this praise demanded a Florence that embodied the character that these writers celebrated. Everything about the city had to fit into that already articulated image. When Alberti returned to Florence for the first time after his family's exile, he found a city that was in the process of actually becoming that place celebrated by those authors, and it gave him confidence that a real Renaissance was indeed possible.

> I then realized that the ability to achieve the highest distinction in any meritorious activity lies in our own industry and diligence no less than in the favors of Nature and of the times. I admit that for the ancients, who had many precedents to learn from and to imitate, it was less difficult to master those noble arts which for us today prove arduous; but it follows that our fame should be all the greater if without preceptors and without any model to imitate we discover arts and sciences hitherto unheard of and unseen.[28]

Even the ubiquitous stone of which Renaissance Florence was built has an aura of sober dignity. *Pietra serena* is a relatively soft gray stone, economical to work, and in combination with walls of white stucco orchestrated by the clever hand of an architect such as Brunelleschi gave an almost graphic clarity to the mathematical logic of early Renaissance churches and public buildings. This is the same city that Dante lauded for her unsalted bread: somber stone and plain sustenance were Florence's proud emblems of her collective character.

Florence is of course well known worldwide as the birthplace of the Renaissance, a reputation the city quite calculatedly cultivated, and with mostly good reason. This is not to say that aspects of the Renaissance weren't flowering in other places in the fifteenth century such as Padua, Ferrara, Rome or Milan. And there had been other minirenaissances in previous centuries: at the ninth-century court of Charlemagne or intermittently in Rome with revivals of earlier Christian art by the thirteenth-century fresco painters and mosaicists Jacopo Toritti or Pietro Cavallini. But there can be no denying the uniquely remarkable achievements for which fifteenth-century Florence was the natural parent—from Brunelleschi's dome on the Cathedral to Donatello's great sculptural revolution to painters from Masaccio to Ghirlandaio, not to mention writers such as Boccaccio, humanists such as Bruni or philosophers such as Marsilio Ficino. The achievements of Florence in this century are an undeniable fact. We have answered some of why this particular Renaissance of classical art and literature caught fire in this specific place. But how is it that this one place produced so much acknowledged genius?

The crucial component of Florentine culture that sparked such a continually high level of achievement likely was a pervasive and ruthless culture of criticism. The Florentines were (and still are) a tough audience. Pushing toward the ideal of the best of the classical past, measuring oneself against others doing the same, always being competitive with antiquity, with other artists and ultimately with oneself definitely sharpened skills. And it sustained high standards for public work, the pinnacle of the patronage hierarchy: An artist wouldn't dare show his work in public unless he was confident that it was the best of which he was capable.

The case of the humanist Niccolò Niccoli is an interesting one, since he represents a way in which the whole thing could

have gone wrong. Niccoli amassed one of the finest libraries of his time; he was a connoisseur of literature and the book; he was an astute judge of classical literary style; and he was, as regards his contemporaries, a bit of a pessimist. His near reverence for Cicero and that author's good Latin style made him ruthless with his contemporaries' attempts in the ancient tongue, and outright opposed to efforts to elevate the Tuscan language to something like it in stature. All well and good for Niccolò in his private study, but his pessimism as regards modern achievement, had it become endemic in Florentine culture, would have snuffed out the optimism that a renaissance required; fortunately more Florentines found themselves in the optimist Alberti's camp than in Niccoli's.

The Florentines were certainly critical of one another, but they were relentlessly promotional of their self-image to the outside world. This ensured that it was *their* idea of the Renaissance that swept Italy and eventually Europe. That we credit the Renaissance to Florence has much to do with the fact that they *conditioned* how the Renaissance would be shaped and received.

This idea of a Tuscan, especially Florentine, Renaissance was definitively codified in the middle sixteenth century by Giorgio Vasari in his *Lives of the Artists*. Later, in the early seventeenth century, as the city's leadership in the arts was on the verge of becoming a thing of the past, that myth, conflated with the history of the Medici, was given monumental form in the fresco cycle in the summer apartments of the Palazzo Pitti. These show a harried group of muses driven from Mount Parnassus by ravenous Harpies, ultimately finding a refuge in Lorenzo the Magnificent's fifteenth-century Florence. Later in the cycle the effects of Lorenzo's beneficence begin to show: He judges a youthful Michelangelo's attempts at sculpting a fawn, putting himself as much in the role of teacher as patron of Florence's most famous

artistic son. By the time of this fresco Michelangelo was more hero than man and his career could stand on its own as the ultimate justification of Mediciian largesse.

Florence also reinforced her civic self-image with public events and processions, as did Venice. But without the institution of the doge and the continuity of a rigid hierarchical structure such as Venice's, Florence's rituals used and impacted the city in very different ways. Inevitably the form of the city both reflected and shaped its public persona. In the Tuscan capital maintaining an image, if not the reality, of communal governance was of paramount importance, the Medici dukes themselves eschewing overtly ducal displays throughout centuries of domination, when any republican image was wholly a fiction.

Communal Florence strung together her public, theatrical, communal and allegorical processions exclusively within existing architectural conditions, inventing different narratives only by the sequence in which the inherited urban "chapters" were read. Even under the Medici rulers their inherent Tuscan conservatism, combined with a characteristic political circumspection, held them back from making the kind of dramatic urban fabric interventions that papal Rome would undertake. Florentine ritual paths that wound through the city are therefore notable in that they relied solely on existing urban patterns and sacred spots (that were, however, often amplified by temporary structures such as triumphal arches) and reverberated very little concrete back to new, permanent urban construction. The memory of these civic narratives played out on the sometimes ragtag streets thus depended completely upon the impact and resonance of their ritual performances—which explains the energy the Medici would put into the always ephemeral *apparata* of their ceremonies. This effectively *was* their form of urban design.

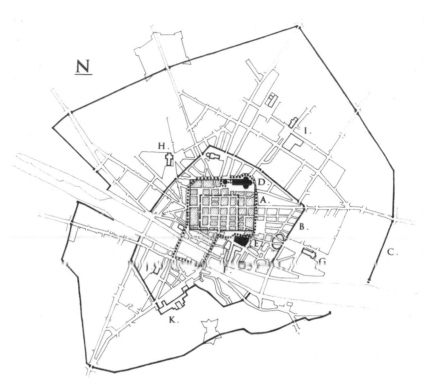

Map 3.1 Florence's walls, processions and monuments: A. first (Roman) circuit of walls (the Byzantine period walls, indicated by a dashed line, are within the shaded zone); the dotted line indicates the path of the San Giovanni and Corpus Christi processional routes; B. mural circuit at the end of the twelfth century; C. Arnolfo di Cambio's circuit of walls (ca. 1300); D. Duomo and Baptistery; E. Palazzo Vecchio; F. Uffizi; G. Sta. Croce; H. Sta. Maria Novella; I. piazza Santissima Annunziata; J. Sto. Spirito; K. Palazzo Pitti

Ritual not only structured space and provided entertainment, it was a kind of social contract, a theatrical display of hierarchies, relationships and mutual responsibilities that was more memorable in a way than a written constitution. The Florentine ritual calendar, both private and public, centered on the feast of the city's patron saint, John the Baptist, 24 June. On the vigil of the feast the clergy enacted their procession that, like the other

important civic processions, followed a route that essentially traced the outline of the old Roman city walls (with a deviation out across the Arno to "capture" it and the Oltrarno into the civic realm), beginning and ending at Santa Maria del Fiore. By tracing the original walls, by dramatizing the commune's hierarchies, by mapping out the structure of exchange, the procession associated with the city's most solemn feast day reestablished annually the communal contract.

> With the movement of the procession from the cathedral, all the bells in the city started to ring and continued until the long procession returned to its starting point. . . . The procession took the goods of the *mostra* [the "show of riches," a display of the city's private wealth that took place the morning of the solemn procession] and transfigured them, so to speak. The *mostra* showed what the merchants had taken in; the procession showed what they had given out. The procession of the clergy must be understood as a demonstration of wealth like that of the *mostra*, but of wealth that had been given to God and thus purified. The procession, by showing the results of continuous charity and altruism, created the civil condition for the contracts that were the center of the day. Without trust, without sacrifice, there could be no contract.[29]

Florence's ritual use of the city tended to "read" the urban fabric rather than "write" it; the processions took advantage of existing urban conditions and landmarks rather than using the ceremonies to propose a mock-up of ideal urban improvements. Having inherited from the Romans a city center grid that remained more or less clear and legible, Florence saw little need to restructure the core of her fabric in order to impose an image of order—since an order, unlike the relative chaos of early Renaissance Rome's inherited medieval fabric, was already there.

The Florentines could, however, reinforce that order by a new architecture that was rational and evoked noble virtues, and this is what the city's Renaissance patrons and architects focused on. As appealing as Florence is to modern-day visitors, it has to be said that the kind of decisive urban design we saw at work in Rome is virtually nonexistent in the Tuscan city during the same period from the sixteenth through the eighteenth centuries. Urban interventions in Florence were almost always deliberately discreet, rarely radical, with perhaps one exception: the piazza Santissima Annunziata with Brunelleschi's *Ospedale degli Innocenti*. Here, and along the via dei Servi that connects it with the Duomo, Brunelleschi's experiments in perfecting the drawing of accurate one-point perspective find three-dimensional realization in the public realm.

Florence's citizen-supported hospitals were a source of pride to the medieval and Renaissance city, and her system of lay confraternities and their charitable activities is a unique aspect of the city's sense of *civitas*. In providing a suitable home for one of these caretaking institutions Brunelleschi's *Ospedale* for orphans, or "Innocents" (*Innocenti*), brings in effect the architectural language of the monastic cloister, with its ordered rhythm of arcades, to the public square. Monasteries were often the sole refuge of orphans; Brunelleschi therefore brought not only the physical form of the cloister but its associations to the res publica. This functionally and symbolically transformed the nature of public space into a more literal mirror of the *civitas dei* like that usually reserved for the monastery. The public square began to display a decorous nobility that suggests it could be a legitimate frame for the good life. Now not only the reclusive world of the cloister but the whole civic realm could share some glimpse of the heavenly order and offer a foretaste of the earthly paradise, an image made permanent through architecture and actual through the charitable public service it shelters.

Across the Arno Brunelleschi apparently intended to achieve much the same effect at his church of Santo Spirito; as built, the church differs somewhat from the master's intention, in part because of the interventions of his follower, Antonio Manetti, who was charged with completing it. But it differs urbanistically from the initial proposal in one substantial way: Brunelleschi had intended that the new church face north, toward the Arno, and be connected with the riverfront by a wide piazza not unlike the one at the Annunziata.[30] This would have been an unprecedented, monumental urban connection with the water and the distant view, anticipating by a century Sansovino's framing of San Marco by his Library. The project never got far, and in the event the church was turned 180 degrees toward the south, away from the river, fronting onto a much more informal piazza. Ideas such as this, however, echo across generations, becoming the seeds of later interventions in other places.

In achieving his virtuous order at the *Ospedale* Brunelleschi deployed the latest means of art, including his "rediscovery" and perfection of perspective drawing. The novelty of Brunelleschi's perfecting the art of perspective was that he found a rational way to accurately represent three-dimensional space on a two-dimensional surface. Indeed we are now so used to seeing space correctly presented to us in paintings and drawings, not to mention photography, that we forget how difficult it was to do this objectively in the early fifteenth century. Since Brunelleschi was also an architect, he inevitably saw real space perspectively, and so for him an ideal architecture, whether the inside of a church or the outside of a piazza, looked like the orthogonal, rhythmically receding world he loved to draw. But he was not so naive as to not recognize that that highly ordered orthogonal world shifted to something much more complex when one moved off the ideal axial vantage point. The beauty, harmony and peace we find in the piazza Santissima Annunziata comes especially from

Fig. 3.2 Piazza Santissima Annunziata

finding those moments when we align ourselves, or become "centered," with that ideal world and watch it all fall into place like a painting before our eyes.

Brunelleschi's Florence in a sense indeed *became* designed, in that it was precisely orchestrated and resembled the world of Renaissance drawing and painting, but virtually all of this achievement was available to the urban public mostly at the level of facades. The piazza Santissima Annunziata would wait another century before the mirror to the *Innocenti* was built, and another century again until the Annunziata would get its outer loggia on the square (in front of a new atrium). It is homage to his vision that the *Ospedale* would compel successors in the two ensuing centuries to complete its original intention. During his lifetime it was only inside churches that Brunelleschi's ordered view of the world fully enveloped and shaped one's experience in the way that he intended.

It was this Florence shaped by Brunelleschi and Michelozzo, enriched by the sculptures of Donatello and Ghiberti, and illu-

minated by the frescoes of Masaccio that Alberti found so convincing as the home of a nascent renaissance. It was an architecture conditioned by a pre-Mediciian and early Mediciian politics, but it found its imagery outside of local politics in the ideals of the classical past, and it was achieved by myriad political forces, from lay confraternities to powerful mercantile guilds, wealthy bankers and religious orders. There was a complex tension of forces that worked against overarching planning but at the same time fostered widespread high standards. When the Medici finally achieved dynastic power, the nature of the urban interventions changed, but fortunately without eradicating the earlier achievements. Indeed they continued to build on them, but with different intent.

The final establishment of the Medici dynasty as hereditary rulers of Florence that happened with Cosimo I's ascension to power in 1537 not only changed the nature of leadership in the city, it changed the perception of power in the city's architecture. By the time Cosimo became Grand Duke of Tuscany in 1569, no longer was there much pretense about maintaining an aura of participatory government as Lorenzo de' Medici had done seventy-five years earlier. Much had happened in the intervening decades, with the family forced out, and forced back in on several occasions, and Cosimo represented a decidedly stable ducal leadership.[31] Not that the earlier Mediciian legacy was to be forgotten nor the intellectual and political context from which it emerged ignored, but those days began to ossify into legend as they became more and more remote. The new rule required new metaphors, even if drawn from the same sources—such as Alberti, for instance.

> [The palace] of a tyrant, being a fortress rather than a house, should be positioned where it is neither inside nor outside the city. Further, whereas a royal dwelling might be sited next to a showground, a temple, or the houses of noblemen, that of a

tyrant should be set well back on all sides from any buildings. In either case an appropriate and useful guideline, which will lend the building dignity, will be to construct it in such a way that, if a royal palace, it should not be so large that it is impossible to throw out any troublemaker, or, if a fortress, not so constricted that it resembles a prison more than the apartment of a fine prince.[32]

Alberti's description of the setting for the house of a tyrant could apply directly to the Medici's power base at the Palazzo Pitti in the Oltrarno. The shift in power resulted in a conscious shift in urban emphasis. The Palazzo Vecchio became the "Old Palace" precisely because Cosimo stayed there fairly briefly at the beginning of his reign, moving eventually to the palace acquired from Luca Pitti (its design sometimes attributed to Brunelleschi) across the river in Florence's equivalent of Rome's Trastevere, the Oltrarno. The shift has left significant marks on the whole urban topography between the old and new settings of power, not the least of which was the amount of upscale building in the previously working-class Oltrarno as the Medici courtiers followed their prince–tyrant across the river.

New bridges were built to connect either side of the Arno; the Pitti Palace was more than doubled in size, its mammoth bossed masonry blocks extended in both directions across its facade, while a new court was added in the rear that transformed the rugged forms of the urban exterior into a more polite rustication toward the garden. New government offices were built between the Palazzo Vecchio and the river around a compressed open court—the famous Uffizi *U* that now houses one of the world's great museums. And between the Palazzo Vecchio and the Pitti the court artist–architect Giorgio Vasari designed a raised, private enclosed corridor (known as the *corridoio Vasariano*) that threaded the Uffizi, emerged to run one floor above

street level along the Arno and across the Ponte Vecchio, negoti-
ated the private tower of the Mannelli family immediately upon
reaching the Oltrarno, disappeared into the urban fabric of the
area until it reappeared across the facade of the graceful little
church of Santa Felicità and disappeared again as it found its
way to the security of the Pitti Palace.

There is perhaps no more telling legacy of Cosimo's reign
than the *corridoio*, built in the remarkably short span of six
months. Simple and effective, mostly discreet but occasionally
conspicuous, prudent but perhaps also just a bit paranoid, it
was novel but still had its roots in Mediciian family history.
When the second Medici pope, Clement VII, fled from the Vat-
ican Palace to the secure rock of the Castel Sant' Angelo during
the Sack of Rome in 1527, he ran along the open passage at the
top of the Leonine wall that stretched across the north side of
the Borgo and was a tempting target in purple for the imperial
arquebussiers. Cosimo preferred instead a more secure en-
closed escape route from a vulnerable position in the heart of
town to his fortified palace that was "neither inside nor outside
the city"; it seems he was worried more about attack by his fel-
low citizens than an invading army. In stitching together two
remote nodes of power for his private comfort and safety,
Cosimo with his *corridoio* reoriented the focus of Florentine
urbanism from the sanctified public realm of Brunelleschi's pi-
azza Santissima Annunziata to the daily exigencies of a ruling
family. Even the wings that shape the dignified court–piazza of
the Uffizi, which owe much to Brunelleschi's *Ospedale degli In-
nocenti* in concept if not form, seem to draw focus away from
the adjacent Piazza della Signoria toward the semiprivate realm
of the offices.

Apart from these interventions, Cosimo I and later Medici
rulers refrained from drastically altering the urban fabric, in-
stead inserting monuments (such as their mammoth family tomb

behind San Lorenzo) that reverberated little outward to their context. In this they avoided the appearance of continually re-designing Florence as the popes would do in Rome, and apart from some drastic interventions of the nineteenth century, the city fabric even today sustains that delicate equipoise between the ordered (mostly the result of the Roman grid) and the "organic" (the result of medieval growth) that fifteenth-century humanists would have known.

Where the whole of Florence instead indeed looks most "designed" is in its skyline as seen from the surrounding hills, as clear a schema of what the city valued as any Roman piazza could be. Interestingly the Florentines must have been conscious, in their valley, of how the city would be perceived to visitors arriving from across those hills all around—and one never has a second chance to make a first impression. From a nearby vantage point such as the lovely monastery of San Miniato, just outside the Porta San Niccolò and across the Arno from the city center, Florence's urban values are precisely diagrammed for us in profile. Looking down, we see a datum of tile-roofed "fabric" buildings all of more or less the same height, whether humble housing blocks or grand Renaissance palazzi, all serene, stable and consistent like the drone behind a Gregorian chant, which together define the compositional ground from which emerge the soaring twin towers of civic virtue: Santa Maria del Fiore with its Campanile, and the Palazzo della Signoria with its own bell tower.

In its clearly orchestrated skyline, in the calculated restraint of its Renaissance architecture, even in the cautiously limited palette of colors in which its stucco is painted, Florence is like a meticulous, penetrating painted self-portrait that reveals the aspirations and persona of its author. No other city, it could be argued, seems so perfectly under control, and no other Italian city so easily appeals to first-time visitors. *Sprezzatura* is the Italian

Fig. 3.3 Panorama of Florence

word for effortlessness that Baldassare Castiglione used in his High Renaissance manual for the courtly class, *The Book of the Courtier*, and he used it expressly in the sense of the art of hiding the effort that goes into a work of art. *Sprezzatura* therefore isn't the result of insouciance but of labor, albeit hidden. As a city realized over the course of centuries, even millennia, Florence evinces a kind of *sprezzatura* of its own, one aimed toward Aristotle's Golden Mean, the point between extremes, a calculated middle ground. Austere but without severity, romantic but not too much, deeply religious but with an eye on commerce, ordered thanks to the Romans but with medieval moments of irregular, seemingly organic planning, Florence represents a kind of synthesis that makes many strangers long to be citizens. Perhaps it was only briefly in the eighteenth century, with visitors such as the ebullient painter Fragonard, that dour sober Florence seemed out of sync with Western culture's dominant rococo sensibilities; today, however, it is overwhelmed by a tourist industry that can't seem to get enough. Through the finely tuned, almost obsessive sensibilities of Florentine patrons

and architects we see how directly great cities grow from the aspirations of those who make them, how the built environment really does represent national character, and how very simple are the principles by which such a city is made. Well-traveled Florentines such as the fifteenth-century merchant Benedetto Dei were confident they had gotten it right on all counts.

> Beautiful Florence has all seven of the fundamental things a city requires for perfection. First of all, it enjoys complete liberty; second, it has a large, rich, and elegantly dressed population; third, it has a river with clear, pure water, and mills within the circuit of walls; fourth, it rules over towns, castles, lands, people, and communes; fifth, it has a university, and both Greek and accounting are taught; sixth, it has masters in every art; seventh and last of all, it has banks and business agents all over the world. Venetian, Milanese, Genoese, Neapolitan, Sienese, try to compare your cities with this one![33]

SIENA

Among the cares and responsibilities that pertain to those who undertake the government of the city is especially that which regards the beauty of the city.

—The Constitution of the Commune of Siena
Translated into the Vernacular, 1309–1310,
quoted in Waley, *Siena and the Sienese*

Siena's origins date back to Augustan Rome, when it was known by the name *Sæna Julia*, but as rivals of the Florentines, staking out their claims of Romanness could lead to ever more elaborate assertions of ancient legitimacy. Florence after all did not claim to be as old as Rome but simply to have been founded

in the waning years of the Republic, before the corruption of the empire. The medieval Sienese, however, made much of assertions that they had been founded by Remus' twin sons, Aschius and Senus (whose own story parallels closely the legend of their uncle, Romulus), even adopting the she-wolf with suckling twins (the *lupa nutrix*) as a civic emblem to reinforce the mythical Roman connection. Several versions of the *lupa nutrix* were set up in the city, the most prominent one on a salvaged antique column, in front of the town hall (the Palazzo Pubblico).[34]

Unlike Florence, though, this southern Tuscan city, between the arid Crete region to the south and the lush Chianti valley to the north, evinces little in its plan (as far as we know) that would be characteristic of its Roman origins as a founded town. (Even if the fifteenth-century Sienese humanist Francesco Patrizi, in his short treatise on the city's origins, would claim that one of the city's districts took its name *Camollia* from the Roman general who had repulsed the Gauls, Furius Camillus.[35] The general appears again in a fresco of Roman heroes in the Palazzo Pubblico in the sixteenth century.) Confronting a more challenging topography than the level valley of the Arno, this earthy city is wholly different in urban form than its archrival, with no evidence of an *ex-novo castrum*'s grid. Instead Siena's three districts—the *Terzi* ("thirds") of *Città*, *San Martino* and *Camollia*—are draped over the ridges of a Y-shaped group of hills, the principal streets following the contours and sloping gently, with the minor ones crossing them, rising and falling sometimes dramatically. At the confluence of these three ridges lies a natural saddle, like a collector or a basin for the rivulets that are the major arteries that, winding, essentially parallel the ridges. These major streets converge in that remarkable bowl of a space that is the Piazza del Campo, the literal and metaphorical heart of the city. Above the Campo on the highest of the ridges in the *Città* district hovers the miraculous Duomo,

Fig. 3.4 Siena,
aerial view of the
Piazza del Campo

dedicated to the Virgin of the Assumption, in its striped white
and green marble facing a luminous contrast to the ruddy brick
and tile of the city fabric that spreads below her, a fabric that
seems to grow directly from the earth that slopes down to the
gentle green valleys all around.

This hilltop site had obvious defensive advantages but cre-
ated practical problems that Florence in its valley along the
Arno River avoided. The principal problem was access to water,
especially as the city's population grew. The challenge of bring-
ing water to Siena led to a native wealth of able hydraulic engi-
neers, who set themselves also to other challenging mechanical
problems. Brunelleschi exchanged ideas with the most notable
of these, who went by the name Taccola (he was born Mariano
di Iacopo), "the self-styled 'Archimedes of Siena,'" who wrote in
Latin and frequented Sienese humanist circles and was on inti-
mate terms with artists such as Iacopo della Quercia.[36] "Taccola
appears to have displayed his greatest originality in hydraulic
applications. . . . In the fields of water control and water con-
veyance (*de aquis stringendis*), Sienese engineers had acquired
expertise and obtained results that few other towns could
match."[37] Below the fabric of the city, some sixteen miles of un-

derground tunnels known as the *bottini*, built largely between the thirteenth and fourteenth centuries, conveyed water from various local and distant sources. But in the popular imagination an abundant underground river of clear water known as the Diana flowed within the bowels of the city's hills.[38] Since Diana was a chaste goddess of mythology, she made perfect sense as the chthonic complement to the city's aboveground dedication to the Virgin Mary.

Siena's three districts are divided into smaller neighborhoods, or *contrade*, whose numbers have varied over the centuries, from forty-two in the fourteenth century to seventeen since the late seventeenth century. These *contrade* evoke even today profound loyalty from their residents, only just less than that accorded the city itself. Residents are baptized in one of the public fonts of the *contrada*, in marked contrast to the Florentines, who had claimed their communal heritage for centuries by all being baptized in the great central Baptistery of San Giovanni. Each of these fountains, much like those of Venice's neighborhoods, speaks of the precious quality of water on these hills. Most colorfully we know the *contrade* today by their representation in the famous Palio horserace that takes place in the Piazza del Campo twice every summer, an event that surprises visitors by the passion it continues to evoke. On an architectural scale the urban impact of these small local centers can't be ignored in shaping the character of the broader harmonious city fabric: Siena is both an aggregate of these neighborhoods and a corpus with many members.

On the ancient via Cassia coming from Rome a visitor is welcomed by an image of the proud tower and bulk of the town hall set into the welcoming crux of the Y. The building's opposite face, its true front, is oriented to the civic center of the Piazza del Campo. Approaching from Florence, the Sienese present one with a more circumspect image: the massive bulk of

San Domenico, the *castello*, and imposing walls, all casting a wary eye on those persistent rivals from the banks of the Arno only 54 kilometers away. But from wherever one approaches, Siena looms proud and serene like a great ship on the rolling green Tuscan "sea."

Similar to all of the cities we are discussing, Siena had an inextricable relationship with its surrounding territory. Known as the *contado* because of the noble *conti* who maintained formidable castles (often to Siena's annoyance) throughout the region, the landscape and its towns and villages made vital contributions to the city's wealth, health and prestige. "Siena was dependant on these territories for taxes, timber, food and military manpower, and in turn promised to maintain peace, security and justice."[39] The city was fully conscious of the importance of this relationship, and in fact the depiction of subject towns formed an important part of the decoration of Siena's principal civic meeting hall. The outlying territories not only provided practical necessities, they also were expected to make symbolic contributions to Siena's ritual life, wax or candles being one of the principal gifts offered especially for the important Feast of the Assumption. These ties bound city and countryside into a consciousness of their mutual dependence and shared identity: Whatever benefited or harmed the city had the same effect on the *contado*, and vice versa.

The city's prominent position on the hills and the way the streets negotiate the contours have given Siena a certain urban drama that flat Florence lacks. The central Piazza del Campo perfectly embodies this theatrical air, almost recalling in form a Roman theater, and is entered through passages that in most cases are not unlike a Roman amphitheater's *vomitoria*. Our observant sixteenth-century traveler Montaigne (who came to Tuscany to seek out the mineral waters and baths that could cure his kidney stones) was enchanted by Siena's main square,

and was highly alive to its simultaneously sacred and theatrical dimensions.

> The square in Siena is the most beautiful that is to be seen in any city. Mass is said there every day in public, at an altar in view of all the houses and shops round about, so that the artisans and all these people can hear it without leaving their place and abandoning their work. And when the elevation [of the Eucharist] takes place a trumpet sounds to give notice to all.[40]

The harmony of the Piazza del Campo in Siena was not created by accident. Private palaces, sometimes churches and even the Duomo for years had been used for meetings. Eventually the area of the Campo was cleared for its amplification and construction of a purpose-built Palazzo Pubblico, or Public Palace, in the 1290s.[41] Strict planning laws enacted in 1297, when this new town hall was built, controlled the height of buildings around the square, materials (brick) and even the window heights and shapes. This continuity had as much a political and symbolic as an aesthetic purpose (representing the harmony of the society that frames the leaders of government or the suppression of individual interest in favor of the common good). Its undisputed success, despite the vagaries of its realization through centuries of building, lends weight to the idea of giving the design of shared civic space over to the public trust rather than to individual whim.

> In a category of its own, surrounded by a special protection verging on that accorded to a religious site, was the Campo, the *campum fori* as it was called, the classical vocabulary conveying a special dignity. There were officials appointed "pro custodia campo fori", their duties being to keep the Campo clear of stones, bricks, timber and dirt and to prevent such activities as

Map 3.2 Madonna della Misericordia overlaid on the Piazza del Campo. The Palazzo Pubblico corresponds to the position of the Madonna's head and shoulders

slaughtering and skinning animals. . . . The wardens' functions extended to the streets immediately adjoining the Campo.[42]

The Piazza del Campo, the ostensibly secular forum for the Sienese republic's citizens, is spread out before the facade of the Palazzo Pubblico almost like a welcoming embrace. Indeed the shape of the piazza was thought to represent the spreading cloak of the Virgin, an image recalling the popular painted theme of the *Mater Misercordia*, or Mother of Mercy. Nestled in her protective embrace, the painted images usually showed saints and citizens (prominent and otherwise) at a much smaller scale, huddled together under the sign of her beneficent charity, sheltered within her broad cloak and implicitly blessed by the child Christ.

One could almost see the fifteenth-century Loggia–Chapel attached to the facade of the Palazzo Pubblico (from which Montaigne would have seen the host elevated) as standing for the

figure of Christ. This "cloak" spread out as the piazza at the same time has its brick pattern divided into nine panels by stone strips, representing the council of The Nine, the elected leaders of the city at the time of the piazza's paving. The dual nature of the space and the town hall behind it, sacred and secular sometimes simultaneously, is replayed again and again in architecture and symbols. The building also occupies a complex pivotal role in the city fabric. Its facade gives onto the piazza, as we have seen, a space nestled in the very crux of the city's three districts, but the great Y of the urban fabric also means that this position opens it up, on the back side, to the valleys between the ridges and their landscape. This hinge position made its rear facade the natural inviting backdrop to a great market of the produce brought in from those verdant fields that the built-up districts frame, suggesting the deep interdependence between the city and countryside that sustained it.

We will spend our time inside the Palazzo Pubblico in the two rooms that arguably are the building's most important, both for their functions and decorations. Entering from the piazza (the building's north side), to our left we find an ample courtyard where the horses prepare for the Palio. Ascending the stairs to the right, we arrive at the main floor, the *piano nobile*—if we continued our ascent we would arrive at the south side of the building and the *secondo piano*'s great loggia looking out beyond the market below to the green valleys to the south. On the *piano nobile* we pass through a series of rooms fronting the piazza to make our way to the rear, below the great second-floor loggia. The larger of the two rooms corresponds in size exactly to the loggia on the floor above, and this great hall opens then to one of the most important fourteenth-century rooms in Italy.

Around these two great adjoining rooms in the Public Palace abundant frescoes articulate the worldview of the government's leaders. In the larger *Sala del Consiglio* is the famous painting of

the paid mercenary (*condottiere*) Guidoriccio on horseback (a work whose history and authenticity is much debated of late) riding past conquered territory. It is positioned near the greatly damaged map of the world that gave the often-used name to the great hall, the *Sala del Mappamondo*. Simone Martini's grand *Maestà*, the Madonna of Majesty, is in the same room on the wall opposite the Guidoriccio. And in the smaller adjacent meeting hall—the so-called *Sala della Pace* or *Sala dei Nove*, the Room of the Nine—is the famous fresco cycle by Lorenzetti that illustrates the relative effects in allegorical terms of good and bad government. This last is a remarkable cycle: It may be the first monumental fresco on a secular theme since antiquity. It shows a wealth of detail about ordinary daily life in an ideal fourteenth-century commune, and it provides an unparalleled document of the high aspirations of the Sienese people roughly a decade before the Black Death would halve their population and crush their optimism. Looking seriously at this fresco is the visual equivalent of reading the paeans to Florence by her civic humanists. As we will see, it is one key to understanding how this extraordinary urban place saw itself.

Before we enter the *Sala dei Nove* the nature and decoration of the *Sala del Mappamondo* (formerly more usually known as the *Sala del Consiglio*) merit more attention. The council that gave the room its original name was a body of 300 representatives of the city's *terzi* (100 per *terzo*). This body was supplemented by a group known as the *radota* (fifty representatives from each *terzo*) with the *Podestà* presiding and a *Capitano del Popolo* also in attendance. The Nine and representatives of the guilds brought motions before the council. Thus a rather large group was in attendance for these regular meetings, and the room was almost like a minipiazza or forum for the building of the Palazzo Pubblico, in a way analogous to the role of the Piazza del Campo outside for the city at large. Lit by four large

windows to the south (corresponding to the four bays of the loggia above), the room also opened back toward the piazza and the north through the arcaded wall of a large chapel and the room beyond. The prominent presence of the chapel and Martini's *Maestà* filling the east wall of the hall kept the realm of the sacred present in the mind of all who debated and deliberated in the room. This aspect is reinforced by what is left of an inscription at the base of the fresco, where the Virgin says in part,

My beloved bear in mind
When your devotees make honest petitions
I will make them content as you desire,
. .
The angelic flowers, the rose and lily
With which the heavenly field is adorned
Do not delight me more than good counsel[43]

Like Duccio's more famous panel painting of the *Maestà* formerly in the Duomo, Martini's fresco includes the four patron saints of Siena as petitioners to the Virgin, thus specifically locating the scene of the exalted theme in the host city. Yet the role of the artwork in the life of the council is plainly evident in the prominence accorded it. It dominates what was likely the orientation of the room toward the narrower eastern end, forming the literal backdrop to the *Podestà*'s chair on a presumed rostrum with the other speakers it supported and was therefore a metaphorical backdrop to all political life. All motions, all petitions, are ultimately, implicitly, offered up to the city's protectress, and she in turn warns sternly against "whoever deceives my land."

Not only was the civic council chamber enriched and made sacred by a large frescoed Madonna, but an actual liturgical space was set up within the palazzo that must have been used in

part to formally ratify council decisions with a sacred ceremony. The *Sala* opens to the north (toward the piazza and opposite the windows to the south) onto an internal chapel; in the *intrados* of one of the arches into the chapel Taddeo di Bartolo painted a *veduta* of Rome sometime between 1407 and 1414.[44] Passing metaphorically "under Rome" must have given the civic ceremonies a virtual papal seal.

The sense of drama of the piazza and stagelike quality of the *Maestà* no doubt suggested the cruel reversal of meanings that Cosimo de' Medici imposed on the great *Sala* after the Florentines definitively brought the city under their sway in 1555. When Cosimo I visited the city for the first time as duke in 1560 he had the great hall set up as a theater, with galleries and a stage, transforming the complex metaphor of civic theater into simple entertainment. Performances continued to be given there throughout the seventeenth century, including the first opera staged in the city.[45] No doubt the Sienese, who were forced to witness that first performance in 1560, found it a bitter pill. The civic meanings that cities encouraged for centuries were often the very images usurped upon their conquest.

The *Maestà* forms a counterweight to the chamber of the Nine. In the north corner of the west wall a door opens to the home of Ambrogio Lorenzetti's magnificent allegory the *Effects of Good and Bad Government* in the *Sala dei Nove*. The *Sala dei Nove* is therefore entered from the *Sala del Consiglio* by a door under the Guidoriccio; the room, like the great hall, has a window that looks out away from the piazza and toward the countryside to the south instead. Upon entering the room one is confronted on the opposite wall with the Bad Government part of the fresco, a frightening image with its devilish ruler and attendant Vices.

Why would this make sense to present first to the visitor, and opposite the view toward the *Maestà*? To understand in part, one should turn and look back at the well-governed city: It fills the wall above the entry door, saying in effect that one has en-

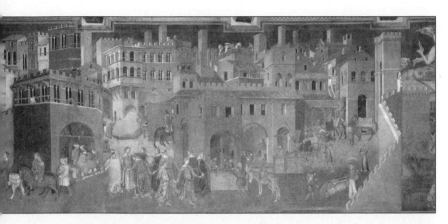

Fig. 3.5 Ambrogio Lorenzetti (ca. 1311–1348), *Allegory of the Good Government: Effects of the Good Government in the City* (1338–1339)

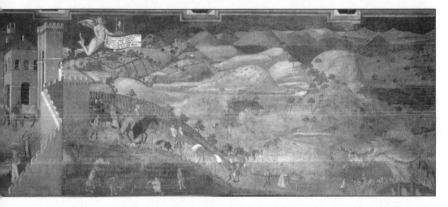

Fig. 3.6 Lorenzetti, *Effects of the Good Government,* detail of country scene

tered this room from the well-governed city, which is none other than the real Siena outside the palazzo's walls. But, as we have seen, the Virgin herself admonishes in her fresco as much as she protects, and so the visitor—and the politicians—are pinned between in effect a promise and a warning. To the right on entering the allegory of Good Government begins with a whole wall dedicated to the Virtues attendant on the good city and the ruler of the city, designated as *Bene Comune,* or the Common Good.

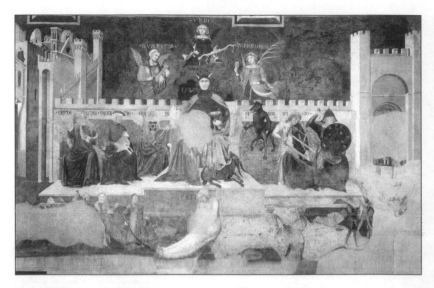

Fig 3.7 Lorenzetti, *Allegory of Bad Government*. Fresco

Above the ruler (who is an allegorical figure rather than an actual representation of a prince, since Siena was in fact a republic) float the three Theological Virtues. He is surrounded by the initials *C S C V* (*Commune Senarum Civitas Virginis*, Commune of Siena, City of the Virgin)—an inscription that reinforces the interpretation of the shape of the Piazza del Campo as representing the protective cloak of the Virgin. The image of the *Mater Misericordia*, the Madonna embracing saints and citizens in her cloak, was especially invoked in time of trouble—and there were many such times in that dangerous century. Here in the seat of secular power the role of piety was inescapable and interwoven with that of civic governance.

Bene Comune is vested in black and white to recall the graphic two-colored clarity of the city's shield (*balzana*) and he sits on a chair—really a bench—draped in an elaborately patterned fabric, flanked by six Virtues, three on either side. On his far right is Peace, an almost classical figure languidly re-

clining in obviously tranquil contentment; next comes Fortitude and Prudence; on his left are Magnanimity, Temperance, and Justice with her usual attribute of a Sword, which represents the authority implicit in the administering of justice. Surprisingly on the opposite end of the same wall we find another Justice—but this is a much more complex allegorical figure, and one intertwined with a bigger almost narrative sequence. She is ruled over by Wisdom, and she occupies a seat (draped in fabric) analogous (albeit slightly smaller) to that of *Bene Comune*. This Justice is the very figure of equanimity and civic virtue. She seems to hold the scales of balanced judgment (suspended from a springy armature mounted to the back of her chair). From the scales two ropes are passed down to a figure of Concordia, who with her left hand (her right seems to be playing something like a dulcimer) then hands the *entwined* ropes to a rather long chain of citizens, who finally entrust the ropes to the good ruler. They are attached to the bottom of his scepter: His authority therefore comes from a chain of citizens who have inherited balanced justice through *concordia*, guided by wisdom. The women dancing in the frescoed piazza—the "cords" wound into a "chord," the inscription in the fresco with the word *sacorda* ("joined together")—all point to Concordia's vital political role.[46]

We have encountered the idea of Concord in humanist thought as the resolution of Discord, the two together generating Harmony. This musical ideal was often used as a metaphor for the ideal of a city or state in which all citizens and interests are resolved into a harmonious political fabric. And this communal fabric was explicitly evident in the physical fabric of the city, the one in the piazza outside the Palazzo Pubblico, but also in the painted architecture of this fresco. The early fourteenth-century preacher Giordano da Pisa stressed that "Unity and order and concord make great strength."[47] Concord emerges

again in the choreography of daily life in the image of the well-governed city's painted piazzas and streets. Even after Siena fell to the Florentines two centuries later Concord would echo through the fabric until the eighteenth century from the many women's religious houses where music was encouraged as perhaps nowhere else in Italy.[48] Back in the real piazza Jacopo della Quercia's Fonte Gaia, dedicated to the Earth goddess, also represents the Virtues, and as part of a fountain, these women are therefore understood to be actually generative of civic life. As we have seen, Siena on its hills was uniquely and vulnerably dependent on difficult-to-obtain water, and water symbolism—especially in this fountain that postdates Lorenzetti's work by more than a century—was deeply meaningful.

The two parts of *Effects of Good and Bad Government* are structured similarly in order to stress their distinct differences. The Good and Bad portions of the frescoes show the city itself and its surrounding countryside, the *contado*, as part of one continuous narrative, thereby stressing their mutual dependence. Since the frescoes are concerned more with effects than causes, the specifics of how a good or bad government actually functions are left somewhat to the imagination, although undoubtedly "good" government was understood to be that practiced by the patrons of the fresco, while "bad" (Tyranny) was almost anything else. What is portrayed regarding rulers are their respective virtues or vices in the form of allegorical figures, and it is these virtues or vices operating through the daily lives of the citizens that supplies the principal theme and catalysts of the cycle.

What the daily life in the city truly seems to be about, judging from the action of the painting, is work: Laborers, merchants, farmers, artisans, professionals, all ply their trades with zeal under the benign protection of the Good City and its governors. The most important sign of the health of a city apparently

is the fact that people are working. The city is kept in good repair because of the masons shown building and maintaining its buildings; the city eats because farmers farm the land and sell their produce in the city; the cobbler cobbles, the teacher teaches. While ostensibly celebrating good government, Lorenzetti labored to represent the life he knew well as an artisan, that of craft, toil and earning, and with the variety he accords the range of labors represented he has made a veritable homage to medieval trades. While he was not unique in his representation of the trades—remember the reliefs on Giotto's Campanile and also the famous Pisano fountain before the Duomo in Perugia—Lorenzetti here is novel in explicitly linking labor with the society and government that allows and sustains it and which it then reciprocally enriches.

> In exalting manual work, the artisan and practical activities codified as "mechanical arts" which form a counterpart to the liberal arts . . . , the fresco [Lorenzetti's *Good and Bad Government*] is not in the least an isolated example. Giotto's campanile at Florence and the Fontana Maggiore at Perugia, each with a different program, reveal an analogous conception of the knowledge (practical and theoretical) that is born from the new social reality: the city, where all professions are reciprocally "useful and necessary."[49]

Lorenzetti's attention to detail and the rich complexity of life he shows must have made his fresco seem very "real" to his fourteenth-century audience; he also, consciously, wrote the inscription carried by Securitas in Tuscan rather than Latin to make it accessible to a wider public. The real world is also intertwined with the allegorical in the *Good and Bad Government* tableau by frescoing only three walls of the Room of the Nine, leaving the fourth, exterior wall (flanked in the corners

by the extensions of good government of the city into the painted countryside) open through its large windows to the real Sienese landscape beyond, thereby blurring the distinction between illusion and actuality. Just as the real city of Siena is alluded to in the image of the well-governed city by the way one enters the room, so too the well-governed *contado* is extended from the fresco out through the room's real windows to the exterior landscape.

By means of this simple leap, practical politics (the actual "good" government of the Nine that takes place daily in the room) ideally merges with the painted allegorical Virtues (the figures surrounding the good governor) and the sacred realm (in the form of the *Mater Misericordia* frescoed in the preceding room and embodied in the shape of the piazza outside) in a complex sequence of scenes that iconographically convey many symbolic readings simultaneously, while their novel realism speaks directly to the humblest petitioner. As a work of art, the fresco is almost inexhaustible in its possible levels of appreciation. As a moral message, it is both a promise to the citizens and an admonishment to their leaders. As an architectural ideal, it both sums up and spurs on an urban vision that would receive additional fleshing out during the next three centuries.

If images of the Virgin and the sacred were not foreign to the Palazzo Pubblico and the Piazza del Campo, secular themes and aspirations were equally at home in the magnificent Duomo dedicated to the Assumption of Mary. Its cupola was completed by 1263, hard on the heels of the last decisive victory of the Sienese over the Florentines (at Montaperti in 1260). The facade was begun after 1285, and work continued on the apse, the baptistery below, and the nave into the fourteenth century. Montaperti and the Duomo's cupola marked a brief glorious moment of triumph for the City of the Virgin over its Tuscan rival, whose own Duomo would be undertaken in less than thirty

years as a dramatic response to this richly decorated crown to Siena's fabric. Indeed even the Florentine decision to clad their Duomo in polychrome marbles—three colors instead of the Sienese two-colored stripes—was no doubt a deliberate case of one-upmanship. Since duomos were such a notable example of civic pride for medieval communes, these two nearby cities almost couldn't help themselves in trying to outdo one another. This is why, upon hearing of Florence's audacious plans to build the then largest cathedral in Italy, the Sienese resolved that their own cathedral was not a *factum* but could be rethought and extended by boldly reorienting it. The completed nave would become the transept for a new nave at 90 degrees to the original, and the new nave would be of prodigious length and dizzying height, augmented by its towering position above the *Terzi* below.

The Commune's grand plans were dashed on a number of counts, the last and most devastating of which being the great plague of 1348. What was completed of the nave still stands today, an oddly inside-out wall on the piazza to the south of the cathedral, housing in what would have been a side aisle in an infill building for the Opera del Duomo museum. When disaster struck, the Sienese placed themselves under the protection of a miraculous icon of the Madonna inside the church, known popularly as the Madonna of the Large Eyes or less descriptively as the Madonna of the Vow. The city's leaders first officially placed the citizens and *urbs* under the protection of Mary on the eve of the battle of Montaperti, with an elaborate procession from the Palazzo Pubblico to the image, in front of which the keys to the city were placed and vows made. (Siena would repeat this gesture five times in subsequent centuries, the last being during World War II, two weeks before the city's liberation by the Allies.) This *Madonna del Voto* was in its day encrusted with gems in addition to its gold ground and presented a sparkling, truly "miraculous"

image. Like the similar Madonna of Thanks that was also venerated in the cathedral, the power of the image was visible, evident—and the architectural context in striped marbles reflected and harnessed real light for spiritual purpose in analogous ways.

The works of art the cathedral boasts are numerous, from the pavements with bold designs in black and white (the city's colors) and others fully polychrome to the great rhetorical pulpit by Nicola Pisano to the altar painting of the *Maestà* by Duccio, now sadly split up and no longer *in situ* (the majority of it housed in Opera del Duomo museum). The completion and installation of this last, a massively detailed work of remarkable narrative richness, was the occasion for a festive triumphal procession with the great opus, which traced the outline of the Piazza del Campo before proceeding to the cathedral.

> On the day on which it was carried to the Duomo [9 June
> 1311], the shops were locked up and the Bishop ordered a great
> and devoted company of priests and friars with a solemn pro
> cession, accompanied by the Signori of the Nine and all the offi
> cials of the Commune, and all the populace. All the most
> worthy were hand in hand next to the said panel with lights lit
> in their hands; and then behind were the women and children
> with much devotion; and they accompanied it right to the
> Duomo making procession all around the Campo, as was the
> custom, sounding all the bells in glory, out of devotion for such
> a noble panel as this.[50]

The pride evinced in this work of art is notable for a pre-Renaissance artist; no doubt Duccio was humble enough to have seen himself as merely the hands of divine inspiration. While the Florentines were celebrating Giotto for his naturalism, the Sienese lauded the richness of their *Maestà* and generally in their Duomo seem to have encouraged an almost Byzantine taste for

the visually miraculous. In this they were fully in accord with earlier medieval thought, like that of Abbot Suger, for example (while the Florentine attitude would ultimately herald the Renaissance that overturned it).

> Thus when—out of my delight in the beauty of the house of God—the loveliness of the many-coloured gems has called me away from external cares, and worthy meditation has induced me to reflect, transferring that which is material to that which is immaterial, on the diversity of the sacred virtues: then it seems to me that I see myself dwelling, as it were, in some strange region of the universe which neither exists entirely in the slime of the earth nor entirely in the purity of Heaven; and that, by the grace of God, I can be transported from this inferior to that higher world in an anagogical manner.[51]

Facing the cathedral is the great complex of the Hospital of Santa Maria della Scala, whose position and purpose points up another contrast with Florence. While the latter's many hospitals were as much lay as religious organizations, Siena's one great hospital served the needs especially of the pilgrims who passed the city on their way to Rome along the ancient via Cassia. Since what brought pilgrims to the city was the lure of the great relics of Rome and the cities along the way, the hospital's chapels celebrated the relics they contained, at least one of which—the Virgin's garter passed to Saint Thomas the Apostle—may have been depicted in a lost fresco on the hospital's facade facing the Duomo.[52] Other frescoes on the facade seem to have depicted the life of the Virgin, appropriate both to the hospital's dedication and the cathedral's, and extended the iconography of Mary once again into the res publica. In service to the poor and the sick in search of indulgences in Rome, in duly honoring the city's patroness and maintaining a well-governed

civitas, Siena dedicated its collective energies to the building out of the earthly paradise through charitable institutions as much as architecture.

Siena in numerous ways saw itself as a mirror of the earthly Roman Republic as much as the superterrestrial *civitas dei*, and its communal republican government was certainly well enough aware of republican Rome's history to be apprehensive about succumbing to the ancient city's imperial fate. That republican bond was evident in the city's motto, *SPQS* (like Rome's *SPQR*), found on public works such as fountains and in the deliberate evocation of Roman sculptural style in the Fonte Gaia in the Piazza del Campo or in the classical architecture of the Loggia di Mercanzia. It was a message that was also preached from the pulpit and in the piazzas, and the Dominicans of Siena were just as active as their more famous Florentine counterparts such as Savonarola in linking the city's political and military fate with the integrity of its collective soul. The public realm, or the res publica, in its built form and in its communal governance was understood to directly reflect or represent the stability and faith of its citizens, and Dominican preachers were uniquely positioned to articulate that message.

The convent of San Domenico even today dominates the approach to the city from the west, and guards, castlelike, that edge of the fabric. Just as the ostensibly secular Palazzo Pubblico in the central Piazza del Campo embodied sacred messages, the Dominicans in their house were conversely entrusted with secular responsibility.

> In its sanctuary were guarded the records of the commune, its chapels housed the city's most important lay confraternities, its doctors of theology dominated the *università degli studi*, and . . . over the centuries its inmates had included the sons of the city's wealthiest and politically most influential families.[53]

One Dominican preacher, Fra Petrus Paulus Salimbeni, member of a prominent Sienese noble family, entitled one of his Lenten sermons for the year 1478 *de republica*. In it he "blends classical ideas of the state as a corpus with the theological metaphor of the mystical body, to produce an image of the republic as a body whose members are bound together by the interests of the common good and who must therefore seek to be at peace with each other."[54] While many intellectuals in Europe who used the body–city metaphor to explain the inextricable relationship of parts to the whole often naturally saw a king or prince as the ideal head, our Sienese monk looked to a wise communal counsel to provide sound leadership and just laws. In this Salimbeni may have been influenced by the ideals of Florentine republican humanists, but he also had as evidence for his position the very harmony of the city fabric itself that had been largely created in the previous centuries and that was itself something well worth defending.

The image of Rome in its republican phase was for Salimbeni, as it would be centuries later for many of the American Founding Fathers, a model of virtue, *gravitas* and justice, and the proof was in the best citizens she had generated—the farmer–statesman Cato or the philosopher–orator Cicero, for example. Familiar with Taddeo di Bartolo's frescoes in the Palazzo Pubblico and perhaps with the patron who had commissioned them, Salimbeni grew up in a culture that was anxious to see his city mirror the order of heaven—indeed he and other Dominicans believed the citizens' very survival depended on it—"Our soul is a very precious thing, and so must have walls and towers, even as such walls guard a city."[55]

Sienese Dominicans could actually point to one of their own, Catherine of Siena, as a homegrown saint who proved the worth and holiness of her city. Florence in fact had no equivalent, and the Sienese relished celebrating her sainthood.

A city on a hill benefits as much from its position as its walls for defense, but often-besieged Siena put no less stock in its walls than did Florence. Like Florence, the city's last circuit of walls included more land than the built-up areas defined, capturing green hills and gardens as well. In the fresco *Effects of the Good Government* it is the going and coming through the walls—walls kept in good repair, it should be noted, unlike those of the poorly governed city—that is one of the main barometers of the economic health and security of the city. Like the fresco advocated, the city provided men and material for the job: "Six official *superstantes murorum et operationem* had the task of employing masons to undertake regular repairs and improvements [to the walls]."[56] It is indeed the allegorical figure of *Securitas* who flies over the city gate in Lorenzetti's fresco, her banner proclaiming that it is she who rules here, and all in the countryside can freely walk and work because of her. As Alberti would later write, "The walls were therefore considered particularly sacred, because they served both to unite and to protect the citizens." The profound symbolic effect of a circuit of walls—reassuring to citizens, intimidating to adversaries—suggested obvious moral lessons, and the very image of a city, as we saw in Rome's medieval maps, was bound up, like Jerusalem, with its walls.

> A city's walls were, like its palazzi and churches, works of art and monuments to civic pride. . . . Such awareness must have been borne even more strongly upon the friars of S. Domenico than upon their compatriots, physically situated as they were atop the western walls of the city and occupying one of its most strategic lookout points.[57]

Siena and the Sienese in the thirteenth century operated as bankers and traders on the wide European stage, just like their rivals, the Florentines.[58] After the plague of 1348, though, and

even perhaps somewhat before, this changed radically, and the Sienese afterward more often than not abandoned trade and settled in as landlords of vast territories around their civic oasis in southern Tuscany. The countryside (*contado*) in more ways than one became the prime source of Siena's sustenance. Not surprisingly then, immediately behind the Palazzo Pubblico, below the windows of the Room of the Nine and in the crease between two legs of the Y, the public market received all the goods of the countryside brought in to be sold in the town, just as the Lorenzetti fresco shows. The Sienese would understand this view of the landscape to encompass also their more distant territorial holdings, even if they couldn't be seen, extending to the west indeed all the way to Massa Marittima and the Tyrrhenian Sea. The fruits of the landscape, vegetables, meat, cheeses, wine and olive oil were a daily affirmation of the truth of Lorenzetti's allegory. Not only the city but also its verdant context were as much meaningful signs as concrete facts.

Returning to the Palazzo Pubblico, where we began, brings us full circle in understanding how the city of Siena saw herself: privileged in position above fertile valleys, privileged in her dedication to the Virgin, privileged in her sage communal government. The order and beauty of the city fabric, along with the fertility and beauty of the landscape that surrounded it, were the most convincing proofs of her blessings.

Siena and Florence stake out two distinct approaches to the making of a meaningful urban fabric. With two distinctly different topographies their profiles on the landscape created differing impressions, and each took advantage of these impressions to forge a powerful urban identity. Florence in its valley was a harmonious datum of tile-roofed dwellings punctuated by the two great poles, equivalent in importance (if unique in form) of the Duomo and Palazzo Vecchio, each with its bell tower. Siena

crowned three hills and was herself crowned by the Duomo, its contour seen from a distance defining the whole town for miles. Siena's Palazzo Pubblico settled into the crux of the three hills, and while capped by a towering campanile that dwarfed Florence's, was inherently deferential to the Duomo even if more central in location. And the Duomo was not far off, the palazzo facing the church, and its Piazza del Campo a symbolic investment of the Madonna into the city's principal public space. Florence's Palazzo Vecchio occupied a storied position at the edge of the old Roman walls over the Roman theater, and its Piazza della Signoria deferred and wrapped around the hulking building. The palazzo and Duomo both faced west, serenely ignoring each other but connected by an important straight street (the via Calzaiuoli)—they were linked and yet distinct centers of power.

What Florence and Siena most deeply share is that they saw their urban forms, and especially their skylines, as directly representing the hierarchy of their collective civic values. This is truly remarkable to us—who have effectively surrendered our cities' skylines to chance and developers for the last hundred years and more, surrendering thereby any opportunity to make them speak in other than economic terms. In examples such as Florence and Siena there is no ambiguity as to how one makes a city "read" as a pointed cultural message: Plainly, if we want our cities to actually say something meaningful that we all can endorse, we can't cross our fingers and hope for the best. Cities that speak must be designed, and we have seen how their forms can speak eloquently, like an accomplished orator, both in plan (walls, streets and squares) and in profile or skyline. But the job of the orator, as Cicero and Plato would have it, was as much concerned with *what* to say as with *how* to say it; what our cities have to say is all of our responsibility to decide, or else it will be decided banally by default.

4

Pienza

SMALL TOWN, BIG IDEA

*I am Pienza, the city that rises, new-built, on the lofty
hillside, and I myself shall tell the reason for my name.
Pius wanted me to be a city decorated with a cathedral and
filled with walls, I who had once been a small town. He
ordered the marble construction, the covered house of the
family in the first part of the fortifications, to touch the
stars. He added my name, chosen according to the custom
of the Senate, and he gave me ceremonies befitting a city
and new laws.*

—Giannantonio Campano (1462) quoted in Mack, *Pienza*

Aeneas Silvius Piccolomini, Pope Pius II, is often regarded as
the first "humanist pope." Indeed his early peripatetic career
was typical of many humanists, who sought employment with
the courts of Europe (of which the papal court was certainly one

of the most prestigious) as secretaries, scholars and diplomats
and accompanied those courts across the continent on their
wanderings and their wars. His education began humbly enough
under the local parish priest of his hometown of Corsignano,
but he soon moved on to university at Siena, pursuing the *studia
humanitatis* in addition to theology and law; he continued his
studies then in Florence with the renowned expert in Greek,
Francesco Filelfo. Contacts developed here, in addition to an ev-
idently charming and forceful personality, sent him on to a series
of appointments with various courts that also introduced him to
travel both within Italy and beyond, to the Council at Basel, and
to service in Austria and Germany, even on to England.[1] Maybe
it was all of this travel that brought him back as pope, most im-
portantly for our purposes, to his roots.

This sensitive yet driven scholar from the Sienese hills is best
known in architectural history for redesigning Corsignano, which
he renamed Pienza after himself, into a model of early Renaissance
planning. Pienza is better known to the average Italian today in-
stead as the home of a particularly fine type of Pecorino (sheep's
milk cheese), and we shouldn't completely ignore this fact, with its
suggestions of the bounty of the nearby Tuscan hills and farms
that Pius knew and loved, in our discussions of the town's archi-
tecture. But Pienza is world renowned because Pius II charged the
Florentine sculptor-architect Bernardo Rossellino with dramati-
cally redesigning the papal birthplace. It has since become a com-
monplace of art history to define that town as the first built
manifestation of the Renaissance desire for an ordered classical en-
vironment. Yet it is difficult to reconcile the actual city with the
idealized painted city views it is supposed to imitate or prefigure.

There is, first of all, in the actual main piazza a distinct vari-
ety and hierarchy of buildings, each of them "typologically
clear"—in other words the palace, church, town hall and so on
are stylistically distinct and clearly based on recognizable build-

Fig. 4.1 Piero della Francesca (ca. 1420–1492), *The Ideal City*

ing models with which the citizens of Pienza would have been familiar. And the buildings are in a sense traditional (that is, with the exception of the papal palace, they were based on pre-Renaissance styles of building). Second, the way in which one approaches or experiences the piazza doesn't really jibe with what we expect from Renaissance paintings of ideal city views. At Pienza the principal approach is from the main street that enters the piazza across its northern edge, not directly on axis with the church, as we might assume. This conditions our perceptions in ways that are, if not richer, at least more surprising and complex than the straight-on type of revelation. Third, somewhat related to the first point, architectural syntax is used here in a highly self-conscious way without being eclectic. The goal of the composition is the ordered variety that also enriched the speeches of the classical orator. How does a discursive argument proceed with the rigor that philosophy demands and the allusions that poetry requires without boring everyone to tears? It is *varietas*, or ordered variety, that surprises and delights without sacrificing logic or poetics; this embracing of *varietas* is perhaps one of the greatest lessons that architects learned from the masters of classical rhetoric. Finally Pienza as we know it was born of the love of both cities and countryside, and their

interdependence is clearer and more poignant here than perhaps in any town of comparable size we can visit today.

> A high mountain rises from the valley of the Orcia River, crowned by a plateau a mile long and much less broad. In the corner which in winter looks toward the rising sun there is a town of little repute but possessed of a healthful climate, excellent wine, and everything else that goes to sustain life. Travellers to Rome from Siena, after leaving the Castle of San Quirico and going straight ahead to Radicofani, pass Corsignano on a gently sloping hill to their left three miles from the main road.[2]

From early fourteenth-century records it seems that virtually the entire population of medieval Corsignano consisted of farmers; apart from only one citizen listed as an artisan, every other resident evidently went to work daily in the fields immediately outside of town. In effect Corsignano was a bedroom community of agricultural laborers, with only a handful of moderately wealthy aristocrats from Siena in permanent residence.[3] Aeneas Silvius Piccolomini was one of these. Having been exiled from Siena for political reasons, his father took up residence in the nearby village of Corsignano and attempted to rebuild his family's fortunes from his landholdings there; Aeneas's education and career was an important aspect of that recovery. As pope, his son succeeded spectacularly. Aeneas never seems to have resented the humble place of his family's exile. Instead the experience of the countryside and intimate contact with those who worked it instilled in him a deep love of nature that he nurtured over the course of his life, even as he pursued cultivated humanist studies. This tendency to synthesize apparent opposites such as concordant discord, city and country, the rustic and the refined finds eloquent physical expression in the rebuilt Pienza.

Pius relished the fruits of the local landscape: the sharp Pecorino cheese, often aged to a spicy pungent flavor; fresh fava beans eaten with the equally fresh and milder pecorino in the springtime; excellent wines, humbler in those days but products of the same soil that give us today the world-renowned Brunello di Montalcino; and exquisite peppery olive oil.[4] We hear that on his way to Rome two years after having been elected pope Pius was forced to stay overnight in a small town and dine on simple fare—onions and bread—from a humble peasant's home; one gets the sense that he probably didn't mind.

For all his love and knowledge of natural beauty, however, the pope who was a child of little Corsignano would have shaken his head at the insensitivity to the hand of divinity operating in the city as much as in the countryside that William Penn evinces in his *Reflexions and Maxims*, where the founder of Philadelphia writes, "The country life is to be preferred, for there we see the works of God, but in cities little else but the works of men."[5] For a Christian humanist such as Aeneas Silvius Piccolomini the best of human endeavor is as much infused with divine presence as is the natural world. Indeed more so, since nature for him is as fallen as man and requires "salvation" by means of positive human intervention, whether in the form of agriculture or architecture. In an illuminated copy of *The City of God* prepared for him before becoming pope Saint Augustine's Heavenly Jerusalem is represented in the guise of Rome.[6] Heaven could be imagined as a real city, and his predecessor, Nicholas V, saw the Vatican Borgo and the Papal Palace as "paradises." Here is an optimism about what we do as human beings in the world, a belief in our capacity for the good, the very proof of which is the sensitive balance between man and nature one finds in Pius's beloved Val d'Orcia and indeed throughout Tuscany. Paradoxically, believing in building this way has meant sensibly concentrating towns into compact units

of highly charged architectural experience that have preserved nature far better than modern sprawl, which has resulted from all of us desiring some small immediate piece of the natural landscape for our own. When towns are compact, their rapport with the landscape is a natural corollary to their design—"Let the site [of the city] therefore have a dignified and agreeable appearance, and a location neither lowly nor sunk in a hollow, but elevated and commanding, where the air is pleasant and forever enlivened by some breath of wind."[7]

The experience of Pienza really begins, as Pius would have wanted it and as many pilgrims passing by on their way to Rome would have found it, in the surrounding countryside, where we see the hill town from a distance rising above the farms and vineyards as Alberti recommends: a striking, mnemonically charged civic image carried with you as you later walk the town's streets. Walking into Pienza (since this is really the only way to enter, the gates these days being wisely closed to automobile traffic), one has a handful of options. Were we to enter from one of the two gates on the east and west ends of the main street (known today as the corso Il Rossellino), we are almost compelled to follow the street to where it might lead, but since it curves slightly, we really don't know where this may be. Clues develop along the way, such as the tall campanile of the Palazzo Comunale farther along or the brilliant sunlight that streams into the street across the piazza, which cleverly opens off to the south. A great clarity is the hallmark of hill towns such as Pienza, where streets, piazzas and gates provide clearly distinct kinds of spatial experiences, not unlike the experience of moving through a well-designed house. "If (as the philosophers maintain) the city is like some large house, and the house in turn like some small city, cannot the various parts of the house—atria, *xysti*, dining rooms, porticoes, and so on—be considered miniature buildings?"[8]

Significantly the Piccolomini Palace, which is such a crucial part of the complex of buildings on the new piazza, had its principal door on the main street, with secondary entrances on the great piazza to the east and toward little San Francesco to the west. Pius himself commented on the fact that the view through this main door continued uninterrupted through the courtyard, to emerge out a rear door across a formal garden and on to the distant landscape beyond. The palace indeed merges aspects of city house and villa; the southern facade is a transformation of the engaged pilaster system of the other three facades into an open loggia on three stories, something known at the time from Tuscan villas but rare for an otherwise urban palazzo. One example Pius would have known well was the Papal Palace in Rome. The formal garden onto which these loggias fronted was a kind of earthly paradise and meant to be seen in immediate juxtaposition to the valley landscape, both cultivated and wild, beyond. It was nature perfected, tamed by artifice into a foil to both the Val d'Orcia and the urban life of Pienza. Pius especially appreciated the *piano nobile*'s rear loggia facing south as a serene spot for winter contemplation; like a similar loggia at the Vatican Belvedere villa, it was a poignant hinge moment between two very different yet inextricably linked worlds, city and country.

The fact that the garden was a *giardino pensile*—a hanging garden—reinforced the delicate counterpoise between artifice and agriculture, both sustained by feats of structural engineering. That it was a *giardino segreto*—a secret garden—gave it allusions to images of the Madonna as a *hortus conclusus* and to Eden itself. It also, as we will see, aided access to sun and breezes as Vitruvius and Alberti recommended. Pius commented thus on the view.

The view from the three porticoes to the south is bounded . . . by towering and wooded Monte Amiata. You look down on the

valley of the Orcia [River] and green meadows and hills covered
with grass in season and fruited fields and vineyards, towns and
citadels and precipitous cliffs and Bagni di Vignoni and Monte-
pescali, which is higher than Radicofani, and is the portal of the
winter sun.[9]

The noble piazza that the palazzo partly defines is structured
like a rhetorical argument for an ideal city. Each of the five prin-
cipal buildings and one additional humble building have a pre-
cisely calibrated role to play in staking out a hierarchy and
rapport of public and private interests. The buildings achieve
this with those tools that were available to us in our brief look
at the Piccolomini Palace; the classical orders, facade materials,
windows and doors and ornament. Each building uses these few
elements in calculated ways, like the carefully chosen words and
inflections of a master orator, to speak about itself and its role in
the ensemble; the ensemble as a whole stands for the town itself
but could also stand as a model for all towns. We will move
counterclockwise around the square, after the palazzo, to exam-
ine how this eloquent argument presents itself.

Adjacent to the palazzo is the cathedral of Pienza. Its interior
is an odd mix of stylistic influences, owed in large measure to
Pius's travels in the north of Europe and his specific demands for
the building; but it is the exterior with which we are most con-
cerned. As bishop of Rome, he was obviously circumspect
enough to place the new church in a hierarchically superior po-
sition to his own family palace; and so the cathedral facade is all
of travertine, relatively finely carved and white, as opposed to
the humbler ochre sandstone of the palazzo. The classical orders
are also used here in their ideal form as fully round columns, in
contrast to the shallow flat pilasters of the palace.

Stepping inside, the most remarkable impression is one of
abundant light. Pius was familiar with many northern European

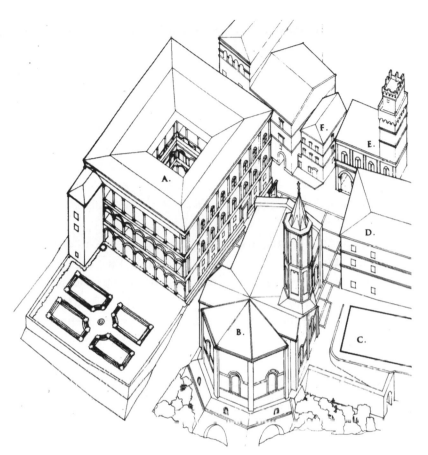

Map 4.1 Axonometric of the piazza from behind the cathedral: A. Palazzo Piccolomini; B. cathedral; C. Canon's Residence; D. Bishop's Palace; E. Palazzo Comunale; F. Artisan's House

churches of tall proportion and ample fenestration. He charged Rossellino with fusing that tradition with local materials and the classical language that Alberti was explicating. The result is a unique blend of influences that took advantage of the church's somewhat precarious position at the edge of the ramparts in order to capture constant southern light. It seems that the earlier church on this site had been oriented perpendicularly to Pius's

new cathedral; that would have given the earlier structure the canonical east-west orientation the Church preferred. By rotating the cathedral 90 degrees Pius and Rossellino dramatically perched the apse out over the steep fall to the Val d'Orcia (creating substructure problems from which the building still suffers). This opened it on three sides to brilliant sunshine, the same sunlight that falls into the piazza from either side of the cathedral. It is also the same sun that warmed Pius as he read under the loggias that overlooked his hanging garden, but in the church it acquires eschatological significance as it floods the altar with divine illumination.

The cathedral facade uses the classical orders not only as bay-defining elements, but as allusively charged devices: Stacked into two tiers, they suggest the remains of Roman theaters and amphitheaters; supporting three arches, they evoke a triumphal arch, something Alberti would exploit in his own church facades. It is this self-conscious use of the antique allusions carried by the orders that marks out the Pienza cathedral as a truly Renaissance work of architecture.

Adjacent to the church's east flank, tucked away off the southeast corner off the square, is the Canon's Residence, a sober, rather humble exercise, asymmetrically composed with its off-center door close to the square. Its facade is of stucco with an etched pattern imitating drafted masonry (a technique known as *sgraffito*, the Italian origin of our word *graffiti*); evidently the real masonry behind the stucco was of a lesser quality. Next to the Canon's Residence, near the facade of the cathedral and precisely opposite the Piccolomini palace, is the house for the bishop of the town. Pienza had been newly raised by Pius to the status of an Episcopal seat.

It is unclear from the evidence whether the building is a remodeling of an earlier structure or a quirky new building over the foundations of the old one. Yet the Bishop's Palace shares

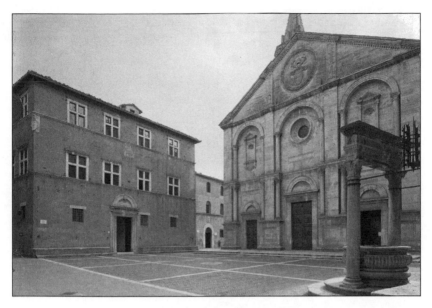

Fig. 4.2 Bernardo Rossellino (1409–1464),
Exterior of the Duomo (*right*) and the Bishop's
Palace (*left*) at Pienza. Duomo, Pienza, Italy

some common traits with its papal neighbor, at the same time distinguishing itself in ways both obvious and subtle. Notably it has the same stone cross-mullioned windows of the larger palace, no doubt a deliberate iconographic choice for these two clerics and patrons of the church. It also has an analogous door surround to the main entry at the palace, although here it faces the square, whereas Pius's own faces the Corso. The arch over the door is actually more akin to the main door of the cathedral, an obvious connection with the bishop's main charge. Sandstone like the papal palace, its facade ashlar is simply dressed, lacking the Piccolomini's carefully articulated pilaster and rustication system, and is sensibly deferential to its benefactor; it shares the palazzo's articulation by string courses into three delineated stories, albeit by more simple molded means.

The Palazzo Comunale is perhaps the most "traditional" of all the buildings on the square, a recognizably miniature version of other Tuscan and Umbrian town halls. It occupies the northeast corner of the piazza, facing the cathedral. Three arches of its ground-floor loggia give onto the piazza; this loggia was a convenient public gathering space and refuge from the sun and rain, as it still is today; upstairs is a large meeting hall for assemblies, whose three windows again overlook the piazza. The Palazzo Comunale's facade, in one sense a step down again from the Bishop's Palace because of its humbler stucco material, is in another way more refined, decorated with elegant *sgraffito* ornament that here emulates the facade rustication and pilasters of the Palazzo Piccolomini.

The Palazzo Comunale indeed is the smallest of the four principal buildings we are considering on the square, but it cleverly holds its own against all of them. It has a more prominent (from the square) campanile than the cathedral and, like the cathedral, has freestanding classical columns (Ionic) sustaining its arcade. Positioned opposite the cathedral, the palazzo is expected to act somewhat as counterweight to the dominant church, yet it is offset slightly to let the via Marconi enter the square almost on axis with the cathedral. Its three upper-floor windows are bifora (double-lobed arches) like those of Pius's palace, but these lack the stone transom bars that transform the latter's windows into Christian crosses. Its arcade restates the arches inside the cortile of the Palazzo Piccolomini, a reference reinforced by the town hall's swag frieze very much akin to the one inside the private palace—a deliberate "borrowing" appropriate to this communal palace.

And yet this arcade raises eyebrows to those familiar with Alberti's dictates on such forms (assuming Alberti's presence behind the planning of the buildings on the piazza). Alberti specifically argued against placing arches directly upon columns, since the

width of the masonry arch would, at its corners, sit beyond the diameter of the column shaft—effectively "floating" from a structural point of view. Some would argue that this anomaly eliminates Alberti's plausible role in the work, but there is another possibility. Since the church facade also has columns that support arches—but there more a decorative layer than an open screen—the seemingly naive "tectonically incorrect" solution at the Palazzo Comunale may be a subtle way (available to the *cognoscenti* only) to make the town hall rhetorically deferential to the church. It acts almost in a self-effacingly "rustic" manner.

Inside, the assembly hall upstairs has a clever, if not exactly subtle, iconography. The windows look directly out onto the papal escutcheon on the cathedral facade, and the opposite wall in the room has a fresco of the Madonna as protectress—so the escutcheon and the Madonna are engaged in a kind of familial embrace of the town leaders.

The final building to consider on the square had none of the public functions of the various *palazzi* and the church, and yet in the "argument" of the ensemble it still has a role to play. The private house flanking the town hall across via Marconi, which originally may have housed an inn (or an artisan's shop), stands for all of the citizens of ex-Corsignano. Like a case of rhetorical synecdoche, where a part of something stands for the whole, this straightforward Artisan's House completes the piazza by introducing those citizens, like the ones in Lorenzetti's great fresco in Siena, who daily sustain the city. Lorenzetti's image was one Pius knew well from his student days in Siena. In the hierarchy of facades this last piece of the puzzle introduces brick to the square, a material ubiquitous in Pienza but otherwise hidden behind stone or stucco on the piazza. A step down again even from the fairly humble Canon's Residence, the house is still enriched by string courses in stone marking out its floor levels, giving it an air of res publica dignity.

Decorum, like *varietas*, was a tool of the orator or really a constraint placed on him by convention and expectation. Our culture, which sees rhetoric as an almost pejorative term, is probably uncomfortable too with the idea of decorum: Isn't this just snobbish pretension, or worse, inhibition? Decorum indeed acquired those connotations, but largely only in the last two centuries (in architecture thanks to the early nineteenth-century arch-neoclassical theorist Quatremére de Quincy). The original classical sense, and the one grasped easily by the humanists, was at once more pragmatic (having to do with matching tone to audience—you won't reach a group of lyric poets by talking about chariot races) and poetic: anthropomorphizing concepts by attaching onto them personalities that are "at home" in different contexts. Beyond the practical formal agenda of letting one know which building is which, the decorous hierarchies of Pienza have a poetic purpose—they succinctly articulate the little town's social structure. Centered on the piazza, framed by the papal family palazzo on one side and the Bishop's Palace on the other, the church is balanced against the loggiaed Palazzo Comunale, staking out the two poles of fifteenth-century civic authority.

This ability to read the hierarchical structure of society in the public square depends on clear building "types"—that is, the essential architectural form proper to a specific function, such as town hall, church, palace and so on. Yet it also depends on kinds of architectural articulation and materials. There is a measured, progressive stylistic stepping down evidenced in this ensemble, from limestone cathedral facade to sandstone rustication and pilasters at the papal Palazzo Piccolomini on its right to the sandstone ashlar of the Bishop's Palace on the left of the cathedral down to stucco *sgraffito* at the Palazzo Comunale. The intention, and it is a meaningful one, is to create a concord of potentially discordant, competing forces, forming an integrated harmonious whole (embodied in the piazza and the *polis*

it broadly represents) that does not suppress individual charac-
ters. It is precisely the uniqueness of these discrete building
blocks that is the necessary condition for concord. As the fif-
teenth-century German theologian and cardinal Nicholas of
Cusa had said about the unity of the church, "All concordance
. . . is the concordance of differences."[10]

In purely formal terms the architect and patron's goal in
Pienza is a measured rhythmic *experience*, generated not by an
ideal viewpoint (*pace* Charles Mack) but the ever-changing view
of an individual's walking approach that begins at the sides of
the piazza, not on axis.[11] Movement dynamically structuring
perception shapes this three-dimensional composition.[12] This
dynamic understanding of space is the seed of a wonderfully vi-
tal approach to design that would continue to inform three cen-
turies of Italian humanist urbanism; we have seen it at work in
the approach to St. Peter's in Rome and along the *Possesso*
route, for example. The history of later Italian Baroque urban
design (which is really an extension of the principles set out in
the Renaissance) is the story of an attempt to invest an even
more contrapuntal, or fugal, ordered variety into both large-
and small-scale coherent planning, but its humble roots are here
in the Val d'Orcia. George of Trebizond, a fifteenth-century
Greek member of the Vatican Curia, made this analogy in dis-
cussing what rhetoricians do—"An architect builds his most
beautiful buildings by using now arches, now a plain wall, and
now bricks, now dressed stone—these being applied, of course,
with art."[13]

The piazza is trapezoidal, wider at the cathedral end than at
the Palazzo Comunale opposite. Where did this shape come
from? This is a difficult question to answer, since we cannot be in
the mind of Rossellino when he drew the plans (and not being a
trained humanist, Rossellino, unlike Alberti, articulated his ideas
not in words but in actual buildings). Yet personal experience

and what certain Renaissance humanists have said proves that there is a special challenge and merit in making a virtue of a necessity—or making a flaw into so integral a part of a design that if it didn't exist it would have to be invented, to paraphrase Bernini. The old Prior's Palace that the new Bishop's Palace replaced was at an angle to the eventual cathedral, but this certainly could have been changed if absolutely necessary. The Palazzo Piccolomini, being square and made parallel to the main street, inevitably was set at an angle to the square, since the street entered it at an angle. Yet this too was mutable, since many Renaissance *palazzi* adapt trapezoidally to oddly shaped sites; or else the street itself could have been changed. The great advantage of the splayed sides seems to be primarily in the views they afford of the landscape beyond the town, seen on either side of the cathedral. It also allows the architectural imbalance from one side of the square to the other to be absorbed by a softer geometry. And maintaining the perfection of the Piccolomini palace certainly had symbolic effect. If Alberti was right in his analogy between city and house, here the palace could become a kind of ideal city, where its internal rigor of organization and perfection of ornament was contrasted to the more complex—and maybe less perfect—world of the town that was, after all, being transformed, not rebuilt from scratch.

> The most important part is that which we call the "bosom" of the house, although you might refer to it as the "court" or "atrium". . . . The "bosom" is therefore the main part of the house, *acting like a public forum*, toward which all of the lesser members converge; it should incorporate a comfortable entrance, and also openings for light, as appropriate.[14]

Alberti provides a credible reading therefore of a house generally, and this palazzo in particular, as an urban microcosm. Since

"the most thorough consideration should be given to the city's layout, site, and outline," he also was concerned to orient both the house and the city toward the most favorable breezes and sunlight, for health benefits and aesthetics. His council on the orientation of porticoes seems to have been followed precisely in the Pienzan palazzo—"The ancients preferred their porticoes to face south, because in summer the arc of the sun would be too high for its rays to enter, whereas in winter it would be low enough."[15]

Some of the microclimatic—and microcosmic—thinking evidenced by the orientation, rigor and openness of the palazzo's plan also reflects the Roman writer Vitruvius' discussion of the layout of cities, which once again reinforces seeing the large house in this case as a small city.

> Once the walls [of the city] have been raised, the division into lots of the area contained within the walls should follow, and the orientation of streets and lanes according to the regions of the heavens. This process will be properly accomplished if, with foresight, the lanes are kept from facing into the path of the prevailing winds. For if the winds are cold, they injure; if hot, they corrupt; if moist, they are noxious.[16]

The piazza and its buildings were certainly the focus of Pius's attention, but he encouraged other projects around the town that spread his high standards to other neighborhoods and attempted to bring them all in line under the same humanist principles. The Palazzo Ammanati, for example, faces the Palazzo Piccolomini across the corso il Rossellino, and the friendly rapport between the two buildings matches the familiarity of their patrons. Giacomo Ammanati was a humanist like Pius and a close confidant. He also shared the pope's love of the life of rustic retreat, or *otium*, as the humanists called it, as an ideal environment for contemplation and scholarship. Like the buildings on the square,

the relationship between these two palaces was carefully calibrated to articulate their roles in the urban hierarchy.

Ammanati's palace shares Pius's and the Bishop's square stone cross-mullioned windows, a deliberate Christian reference appropriate for these three prelates. Stucco instead of sandstone on its two facades, its *sgraffito* ornament describes a facade system similar to the Piccolomini palace, with pilasters and rustication here revealed only by incised lines. Stone string courses divide the facade into three stories as in the papal residence, with *sgraffito* ornament below that resembles the frescoed friezes around the courtyard of Rossellino's grander palazzo. And the simply arched principal doorway opens toward Pius's own, sharing therefore in the extended view through his courtyard, across the garden and on to the open landscape in the distance.

Evidently built out of love for Pienza and friendship for Pius, Ammanati's palace continued to call him in the years after the pope's death; his letters recall fondly the beauties of the place and his enviable quality of life there. His tastes accord well with the many foreigners who today come to this part of Tuscany to buy into a bit of this world and its peace and beauty. Aeneas Silvius Piccolomini, we can say, had at least one friend and colleague in his day who shared his vision, and Pienza was the better for it.

Pius encouraged the building of a kind of Curial Row leading out of the piazza to the east, begging, cajoling and browbeating notable cardinals to also build in Pienza.[17] He seems to have intended that Curial functions could continue here "off season," the town becoming a virtual summer Vatican, and the cardinals would just have to learn to love life in the country. Some, like Ammanati, shared Pius's rustic and humanistic tastes and only too happily bought land and built. Others, such as Rodrigo Borgia, the wealthy Spaniard and notorious inspiration to Machiavelli as the future Pope Alexander VI, grudgingly did what was

required of him—paying to build the Bishop's Palace and relocating the hospital that had occupied that site—but with little love, motivated rather by pure realpolitik. Similarly the youthful Cardinal Gonzaga, who owed his elevation to the purple to Piccolomini, hemmed and hawed his way through papal harangues before finally beginning some kind of building just before the pope died—and naturally never seems to have finished.

Not surprisingly many longtime Corsignano residents were displaced by all of these acquisitions and new buildings, and Pius had no desire to ignore the ethos of the well-governed city he knew from the Lorenzetti frescoes, where all strata of society were "useful and necessary" for a harmonious city. So he early saw to building a new stretch of houses *a schiera*—rowhouses— in an apparently unbuilt northeastern corner of town for these *artigiani* whose families he had no doubt known since childhood. The buildings were of the simplest type: a workshop at street level, with a flanking doorway up a few steps that led inside immediately to a stairway to the upper residential floor. Apart from the fact that they were done at all, which is remarkable enough (we have little direct evidence of other such early Renaissance "low-income housing"), they are notable architecturally for their rational metrical disposition along a new street called *delle Case Nuove* (Street of the New Houses) and not insignificantly for the fact that they actually had a view. They faced in the opposite direction of the Piccolomini palace, toward the north, a view that the pope himself described thus.

As you look to the north diverse hills and the lovely green of forests are spread before you for a distance of five miles. If you strain your eyes you can see as far as the Apennines and make out the town of Cortona on a high hill not far from Lake Trasimeno, but the valley of the Chiana, which lies between, cannot be seen because of its great depth.[18]

Perhaps it is not coincidental that some of the land for these new houses was purchased from the brothers Giovanni and Deo Fortunato da Cortone (that is, from Cortona): Their property looked out toward their ancestral home.[19]

Pius saw Pienza as a home away from Rome, for himself and the church hierarchy, not in order to escape the Rome of ancient memory or the Rome of Alberti's new classical dreams but rather to escape the gritty reality of the mid-fifteenth-century city that was an intractable landscape of power politics and tumbledown ruins. The pope was realistic enough to have realized that, given the inevitably short span of his reign (in the end just under six full years), his impact on urban culture could be most comprehensive in a place such as Corsignano. But perhaps he intended that the lessons his experiment fostered there would eventually reverberate back to the *caput mundi*, and indeed, as we have seen, they did.

Rome, both the Idea of her and her ruined remains, was in the background of the whole humanist Renaissance. But what was it specifically about mighty Rome that Pius brought to little Corsignano? There was, first of all, his name, and therefore the name of the town: Pius's choice of name was a clever reference from his humanist studies. Recall that it was the Trojan refugee Aeneas who founded Rome. Virgil refers to him often as "pious Aeneas," since he evinced such deep respect for his family by saving his father, Anchises, from Troy's flames, and thereby also saving the family gods. Aeneas thus carried out with him not only Anchises but also the symbols of the home hearth and family ancestors. Aeneas Silvius Piccolomini was also "pious" in returning to the place where his father lived and was buried to found the town anew and invest it with a new life. He was a new Aeneas, in the role of the Trojan who founded a new Italic city that would generate Rome. Pius also brought a pragmatic desire to realize in this small town what his papal predecessor Nicholas V desired

but could not realize for Rome: the "most perfect paradise" of the Vatican district, a City of God on the Tuscan side of the Tiber. Pius recognized the intractable nature of the Roman topography, both physical and political, and saw his hometown as an easier proving ground of Renaissance ideas, a new papal city as a shining light and example to the city of Saint Peter.

The dependence of Pienza on what poets and rhetoricians had to say ought to be clear enough. But we might also notice in all of this careful coordination something akin again to musical composition. In many ways Pienza gives us a clearer idea of what was meant by the "concordant discord" we confronted in discussing Florentine humanism. Elevated music in the fifteenth century was almost exclusively ecclesiastical, and mostly polyphonic—that is, composed with overlaid melodic lines. Each melody could be relatively simple but the complexity comes from the layering of many of these uncomplicated textures atop of one another. In Pienza this happens with both the simple components of the classical language of architecture used—pilasters, string courses, cornices, window types, facade materials and so on—and the simple and clear types of buildings disposed around the main square—palace, cathedral, town hall, bishop's house. Alberti and other humanists believed that our recognition of harmony, whether visual or aural, was in what the *experience* of beauty consisted. They believed this not because beauty is in the eye (or ear) of the beholder but rather because, microcosms of the Divine that we humans are, we each possess a little of the divine capacity to perceive and understand harmony (of which God is the fullest expression). Harmony needs discord, beauty needs variety, but without concord and decorum they are all noise and chaos. The little Renaissance chorus that is the buildings on the piazza of Pienza stretch but do not break the bounds of their art, and in that there is much we can learn about classical composition.

Variety is always a most pleasing spice, where distant objects agree and conform with one another; but when it causes discord and difference between them, it is extremely disagreeable. Just as in music, where deep voices answer high ones, and intermediate ones are pitched between them, so they ring out in harmony, a wonderfully sonorous balance of proportions results, which increases the pleasure of the audience and captivates them; so it happens in everything else that serves to enchant and move the mind.[20]

Ultimately this would be mere formalism were it not for the fact that Alberti and Pius believed this nobly harmonious environment would generate an equally harmonious society. Aesthetic enchantment was but the first step in order to "move the mind." By tapping into the order of a cosmos where God, according to the apocryphal Wisdom of Solomon, ordered everything in measure, number and weight (*omnia mensura et numero et pondere disposuisti*), and where the heavenly spheres revolved to perfect music, our environment as a mirror or vestige of heaven could, they believed, have a heavenly effect on its inhabitants and orchestrate society into a microcosmic paradise of peace and justice. We are rightly suspicious of utopian experiments after the horrors of the twentieth century, but indeed the humanist definition of harmony allowed for dialogue, counterpoint and dissonance. It was directly responsible for building places such as Pienza that resonate with us moderns as the most human of environments, suggesting that something is worth learning there not only about the products of Renaissance creative energy but also its process.

What is the big idea of this little town of Pienza? While its physical form is overlaid with a rich texture of multiple humanist themes, Pienza is still at its root very clear on one thing, mostly

forgotten in the building of cities in the last two hundred years: Chance can't hold a candle to Design as a way to generate noble, beautiful, allusive and richly complex urban environments. Perhaps design first got a bad name in the nineteenth century with the grandiloquent, bombastic and overzealous efforts on the scale of Baron Haussman's Paris, or along the *ringstraße* of Vienna. The turn-of-the-century Viennese urban theorist Camillo Sitte saw the antidote to this scaleless planning in his personal notion of how medieval space was created (in a nutshell, by eye). Most cities surrendered their design to planning and zoning rules in the twentieth century (with the exception of those vast ghastly urban experiments such as Brasilia or Albany, New York), effectively designing by legislation at best; chance results were left too hopefully to happy juxtapositions of competing interests. Sitte, however, in that era fostered an underground movement that chipped away at the value of classical planning as practiced by the humanists of the Renaissance, substituting in its place a picturesque "intuitive" approach that looked for the subtle misalignments and surprise that he claimed to find in medieval towns. Pienza, though, shows us that we can, if we draw on the fullness of our cultural traditions, invent places that have both order and variety, that are both simple and sublime, that bring nobility and grace to the humble and plain, that reconcile city and countryside while compromising neither. The experience of Pienza sets the bar high for the standards of what constitutes good design at the scale of a small town or a large city; and frankly, knowing Pienza exists makes it disingenuous for us to pretend that the humble can't be invested with the noble. On the contrary, in high-minded simplicity there can be dignity and grace. It wasn't really power or money but rather ideas that Aeneas Silvius Piccolomini brought back with him from mighty Rome to his little hometown.

Conclusion

WHAT WE'VE LOST AND
WHY THESE IDEAS MATTER TODAY

*The devices in civic design that had adorned Europe—
derived chiefly from the notion that the space between the
buildings was as important as the buildings themselves—
did not jibe with American property-ownership traditions,
which put little value in the public realm. Rome had the
Campidoglio, Paris had the joyful Place de Vosges, and
New York got the marshalling yards of the New York
Central Railroad.*

—James Howard Kunstler, *The Geography of Nowhere*

*M*aybe it's not our fault. If we lack the great settings for our
public realm that Rome and Paris have it may be only an accident
of birth. After all, the urban tide had shifted all over the world
by the nineteenth century, and Rome herself produced no great
contributions to the res publica that were contemporaneous with

the marshaling yards of the New York Central Railroad. Something had changed since the eighteenth century in the sense of what cities were all about, and it is our misfortune that the great growth of American cities happened well after the Idea of the City had lost its allure to the Western mind.

THE MYTH OF NATURE

Perhaps it was in part the grand canal at Versailles that drained the City of some of its meaning. In many ways the geometrically ordered landscape of Louis XIV's château at Versailles came to have more of an impact on later urban form than would the city of Rome, and the great garden's enormous scale and complex organization took on characteristics that until then had been reserved for cities. When the renowned French seventeenth-century landscape architect André Le Nôtre appropriated the three-pronged *trinitas* street patterns of Rome to lay out the radiating garden promenades of the formerly Parisian courtiers at Louis XIV's château-as-capitol, he reduced a profoundly divine, ultimately urban metaphor to a merely formal strategy, a way of connecting one place with several others.[1]

Originally a hunting lodge for Louis XIII, the château lacked any urban context; after the court located there, a town grew up on its northern, Parisian side, along the three boulevards laid out by Le Nôtre. The trident of streets that focused on the château as one approached from Paris seemed to reverse not only the direction but also the meaning of the piazza del Popolo. Instead of the Porta del Popolo there is Louis' *apartement*; instead of Sta. Maria dei Miracoli and Sta. Maria in Montesanto there are twin stables; on the garden side a veritable constellation of radiating avenues through the bosques and parterres eradicated forever any specific symbolic intent of an urban trident.

The trident street pattern as it had first arisen in Rome under Pope Nicholas V had sacred trinitarian connotations that were very much intentional, and effectively mapped onto the Roman urban fabric a *vestigium*, a trace or reflection, of the Trinity, investing the streets of Rome with symbols of sacred mystery. Conversely the myriad radiating trident "streets" used at Versailles as garden paths, sapped of any particular symbolic content, turned the multiple-pronged intersections into abstract diagrams, forms instead of signs, removed from an urban context and translated into ornaments to a vast park. Eventually the City as an Idea could be similarly devalued by removing it from the invested meaning of a particular place, so that a superficial connoisseurship of urban form took the place of a profound urban rhetoric.

We have seen how Rome, Venice, Florence, Siena and Pienza drew on the specifics of their location to infuse the broad principles of classical form with local meaning. Instead by the middle eighteenth century the city was merely a system, a technique, a way of organizing people and functions. In a certain sense it is like the way that the hanging of sacred altar paintings in museums, separating them from the ecclesiastical context that had given them meaning, contributed in no small part to the comprehensive revaluation of painting itself as a portable investment–commodity in the nineteenth century. By extracting any artistic product from its native context its meaning not only changes, it can be mostly lost if the meaning does not evolve and adapt. And the very nature of an art, whether painting or urban design, is radically altered when its traditional means are directed toward other ends.

The radiating avenues in the "Garden as City" of Pope Sixtus V's Villa Montalto on the Esquiline hill in Rome only extended a long tradition of an urbane country life; and so too did Le Nôtre's gardens, albeit at a greater scale. Sixtus indeed may have used the yielding open spaces of his personal garden as a testing ground for the boulevards that he would lay out in Rome to connect the

city's seven pilgrimage churches. But it was specifically because Versailles *functioned* as a substitute for a civic capital when Louis XIV moved his court there that its grandiloquent potential later reverberated back to the city of Paris with the return of the court and its courtiers–aesthetes after Louis' death in the early eighteenth century. Thereafter future Parisian urbanism was shaped along the lines of Versailles, and it was this "Versailled" Paris that subsequently inspired numerous international imitators. In other words the formal urban references in the plans of Sixtus V's Villa Montalto on the Esquiline hill, within the old Roman walls, or Cardinal d'Este's villa in nearby Tivoli, only made the relationship between the works of man and the works of nature poetic. Whereas Washington, D.C., for example, drew on a garden rather than an urban model (in part perhaps because its designer was the son of a gardener at Versailles) and never quite knew how to make a city of it. Pierre L'Enfant's adapting Versailles' plan to Washington by essentially transforming the trees back into buildings (and mostly monumental ones) impoverished the urban fabric by arbitrarily applying a formal pattern sapped of its meaningful res publica–res privata intent. Arguably this urban form-without-meaning condition is one from which Washington still suffers everywhere but around the Mall.

On the Mall it has been said one could comprehend our Constitution in the arrangement of the buildings and monuments. But away from this monumental park the city has been less successful in weaving together the complex interactions of the res privata—the dwellings of ordinary citizens and their daily needs—with the res publica—the public features of not only our national but our civic life. It is in essence the inability of Washington to function as a model city for the republic, rather than the model republic in the guise of a city, that prevents it from equaling the great cities of the past. Still, the bones are there in the plan to be fleshed out eventually into something remarkable

and human, and Washington has at least stoutly defended the symbolic meaning of its skyline against private interest.[2]

Perhaps not coincidental is that, while Versailles was being laid out during the reign of Louis XIV, the military engineer Vauban was turning the art of city building into a science where "No thought was spent on the traditional question of the place's 'meaning'." The subsequent devaluation of the City as an ideal through the eventual elevation of Nature to its place by the Enlightenment intellectually bankrupted the quintessentially urban notion of Saint Augustine's *civitas dei*, substituting in its place an image of an idyllic Romantic pasture. Verification of the demoralizing effects of urban squalor was soon at hand in the nineteenth century with the Industrial Revolution, when cities such as London became ruthlessly implausible contrasts between the Terraces of the well-to-do and the warehouses of the poor. By the twentieth century the only hope for a "City Beautiful" was the planting of trees along boulevards (since we couldn't completely believe any longer in the humanizing effects of buildings), and the building of isolated classical mausolea for cultural and political institutions. The famous ephemeral "White City" of the 1893 Chicago World's Fair was a monumental park essentially without any sustaining fabric, and yet it was the best that the end of the classical Beaux Arts tradition could muster, a fleeting vision on the cultural horizon, a last monumental gasp of a depleted urban ideal on land that would remain essentially a park to this day. It was a vision of a city of monuments without fabric, or a res publica without the res privata. Meanwhile the real urban skyline of Chicago and other twentieth-century cities was surrendered to the developer and the street to the automobile. Not many decades after skyscrapers appeared on the skyline, vast expanses of landscape outside of our cities would be lost to indifferent sprawl, eradicating the very Nature a fleeing urban populace was desperately trying to inhabit.

So formal urban planning was coopted by courtly garden de-
signers and returned its strategies back to the city drained of its
symbolic content. But the City arguably also suffered from the
substitution of Nature as a model and image of paradise. By
positing Nature as opposed and superior to the works of the hu-
man hand, the easy sentimentality that went along with roman-
ticism was too ready to associate the city with everything that
Nature was not—that is, all the ills that man has generated the
more he has distanced himself from his natural state. Conse-
quently the city shrank in our collective consciousness to some-
thing not only less than but also other than the good and noble
place of our dreams and aspirations. This was mostly confirmed
by those who shaped the way in which we saw and used the
land, and the Manifest Destiny they projected onto the "unin-
habited" landscapes of the American West. There dreams could
supposedly be wrought autochthonously, by honest manual ef-
fort sustained by a spiritual clarity seemingly so unlike the natu-
rally corrupt means of city dwellers.

The antidote to this decaying spiral was always there in the
humanist city. As we have seen, the relationship between
countryside and city in the Middle Ages and Renaissance was
a harmoniously concordant discord, a juxtaposition of oppo-
sites. In the cities we have visited Nature is wholly herself in
the countryside and rarely enters the city gates; conversely ur-
ban sprawl is contained by the walls and building in the rural
contado is sporadic at best. Each realm is distinct in character
and function, and each preserves and sustains the other. Walls
preserve not only the city, but also the countryside in Loren-
zetti's fresco. Paradoxically all this is achieved under the um-
brella of the City as a metaphor for paradise; whereas, since
Nature has supplanted the urban realm as an ideal in our col-
lective consciousness in the last two centuries, we have set
about obliterating the natural landscape on an unprecedented
scale.[3]

THE CITY AND THE BODY

Given that cities bear the same logic, measurements and form as the human body . . . it is likewise important to note that the body possesses all the articulation and members observable in the city and its buildings.

—Francesco di Giorgio from his *Treatise*
in Millon, ed., *The Renaissance*

If the City lost its traditional role and relationship to Nature between the eighteenth and nineteenth centuries, something also changed between the City and its analogy to the human body. Instead of seeing in urban form a mystical, mythical and macrocosmic image of the body—like the ideal body of the Vitruvian type made famous in Leonardo da Vinci's drawing, whose proportions harmonize, literally and figuratively, with the ideal proportions of cosmic geometry and where the analogy's principal value is symbolic—by the late eighteenth century what the body provided the city was a mechanistic metaphor, useful essentially for systems of organization. It was the way the body *worked*, not what it could *mean*, that became of interest and importance to city planners. So for the French urban planner Pierre Patte streets were systems of circulation, "arteries" for the conducting of people the way blood is conducted through the body.[4] For Washington's L'Enfant it was breathing that mattered, and he thought the new capital would breathe much better with wide diagonal boulevards.

Instead the Renaissance humanist tradition saw the human body as a little world, in its most perfect form a *vestigium* of the geometry that ordered the heavens. Greek and Roman artists shaped this view and gave it canonical stature in number and measure, while the Christian tradition added the symbolic layer of a God who had become Man. Both traditions saw the body as a good, noble and quasi-divine thing, a perfect architecture shaped by a divine Architect. Thus not only were men and

women formed in the image of the cosmos, but the City by analogy embodied those transcendent formal allusions: The civic body shared the symbolic meanings more than the working mechanics of the human form.

As the body came to be understood by the eighteenth century more and more like a machine (a mechanism whose functions could be understood minutely and translated into general principles of movement and structure), the city's corporeal allusions were reduced mainly to issues of health. Good circulation—of blood, breath and traffic—made a healthy body and a healthy city, as did cleanliness, and the infrastructure—the bowels and intestines of the city—were of vital importance to keeping things working on the surface. Just as man's position in the cosmos lost its stature and symbolic dimension with the waning of mythology, and the earth lost its focal position among the sun and planets after Copernicus, the city shared the same fate, relegated to a supporting role in the story of human progress. Moreover, the mechanistic metaphors of the city, its traffic systems and infrastructure, only needed a generically biological model; after all, not only man's body but all bodies need healthy circulation, good intestines, well-structured bones. So these qualities in a city did not necessarily require human analogy (which is only useful because of its empathetic comprehensibility to us)—a city could just as easily be likened to a rhinoceros or a rodent. The point is not that the Renaissance understood the body better than the Enlightenment did—they didn't—but that they accorded it a reverence and meanings that invested the cities that invoked it with deeper resonance, and made those cities paradoxically more human than their modern successors.

COMMON DREAMS

*It is astonishing how every kind of visual communication
came to reflect the new order, how every theme and slogan*

*became interwoven. Again, however, there was no master
plan outlining some sort of propaganda campaign for the
revival of Rome. As in the development of imagery after
[Augustus' victory over Marc Antony at] Actium, much
happened as if on its own accord, once the princeps had
shown the way and taken the first steps.*

—Zanker, *Power of Images*

A subtle point of Paul Zanker's in his book on the cultural pro-
gram of the Augustan Age in ancient Rome is that those who
sustained the *princeps*'s agenda actually shared and believed in
it. Minor officials, wealthy citizens and devout freemen dedi-
cated altars, paid for sculptures and frequented the temples that
Augustus decreed essential to the city's self-image. Without a
doubt, if a harmonious city is the goal, imposing it only from
above is a strategy doomed to failure. And if this were true in a
nascent first century B.C. "global" empire such as Rome, it is
even truer for our twenty-first-century democracies. This does
not mean that great cities require unthinking execution of a col-
lective will. But it does mean that an enormous task of general
education stands in the way of recalling the humanist city from
its sleep. If the first step of education is the desire to know, how-
ever, then awakening our love for great cities may indeed have
already begun: How many tourists visit Rome, Venice and Flo-
rence and see something not just different but better than the ur-
ban culture they know? Usually that desire is all too quickly
transferred toward easy acquisition: a bottle of olive oil or Chi-
anti at the airport, or maybe something of real craft from a Flo-
rentine woodworker or Venetian lace maker. But how much
better would it be if these urban tourists came home and went
about lobbying for walkable neighborhoods, accessible and
beautiful public space or some kind of limit to sprawl—and then
even began thinking about what their cities meant, or should
mean? If we see our landscape, both urban and rural, as a result
of choice, not of fate, then in the cities we visit in person and on

the printed page we find living models for the choices we could be making.[5]

THE ARCHITECTURE OF ASPIRATIONS

We might find it uncomfortable for our secular cities today to learn from some of the insistently Christian messages hammered home in the five Italian cities we have visited; and indeed by no means can only those particular messages generate that kind of architecture. But it has been a mistake for urban theorists in the last two centuries to have effectively substituted the mechanics of politics for the values of religion as the only elevated content cities can embody. This is a mistake because political systems, if they are healthy, can ennoble architecture with positive values; but just as easily, malignant politics such as fascism have tainted the whole classical tradition in the twentieth century, and this is an enormous cultural loss.

The difference between the architecture of humanism and religion that we have investigated in these chapters and the architecture of politics and business in which we live in twenty-first-century America is that the former, even when the religion was corrupt or the learning narrow, sought to represent aspirations rather than reality. This allowed those cities to be always better than the people who made them, whereas business and politics rarely provide built contexts that transcend their immediate contingent reality and just as rarely equal the merits of the best people who made them. So we have the paradox today of being a generally more equitable society than, say, fourteenth-century Siena, but we have built for ourselves a far less humane environment.

The myths we have uncovered were not a result of the practical political systems of their respective cities, they in fact predate

them, indeed they go a long way toward also having shaped the very political structures that the architecture houses. Certainly the myths went through processes of transformation, but perhaps the worldview they embody indeed was a necessary precondition for their city's approach to religion, to government, but most especially for our purposes to the architecture of the city. They are myths as allegories, and what they reveal are a set of ideals, values, or virtues that underpin every substantial decision made about the shape of their cities and the societies shaped by the City as an Idea.

If we could imagine a city built to articulate political virtues rather than political systems or techniques, we might find our way back to the culture of Florentine civic humanists. One way to begin this process would be to remove the mission of civic architecture from pure pragmatics and give back to it some kind of transcendent value system—and these values are not as hard to find or agree on as we might think. Indeed cities could again represent without much hesitation or debate the things that the humanist tradition has always celebrated: memory, learning, justice, the good life, the nobility of the human being and human endeavor, permanence, harmony and transcendent beauty.

Great cities, as we have seen, are built to represent the best to which their culture can aspire. These ideals, dreams or myths that inform city building last longer than any master plan drawing—they can survive generations, even centuries. They form the common culture of citizens, the motivation and goal for all their urban aspirations and efforts, and are a recurring draught of inspiration across time; in the end they justify stretching the limits of our resources to create something that will far outlast us. They bring to mind the architectural historian Leland Roth's synopsis of the era of the great American architectural firm McKim, Mead and White: The turn of the twentieth century represented a time when we built "not with our surplus, but

with our essence."⁶ We must accept that the costs of building great cities can't be justified in purely pragmatic terms.

> Pius said, "You did well, Bernardo, in lying to us about the expense involved in the work. If you had told the truth, you could never have induced us to spend so much money and neither this splendid palace nor this church, the finest in all Italy, would now be standing. Your deceit has built these glorious structures which are praised by all except the few who are consumed by envy. We thank you and think you deserve especial honor among all the architects of our time"—and he ordered full pay to be given him and in addition a present of 100 ducats and a scarlet robe. He bestowed on his son the grace he asked and charged him with new commissions. Bernardo, when he heard the Pope's words, burst into tears of joy.⁷

THE CITY AS A BOOK

If there is a deep relationship between the body and the city, there is another kind of useful analogy available between the book and the city. Rome, the city as a book, can be read at many levels; similarly one could develop the metaphor of the book as a model of the urban experience, where potential narrative paths diverge and reconnect but sometimes leave us hanging. Umberto Eco posits the Forest as a metaphor for narrative experience, but the City is an even richer model for a reader's journey.⁸ If the makers of our contemporary cities can no longer read the cities of the past, how can they hope to regain the ability to write an urban landscape that equals the best we have built?

One small fragment of contemporary Rome condenses both books and cities into another kind of metaphor for the state of the culture of the City and a hope for its renewal. The early six-

teenth-century Palazzo Lante presents a recently renovated fa-
cade to the junction of via Monterone and piazza dei Caprettari
in the heart of the *abitato*, just southwest of the Pantheon. In-
complete toward the piazza, Palazzo Lante's jagged masonry
edge speaks to the family's even grander, unrealized aspirations.
Upstairs on the top floor in a small, elegant little office, Dr. Enzo
Crea maintains one of Italy's finest art book publishing houses,
Edizioni dell'Elefante.

Dr. Crea fights a lonely, but neither solitary nor unrecog-
nized, battle. He is widely celebrated in narrow circles of
cognoscenti and operates on a small field with not insubstan-
tial implications. Neither anachronistic nor mainstream, he is
a humanist publisher, a sort of latter-day Aldus Manutius,
whose reprints of beautiful ancient texts, limited editions of
new poetry and publications of new penetrating historiogra-
phy balance looking back and looking forward. In his care for
the book as a thing, as much as a "container of content," he
acknowledges in one sphere what the urban realm needs to re-
cover for itself: a reverence for the physical environment as
more than the sum total of its practical uses. To build, indeed
to make anything, is ultimately at its best a deeply meaningful
act with long-term implications for our immediate environ-
ment and cultural legacy. Perhaps for the first time in many
years we have realized this again with the problem of rebuild-
ing the World Trade Center site.

When Victor Hugo has his monk gesture from the printed
book to the Gothic cathedral outside the window in *Notre
Dame de Paris*, he has him ominously proclaim, "this will de-
stroy that." But what will happen next when the book as an
object itself is in danger of destruction, replaced by other, tech-
nological transmitters of "content"? This is in practical terms
unlikely to happen; books are not going away any time soon.
Cities, Gothic cathedrals and books have proven marvelously

resilient given the attacks on their usefulness each has sustained, but what happens when the ideas they embody no longer inspire us to reconstruct them again? The book requires an able engaged reader as much as an able publisher, as Umberto Eco and Ivan Illich have shown.

> "All nature is pregnant with sense, and nothing in all of the universe is sterile." In this sentence, Hugh [Abbot of St. Victor] brings centuries of Christian metaphor to their full maturity. . . . Nature is not just like a book; nature itself is a book, and the manmade book is its analogue. Reading the manmade book is an act of midwifery. Reading, far from being an act of abstraction, is an act of incarnation. Reading is a somatic, bodily act of birth attendance witnessing the sense brought forth by all things encountered by the pilgrim through the pages.[9]

Yet the book also requires a culture of the book as a value in and of itself. This is Enzo Crea's and his son, Alessio's, field of battle. They are alive to what books say, how they feel in the hands, how they look (and no doubt even how they smell) and what they *mean*, and this care is reflected directly in the books they make with so much effort. And that effort is the best line of defense in keeping the book as a valued object alive.

What was true for the book was also once true of cities and their buildings: Reading them was a dynamic participatory act, and a city's narrative content was continually reborn for the alert citizen. "Building" the city in its fullest sense was therefore a continuous process rather than a onetime act, and the meanings cities embodied were placed there and actively retrieved in a continual exchange. Keeping cities alive is an ongoing operation of building even more than preservation—because the latter is ultimately, tragically, a pessimistic resignation to our inability to equal the past. The Renaissance, after all, destroyed a tremendous amount of ancient Rome in cannibalizing it for its own

uses; but the Rome it made gave a new life to that moribund place of tumbledown ruins. Keeping a city alive has more to do with construction than conservation.

THE REMEMBERED CITY

As books build on other books, cities have built on the image of other cities; there is no shame in this, nor a lessening of aspirations. On the contrary, for cities to contest their greatest predecessors is motivation to exceed them. Venice, for example, took on several of them—Alexandria, Constantinople and Rome—and emerged confidently unique for it.

Thus, if we need to recover one fundamental trait before embarking upon this seemingly arduous task of building cities that embody our ideals, it is the Renaissance's optimism in the face of a great legacy. We need confidence in our potential to operate positively for the good in the world, and therefore to believe we can measure up to the best of the past. Bramante and Alberti were convinced that they could not only measure up to antiquity but could exceed it.

The single most telling characteristic of the Renaissance mind is indeed this courageous optimism. Is it brash, foolish, naive or wrongheaded to believe we can equal the best of the past, or is it more honestly just plain timid or pessimistic not to try? We certainly owe the achievements of Renaissance Rome, Florence or Venice to the latter opinion; take this small sixteenth-century panegyric about a contemporary Venetian rival to a renowned classical Greek sculptor as an example.

> If some worthy man from ancient times could behold these sacred towers of the sea [the bronze flagpoles in the Piazza San Marco in Venice] he would swear that they were the product of Phidias's genius, but he who has sculpted [them] is Alessandro

Lionpardo, the new glory of our age, who shines like a star
upon the Venetian waters.[10]

Obviously it takes more than will to equal Phidias; it takes
skill. But without optimism, ability is satisfied with the novel
rather than the exceptional.

BACK TO PARADISE

The Herculean task of reclaiming beauty and meaning for sky-
line and street requires nothing less than reclaiming the Image
of the City as a metaphor for Paradise, despite all contemporary
evidence to the contrary and all the self-imposed roadblocks in
the way. It is not enough merely to reappropriate the formal
components by which the City may be, in the late urban histo-
rian Spiro Kostoff's word, *assembled*.[11] We define our aspira-
tions in the building of our legacy, and so it is not merely a
question of *what* we build but *how* we build and *why*. Surely
our contemporary built environment lacks beauty or the proper
human scale and balance of the res publica and res privata, but
it also lacks the humanizing effects of meaning and empathy, is-
sues that ennoble not only our public life but our public soul.
Forms that arise without meaning are arbitrary and therefore at
best meaningless. At worst they are bearers of meanings we may
not endorse (consider the cynical message of the Manhattan sky-
line, where the city's hierarchy of values, if it matches the
heights of its buildings, is solely economic in scale). In noble
cities redolent with meaning we find the best of our human ca-
pacity to intervene in the world and leave behind a legacy that
allows our children to most fully live the good life.

The most courageous first step then is reclaiming the ability
to reimagine the City, to conceive if not yet realize an image of a

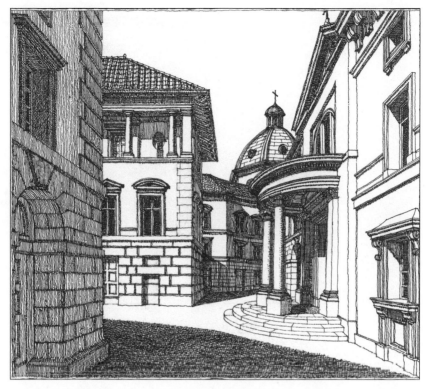

Fig. C.1 Thomas Norman Rajkovich (1960–), *Ideal Rhetorical City View*

city that embraces the best of our aspirations. Simply put, we need to draw it.

Can we credibly put a picture on our aspirations? Does that image measure up with the greatest cities we know? What ultimately does it *say*, and at how many levels? We do not lack for audacity in so many other fields today, but in this most lasting legacy we have mostly surrendered our contributions to chance. Rome, Venice, Florence, Siena and Pienza are more than tourist destinations, they are living models—built by human hands not so different from our own—of humane ways of living together and living on the land.

NOTES

INTRODUCTION

1. The Renaissance writer and architect Leon Battista Alberti, in the first treatise on the art of building since antiquity, could not begin to discuss the making of architecture without first describing how cities should be designed—for him the noblest architecture was *civil* in the fullest sense of the word.

2. For 2000 the bureau says 80.3 percent lived in a "metropolitan" area; see **www.census.gov/statab/www/poppart.html**. The bureau's website provides this definition of *urban* (emphasis mine): For Census 2000, the Census Bureau classifies as "urban" all territory, population, and housing units located within an urbanized area (UA) or an urban cluster (UC). It delineates UA and UC boundaries to encompass densely settled territory, which consists of:

- core census block groups or blocks that have a population density of at least 1,000 people per square mile and
- surrounding census blocks that have an overall density of at least 500 people per square mile.

In addition, under certain conditions, *less densely settled territory may be part of each UA or UC.* See **www.census.gov/geo/www/ua/ua_2k.html**.

3. See Koolhaas, *Delirious New York.*

4. The city was sacked by the Visigoths under Alaric in A.D. 410.

5. Mauro, "Pius II: Humanist Pope," ch. 2.

6. Rowland, *Culture of the High Renaissance,* 10.

7. The aspects of humanist culture that had changed for the Middle Ages after the end of the classical period was the loss of many Roman and Greek authors' works and the addition of or substitution with the writings of Christian authors. While the Church had its problems with some of the more licentious classical writers such as Ovid, it endorsed the core of the education system that had created Ovid because this was also the system that formed late classical saints and thinkers such as Augustine, Jerome and Boethius. Medieval scholars struggled to reconcile the philosophy of Aristotle, which gave order to this academic tradition, with the teachings of Christ and the saints, and the heroic achievement of Thomas Aquinas's monumental *Summa Theologica* was the fullest reconciliation

238 *Notes*

of Aristotle and Christianity available. In the next centuries early Renaissance thinkers would seek more direct contact with the classical past than had their medieval scholastic predecessors by hunting down unrecognized ancient texts in far-off monasteries, studying Arabic translations of otherwise lost classical authors, reintroducing the pivotal role and writings of Plato and the study of Greek into the canon, and stripping away centuries of accrued misinterpretation (historians call this new attitude *philological rigor*). These scholars finally reorganized the *studia humanitatis* in ways that carried on for centuries across Europe as the education system that would give the English-speaking world Shakespeare (who had read Ovid, Plutarch and Virgil in "grammar" school) and Milton.

8. Arendt, *Between Past and Future*, 225. Cicero too sums up the priority of authority in classical humanism in *Tusculan Disputations* (translation by Arendt), "It is a matter of taste to prefer Plato's company and the company of his thoughts even if this should lead us astray from truth."

9. Born Aeneas Silvius Piccolomini.

10. Burkhardt, *Civilization of the Renaissance in Italy*, pt. 2, "Personality."

11. Alberti, *On the Art of Building*, Book 8, sec. 4, 257.

12. The other architect in Vincenzo Scamozzi, Palladio's follower, whom we will encounter in Venice.

13. Perez-Gomez, *Architecture and the Crisis of Modern Science*, 212.

CHAPTER 1: ROME

1. For a full treatment of Rome's origins see Rykwert, *The Idea of a Town*.

2. Five centuries after Aeneas' grandson Romulus built the city's first wall at the foot of the Palatine hill the Romans, commanded by the Sibylline Books, brought the goddess Cybele (the Great Mother, the Earth Mother or Mother Nature) to Rome from Mount Ida and installed the Phrygian deity on the Palatine. Cybele, goddess of agriculture but crowned with turreted city walls, condensed in her image the intricate, intimate interdependence of city and countryside.

3. Zanker, *Power of Images*, 98.

4. Ibid., 101.

5. Rowland and Howe, *Vitruvius*.

6. The emperor's title *pontifex maximus*, literally "great bridge builder," signified in fact *high priest*; it would be adopted later by the popes as their classical moniker.

7. Zanker, *Power of Images*, 89.

8. Hadrian's temple required as well the relocation of the Colossus of Nero, which was transformed into a statue of *Sol* (the Sun); see Boatwright, *Hadrian and the City of Rome*, 120ff. for a full treatment of the temple and its precinct.

9. Ibid., 129.

10. Jacks, *The Antiquarian and the Myth of Antiquity*, 26.

11. Pantheon, from *pan-theos*, was the place where all the gods were worshiped.

12. For an ingenious answer to explain the anomalies see Jones, *Principles of Roman Architecture*, 199ff.

13. Ibid., 206ff., which depends on Hasselberger, *Mitteilungen des Deutschen Archäologischen Instituts*, "Ein Giebelriss der Vorhalle des Pantheon," CI, 279–308.

14. Boatwright, *Hadrian and the City of Rome*, 161ff.

15. Spence, *The Memory Palace of Matteo Ricci*, 2.

16. Calvino, *Invisible Cities*, 15–16.

17. Ibid.

18. MacDonald and Pinto, *Hadrian's Villa*, 193.

19. *Tibur Vetus*: Ibid., 207; *teatrum mundi*, literally "theater of the world."

20. Translated by Fr. Christopher Dillon, O.S.B., from Krautheimer, *Rome*, 200.

21. Ibid., 188.

22. Frugoni, *A Distant City*, 8.

23. *Illiterate* meant then what it meant in the Renaissance—that is, "unlettered" (i.e., not unable to read but unable to read *Latin*).

24. Frugoni, *A Distant City*, 12.

25. Ibid., 10ff.

26. Huizinga, *Waning of the Middle Ages*, 194.

27. Eco, *Art and Beauty in the Middle Ages*, 54–55.

28. Jacks, *The Antiquarian and the Myth of Antiquity*, 54; he goes on to quote the fourteenth-century author Galvaneo della Fiamma, "As Rome takes the form of a lion, so Brindisi the deer, Troy the horse, Carthage the cow, Genoa the griffon, Cremona the pig, Pavia the fox, Piacenza the rooster."

29. Stinger, *The Renaissance in Rome*, 39.

30. Krautheimer, *Rome*, 189.

31. Hildebert of Lavardin, in ibid., 201.

32. Krautheimer, *Rome*, 191.

33. Born in 1444, Bramante arrived in Rome just before the holy year of 1500; blessed with a charming personality, he was known by the diminutive Donino to his friend Leonardo da Vinci.

34. The other, certain, as it turns out, was the Circus of Nero in front of what became the Vatican basilica; the spine of the Circus of Nero corresponds more or less to the modern boulevard called the via della Conciliazione.

35. Bruschi, *Bramante*, 129ff.

36. Partridge, *The Art of Renaissance Rome*, 46–49.

37. Compare with Krautheimer, *Rome*, 205.

38. I owe this observation to Richard Cameron and his students at the University of Notre Dame's Rome Studies program, 1990–1991.

39. The Pantheon: Known since the seventh century as the Church of Sancta Maria ad Martyres.

40. Rowland, *Culture of the High Renaissance*, 164.

41. Saint Augustine, *De Trinitate*, vol. 9, bk. 6, 281.

42. Westfall, *In This Most Perfect Paradise*, 96–98.

43. Stinger, *Renaissance in Rome*, 263–64.

44. *Laudatio Florentiæ Urbis* in Jacks, *The Antiquarian and the Myth of Antiquity*, 82; he refers the reader to the full translation in B. G. Kohl, R. G. Witt and E. B. Welles, *The Earthly Republic: Italian Humanists on Government and Society* (Philadelphia: University of Pennsylvania, 1978), 139.

45. Briganti, *Gli Amori degli Dei*, 37.

46. All the world's a stage, And all the men and women merely players: They have their exits and their entrances; And one man in his time plays many parts, His acts being seven ages. (2.7.139)

47. Krautheimer, *The Rome of Alexander VII, 1655–1667*, 4, 6. He continues, "It is what Du Bellay, writing in 1558, has in mind: . . . *Rome est de tout le monde un publique éschafault Un scène, un théâtre auquel rien ne default De ce qui peult tomber ès actions de l'homme. Icy se void le jeu dela Fortune. . . .*"

48. Alberti, *On the Art of Building*, 23.

49. The piazza was much altered in the early nineteenth century by the architect Giuseppe Valadier, when it acquired the grand exedras that widened the piazza dramatically to the east and west.

50. Sta. Maria dei Miracoli on the right, Sta. Maria in Montesanto on the left.

51. Westfall, *In This Most Perfect Paradise*, 149–50.

52. Frieberg, *The Lateran and Clement VIII*, 29.

53. Connors, "Alliance and Enmity," 211.

54. The Banco di Santo Spirito was linked by temporary triumphal arches to its neighbors for Leo X's procession in 1513, allowing views through the arches not unlike the "streets" added later by Vincenzo Scamozzi to the *scena* of Palladio's Olympic Theater in Vicenza.

55. Ingersoll, *Ritual Use of Public Space in Renaissance Rome*, 186ff.

56. Eco, *Six Walks in the Fictional Woods*, 6.

57. Another was the so-called Marforio, now in the Capitoline Museums; a female contributor to the conversation was the Madama Lucrezia in front of the church of San Marco. More aptly named "ventriloquist" statues, these weathered marble figures were used by anonymous Roman pundits to say what couldn't be said in public. The Romans would attach diatribes and poems, in Latin or local dialect, to the figures in the dead of night, sometimes covering the figures in a veritable textual toga. The tradition continues even today on the Pasquino in its eponymous piazza.

58. Palazzo Orsini: later the Palazzo Braschi and now the Museum of Rome.

59. Frugoni, *A Distant City*, 89.

60. The dome was designed by Carlo Maderno, architect of the completion of St. Peter's, circa 1620.

61. Hammond, *Music and Spectacle in Baroque Rome*, 43; and Scott, *Images of Nepotism*.

62. *IL 60: Essays Honoring Irving Lavin*.

63. Ingersoll, *Ritual Use of Public Space in Renaissance Rome*, 151–53.

64. Westfall, *In This Most Perfect Paradise*, 103.

65. Ibid., 103ff.

66. Gianlorenzo Bernini, quoted in Wittkower, *Art and Architecture in Italy*, 195.

67. Lavin, *Bernini and the Unity of the Visual Arts*.

68. Francesco di Giorgio, from his *Treatise*, quoted in Millon, ed., *The Renaissance*, 540.

69. *Borgo* could mean both neighborhood and street.

70. Paul, *Letter to the Ephesians*, 2.14–16, 19–22.

71. "Spiritual Exercises": Weil, *The History and Decoration of the Ponte Sant Angelo*, 89ff. The *Cathedra Petri* is a representation of the chair of Saint Peter, a relic of which is encased within it. A cathedral is the home of the bishop's chair; San Giovanni, not St. Peter's, is the cathedral of Rome.

72. Thanks to records of his statements contained in Chantelou's contemporary diary of the artist's trip to France, and from the research of historians such as Rudolf Wittkower, Irving Lavin and Tod Marder. Blunt, *Diary of the Cavaliere Bernini's Visit to France.*

73. Rowland, *Culture of the High Renaissance*, 141.

74. His chosen name was, like many popes, a deliberate reference to an eponymous predecessor whom they admired; it also had a certain archaic Greek appeal in its equivalent *Xystus*, which can mean a type of classical garden.

75. Krautheimer, *Rome*, 49.

76. Ibid., 49–50.

77. Frugoni, *A Distant City*, 14.

78. The actual architect behind most of his projects was the highly competent, if somewhat uninspired, Domenico Fontana; like many other notable "Roman" architects, he hailed from the canton of Ticino in Switzerland.

79. Illich, *In the Vineyard of the Text*, 109–10.

80. O'Malley, *Rome and the Renaissance*, 279.

81. Saint Augustine of Hippo, *Confessions*, vol. 10, bk. 9, 216.

82. Pirro Ligorio, antiquarian and architect of the Casino of Pius IV in the Vatican gardens, from his *Libro X*, circa 1560, in Smith, *The Casino of Pius IV*, 42.

CHAPTER 2: VENICE AND THE SEA

1. Crouzet-Pavan, *Venice Triumphant*, 44.

2. Ibid., 17.

3. Kallendorf, *Virgil and the Myth of Venice*, 17–18.

4. Ibid., 25.

5. Ibid., 26–27.

6. Muir, *Civic Ritual in Renaissance Venice*, 119–23.

7. Contarini quoted in Kallendorf, *Virgil and the Myth of Venice*, 16–17.

8. Tafuri, *Venice and the Renaissance*, 21, citing a petition of 1507 from the convent of San Salvador to the Doge and Council of Ten.

9. Ibid., 18–19.

10. Newett, *Canon Pietro Casola's Pilgrimage to Jerusalem*, 338.

11. Crouzet-Pavan, *Venice Triumphant*, 23.

12. Ibid., 32.

13. Howard, *Architectural History of Venice*, 150–52.

14. Old and new Procuratie: They became "Vecchie" when the later Procuratie (Nuove) were built.

15. Muir, *Civic Ritual in Renaissance Venice*, 190 (emphasis mine).

16. Summa of human culture: Brown, *Venice & Antiquity*, 43.

17. Tafuri, *Venice and the Renaissance*, 139.

18. Muir, *Civic Ritual in Renaissance Venice*, 220.

19. In Tafuri, *Venice and the Renaissance*, 146.

20. Ibid., 148.

21. Brown, *Venice & Antiquity*, 282.

22. Tafuri, *Venice and the Renaissance*, 157; for the connection between Serlio, Camillo and Sansovino see 58ff.

23. Serlio's influence: Onians, *Bearers of Meaning*, 287–99.

24. Cleugh, *The Divine Aretino*, 111.

25. Pincus, *Tombs of the Doges of Venice*.

26. Howard, *Jacopo Sansovino*, 8.

27. Ibid., 1.

28. Ibid., 8.

29. Johnson, "Jacopo Sansovino, Giacomo Torelli," 436–53.

30. The *scena frons* represented an urban palace front.

31. Johnson, "Jacopo Sansovino, Giacomo Torelli."

32. Onians, *Bearers of Meaning*, 288.

33. Sansovino would have known the spandrel Victories–attic cherubs arrangement from Peruzzi's facade of the Villa Farnesina in Rome.

34. Lotz, *Studies in Italian Renaissance Architecture*, 83–84.

35. Onians, *Bearers of Meaning*, 274.

36. Tafuri, *Venice and the Renaissance*, 167.

37. Napoleon would callously destroy an aspect of the piazza's meaning when he replaced the church of San Geminiano with a ballroom behind a new Scamozzi-like facade, making the trivial reading of the piazza as "Europe's living room" a concrete fact. The so-called Napoleonic wing was instigated by the conversion of the Procuratie Nuove into a royal palace. What the palace lacked was a ballroom, and so the wing was erected to satisfy the private use of the formerly public office building.

38. Marin Sanudo, *I diarii*, quoted in Brown, *Venice & Antiquity*, 273.

39. Cardinal Bessarion, 1468 donation letter, in Chambers and Pullan, *Venice*, 357–58.

40. Crouzet-Pavan, *Venice Triumphant*, 181.

41. Finlay, *Politics in Renaissance Venice*, 40–41.

42. Crouzet-Pavan, *Venice Triumphant*, 150ff.

43. Ibid., 152.

44. Ackerman, *Palladio*, 145–48.

45. Tzonis and Lefaivre, *Classical Architecture: The Poetics of Order*, 152ff.; see esp. 157: "*aposiopesis* [is] the interruption of a series . . . *abruptio* the breaking off of an element of a series . . . and *epistrophe* the return to the initial series or element."

46. Wittkower, *Art and Architecture in Italy*, 292–300.

47. Europeanwide implications: cogently laid out in Wills, *Venice*, 343–55. This is an excellent source generally for the representation of Venetian society, religion and politics in the visual arts.

48. Crouzet-Pavan, *Venice Triumphant*, 32.

49. Muir, *Civic Ritual in Renaissance Venice*, 190.

CHAPTER 3: FLORENCE VS. SIENA

1. Alberti, *On the Art of Building*, Book 7, sec. 1, 189.
2. For which they were poorly rewarded; see *Metamorphoses* 11.199f in Preston, *Dictionary of Pictorial Subjects*.
3. See Apollodorus, *Library* 3.5.5, and Apollonius Rhodius, *Argonautica* 1.735f, both cited in Preston, *Dictionary of Pictorial Subjects*.
4. Abbess Hildegard of Bingen, *O Ierusalem*, in Page, *Feather on the Breath of God*, 13.
5. Alberti, *On the Art of Building*, Book 4, sec. 2, 95 (emphasis mine).
6. Ibid., xviiff.
7. Suffix *-chester*: Rykwert, *The Idea of a Town*, 68.
8. Leonardo Bruni, *History of the Florentine People Book XII*, in Baldassarri and Saiber, eds., *Images of Quattrocento Florence*, 16.
9. Cristoforo Landino, "To Antonio Canigiani: On the Founding of Florence," in Baldassarri and Saiber, eds., *Images of Quattrocento Florence*, 30.
10. Alberti, *Profugiorum ab aerumna, libri III*, in Smith, *Architecture in the Culture of Early Humanism*, 7.
11. Warren, "Brunelleschi's Dome," 92–105.
12. Grafton, *Leon Battista Alberti*, 281.
13. Ibid., 281.
14. Ibid., 282 (emphasis mine).
15. Frugoni, *A Distant City*, 174ff.; and Beccherucci and Brunetti, *Il Museo dell'Opera del Duomo a Firenze*, vol. 1, 234.
16. Seznec, *Survival of the Pagan Gods*.
17. Fei, Sica, and Sica, *Florence*, 41.
18. Hibbert, *Florence*, 49.
19. Frugoni, *A Distant City*, 59.
20. Goro Dati, *Istoria di Firenze dall'anno MCCCLXXX all'anno MCCCCV*, in Baldassarri and Saiber, eds., *Images of Quattrocento Florence*, 17 18.
21. Rubinstein, *The Palazzo Vecchio*, 47.
22. Mid fifteenth century: When it was redecorated by Michelozzo; other substantial renovations followed in the subsequent century.
23. In my immigrant grandparents' neighborhood in Allentown, Pennsylvania, one was known as *Toscano* or *Veneto* or *Romano*.
24. Coluccio Salutati, *Invectiva in Antonium Luschum*, ca. 1400, in Smith, *Architecture in the Culture of Early Humanism*, 180.
25. Ibid.
26. Bruni, *Praise of the City of Florence*, in Baldassarri and Saiber, eds., *Images of Quattrocento Florence*, 41.
27. *Epistolarum* in Jacks, *The Antiquarian and the Myth of Antiquity*, 83.
28. Leon Battista Alberti's Dedicatory letter to Filippo Brunelleschi, in Alberti, *On Painting*, 34–35.
29. Trexler, *Public Life in Renaissance Florence*, 250–51.
30. Goy, *Florence*, 213–14.

31. For a thorough and thoroughly readable account of the Medici in Florence see Hibbert, *The House of Medici*.

32. Alberti, *On the Art of Building*, 121–22.

33. Benedetto Dei, from a panegyric of Florence, "The City's Unparalleled Prosperity," in Baldassarri and Saiber, eds., *Images of Quattrocento Florence*, 86–87.

34. Jacks, *The Antiquarian and the Myth of Antiquity*, 86–87.

35. Ibid., 89.

36. Galuzzi, *Renaissance Engineers from Brunelleschi to Leonardo da Vinci*, 27.

37. Ibid., 32.

38. Ibid., 120–21; these *bottini* were still in use until the last few decades.

39. Norman, *Siena and the Virgin*, 10ff.

40. Montaigne, in Frame, *Travel Journal*, 159.

41. Waley, *Siena and the Sienese in the Thirteenth Century*, 8–9.

42. Ibid., 12.

43. Norman, *Siena and the Virgin*, 54.

44. Jacks, *The Antiquarian and the Myth of Antiquity*, 86.

45. Reardon, *Holy Concord Within Sacred Walls*, 123.

46. Frugoni, *A Distant City*, 131.

47. Ibid., 187*n*247.

48. Reardon, *Holy Concord Within Sacred Walls*, 3ff.

49. Frugoni, *A Distant City*, 162.

50. From the *Cronache Senesi*, in Norman, *Siena and the Virgin*, 21 (trans. with amendments from White, *Duccio*).

51. Panofsky, *Abbot Suger*, 63, 65.

52. Norman, *Siena and the Virgin*, 87ff.

53. Paton, "'Una Città Fatticosa,'" 113.

54. Ibid.

55. Ibid., 121–22.

56. Waley, *Siena*, 14.

57. Paton, "'Una Città Fatticosa,'" 123.

58. Pinto, "'Honour' and 'Profit,'" 81ff.

CHAPTER 4: PIENZA

1. Mack, *Pienza*, 27–28.

2. Pius II in ibid., 18.

3. Ibid., 26.

4. Montalcino: A product of nineteenth-century oenology.

5. Penn, *Reflexions and Maxims*, pt. i, no. 52.

6. Westfall, *In This Most Perfect Paradise*, 86.

7. Alberti, *On the Art of Building*, Book 1, sec. 4, 13.

8. Ibid., Book 1, sec. 9, 23.

9. Pius II, *Commentarii*, in Mack, *Pienza*, 60.

10. Nicholas of Cusa, *de Concordantia Catholica* (1433) in Ross and McLaughlin, eds., *Portable Renaissance Reader*, 624ff.

11. According to Mack, the ideal view is that from the street perpendicular to the cathedral as it enters the piazza. This is unlikely, however, since it was not the main street of the town and did not have its own gate, nor was it marked in any way at the town edge as a primary conveyor.

12. Smith, *Architecture in the Culture of Early Humanism*, 119–25.

13. George of Trebizond in Baxandall, *Giotto and the Orators*, 94–95.

14. Alberti, *On the Art of Building*, Book 5, sec. 17, 146 (emphasis mine).

15. Ibid.

16. Rowland and Howe, *Vitruvius*, Book 1, ch. 6, pt. 1, 29.

17. Mack, *Pienza*, 125–39.

18. Ibid., 60.

19. Ibid., 150.

20. Alberti, *On the Art of Building*, Book 1, sec. 9, 24.

CONCLUSION

1. If the plan of Versailles did have a message, it was the domination of nature. But this is not the same as symbolic or allegorical content.

2. See Léon Krier's project for the city, most recently published in Krier, *Architecture*.

3. The Congress for the New Urbanism and its cofounder, Andres Duany, have adopted the concept of the transect to clarify this phenomenon and its rehabilitation; see their website **www.cnu.org**.

4. Sennett, *Flesh & Stone*, 264. Sennett refers to Christian Patte, but I believe he in fact meant Pierre, the eighteenth-century architect, engraver, and theorist.

5. As Léon Krier contends in *Architecture*.

6. Roth, *McKim, Mead, and White*, 361.

7. Pope Pius II in Mack, *Pienza*, 107.

8. Eco, *Six Walks in the Fictional Woods*, 6. Eco, it should be said, suggests cities can be types of "woods."

9. Illich, *In the Vineyard of the Text*, 123.

10. Pietro Contarini, *L'Argoa volgar*, in Chambers and Pullan, *Venice*, 399.

11. Kostoff, *The City Assembled*.

12. Paul, *Letter to the Ephesians*, 2.14–16, 19–22.

ILLUSTRATIONS

BIBLIOGRAPHY

Ackerman, James S. *Palladio*. New York: Penguin Books, 1979.
Alberti, Leon Battista. *On the Art of Building in Ten Books*. Translated by Joseph Rykwert, Neil Leach, and Robert Tavernor. Cambridge, MA: MIT Press, 1989.
———. *On Painting*. Translated by Cecil Grayson. New York: Penguin Books, 1991.
Arendt, Hannah. *Between Past and Future*. New York: Viking Penguin, 1993.
Augustine of Hippo, Saint. *Confessions*. Translated by R. S. Pine-Coffin. New York: Penguin Books, 1984.
———. *De Trinitate*. Translated by Stephen McKenna. Washington, DC: Catholic University of America Press, 1988.
Baldassarri, Stefano Ugo, and Arielle Saiber, eds., *Images of Quattrocento Florence: Selected Writings in Literature, History and Art*. New Haven, CT: Yale University Press, 2000.
Baxandall, Michael. *Giotto and the Orators: Humanist Observers of Painting in Italy and the Discovery of Pictorial Composition 1350–1450*. Oxford: Oxford University Press, 1971.
Beccherucci and Brunetti. *Il Museo dell'Opera del Duomo a Firenze*. Milan: Electa, 1970.
Blunt, Anthony. *Guide to Baroque Rome*. New York: Granada, 1982.
Boatwright, Mary Taliaferro. *Hadrian and the City of Rome*. Princeton, NJ: Princeton University Press, 1987.
Briganti, Giulio. *Gli Amori degli Dei*. Rome: Edizioni dell' Elefante, 1987.
Brown, Patricia Fortini. *Venice & Antiquity*. New Haven, CT. Yale University Press, 1996.
Bruschi, Arnaldo. *Bramante*. London: Thames & Hudson, 1977.
Burkhardt, Jacob. *Civilization of the Renaissance in Italy*. Translated by S. G. C. Middlemore. New York: Penguin, 1990.
Calvino, Italo. *Invisible Cities*. Translated by William Weaver. New York: Harcourt Brace Jovanovich, 1974.
Chambers, David, and Brian Pullan. *Venice: A Documentary History, 1450–1630*. Oxford: Oxford University Press, 1992.

de Chantelou, Paul F. *Diary of the Cavaliere Bernini's Visit to France*. Edited by Anthony Blunt. Princeton, NJ: Princeton University Press, 1985.

Cleugh, James. *The Divine Aretino*. New York: Stein and Day, 1966.

Connors, Joseph. "Alliance and Enmity in Roman Baroque Urbanism." *Römisches Jahrbuch der Bibliotheca Hertziana 25*, 1989.

———. *Borromini and the Roman Oratory: Style and Society*. Cambridge, MA: MIT Press, 1980.

Crouzet-Pavan, Elizabeth. *Venice Triumphant: The Horizons of a Myth*. Translated by Lydia G. Cochrane. Baltimore: Johns Hopkins University Press, 2002.

Eco, Umberto. *Art and Beauty in the Middle Ages*. Translated by Hugh Bredin. New Haven, CT: Yale University Press, 1986.

———. *Six Walks in the Fictional Woods*. Cambridge, MA: Harvard University Press, 1994.

Fei, Silvano, Grazia Gobbi Sica, and Paolo Sica. *Florence: An Outline of Urban History*. Florence: Alinea Editrice, 1995.

Finlay, Robert. *Politics in Renaissance Venice*. Princeton, NJ: Princeton University Press, 1980.

Frieberg, Jack. *The Lateran and Clement VIII*. Ann Arbor, MI: University Microfilms International, 1988.

Frugoni, Chiara. *A Distant City: Images of Urban Experience in the Medieval World*. Translated by William McCuaig. Princeton, NJ: Princeton University Press, 1991.

Galuzzi, Paolo. *Renaissance Engineers from Brunelleschi to Leonardo da Vinci*. Florence: Giunti, 1996.

Goy, Richard. *Florence: The City and Its Architecture*. New York: Phaidon, 2002.

Grafton, Anthony. *Leon Battista Alberti*. London: Penguin Press, 2001.

Hammond, Frederick. *Music and Spectacle in Baroque Rome*. New Haven, CT: Yale University Press, 1994.

Hasselberger, Lothar. "Ein Giebelriss der Vorhalle des Pantheon." *Mitteilungen des Deutschen Archäologischen Instituts: Römische Abteilung*, 1994.

Hibbert, Christopher. *Florence: The Biography of a City*. New York: Penguin, 1994.

———. *The House of Medici: Its Rise and Fall*. New York: Penguin, 1982.

———. *Rome: The Biography of a City*. New York: W. W. Norton, 1985.

Howard, Deborah. *The Architectural History of Venice*. New Haven, CT: Yale University Press, 2002.

———. *Jacopo Sansovino: Architecture and Patronage in Renaissance Venice*. New Haven, CT: Yale University Press, 1975.

Huizinga, Johan. *The Waning of the Middle Ages*. London: Harmondsworth, 1965.

IL 60: Essays Honoring Irving Lavin on His 60th Birthday. New York: Italica Press, 1990.

Illich, Ivan. *In the Vineyard of the Text*. Chicago: University of Chicago Press, 1993.

Ingersoll, R. J. *The Ritual Use of Public Space in Renaissance Rome*. Ann Arbor, MI: University Microfilms International, 1993.

Jacks, Philip Joshua. *The Antiquarian and the Myth of Antiquity: The Origins of Rome in Renaissance Thought*. Cambridge: Cambridge University Press, 1993.

Johnson, Eugene J. "Jacopo Sansovino, Giacomo Torelli, and the Theatricality of the Piazzetta in Venice." *Journal of the Society of Architectural Historians* 59, 4 (December 2000).

Jones, Mark Wilson. *Principles of Roman Architecture*. New Haven, CT: Yale University Press, 2000.

Kallendorf, Craig. *Virgil and the Myth of Venice*. Oxford: Oxford University Press, 1999.

King, Margaret L. *Venetian Humanism in an Age of Patrician Dominance*. Princeton, NJ: Princeton University Press, 1986.

Kohl, Benjamin G., and Ronald G. Witt. *The Earthly Republic: Italian Humanists on Government and Society*. Philadephia: University of Pennsylvania Press, 1978.

Koolhaas, Rem. *Delirious New York*. New York: Monacelli Press, 1997.

Kostoff, Spiro. *The City Assembled*. Boston: Little, Brown, 1992.

Krautheimer, Richard. *Rome: Profile of a City, 312–1308*. Princeton, NJ: Princeton University Press, 1980.

———. *The Rome of Alexander VII, 1655–1667*. Princeton, NJ: Princeton University Press, 1985.

Krier, Léon. *Architecture: Choice or Fate*. London: Andreas Papadakis, 1998.

Kunstler, James Howard. *The Geography of Nowhere*. New York: Simon and Schuster, 1993.

Lavin, Irving. *Bernini and the Unity of the Visual Arts*. New York: Oxford University Press, 1980.

Lotz, Wolfgang. *Studies in Italian Renaissance Architecture*. Cambridge, MA: MIT Press, 1977.

MacDonald, William L. *The Architecture of the Roman Empire*. Vol. 2. *An Urban Appraisal*. New Haven, CT: Yale University Press, 1986.

MacDonald, William L., and John A. Pinto. *Hadrian's Villa and Its Legacy*. New Haven, CT: Yale University Press, 1995.

Mack, Charles. *Pienza: The Creation of a Renaissance City*. Ithaca, NY: Cornell University Press, 1987.

Mauro, Thomas. "Pius II: Humanist Pope." Ph.D. diss., University of Chicago, 2002.

Millon, Henry, ed. *The Renaissance: From Brunelleschi to Michelangelo*. New York: Rizzoli, 1994.

Montaigne, Michael de. *Travel Journal*. Translated by Donald M. Frame. New York: North Point Press, 1983.

Muir, Edward. *Civic Ritual in Renaissance Venice*. Princeton, NJ: Princeton University Press, 1980.

Newett, Margaret M. *Canon Pietro Casola's Pilgrimage to Jerusalem in the Year 1494*. Manchester, 1907.

Norman, Diana. *Siena and the Virgin: Art and Politics in a Late Medieval City State*. New Haven, CT: Yale University Press, 1999.

O'Malley, John W. *Rome and the Renaissance: Studies in Culture and Religion*. London: Variorum Reprints, 1981.

Onians, John. *Bearers of Meaning*. Princeton, NJ: Princeton University Press, 1988.

Page, Christopher. *A Feather on the Breath of God*. London: Hyperion, 1986.

Panofsky, Erwin. *Abbot Suger on the Abbey Church of St.-Denis and Its Art Treasures*. Princeton, NJ: Princeton University Press, 1946.

Partner, Peter. *Renaissance Rome 1500–1559: A Portrait of a Society*. Berkeley: University of California Press, 1976.

Partridge, Loren. *The Art of Renaissance Rome*. New York: Abrams, 1996.

Paton, Bernadette. "'*Una Città Fatticosa*': Dominican Preaching and the Defense of the Republic in Late Medieval Siena." In *City and Countryside in Late Medieval Italy*. London: Hambledon Press, 1990.

Penn, William. *Some Fruits of Solitude, in Reflexions and Maxims, Relating to the Conduct of Human Life*. London: E. Arnold, 1901.

Perez-Gomez, Alberto. *Architecture and the Crisis of Modern Science*. Cambridge, MA: MIT Press, 1990.

Pincus, Debra. *The Tombs of the Doges of Venice*. Cambridge: University of Cambridge Press, 1999.

Pinto, Giuliano. "'Honour' and 'Profit': Landed Property and Trade in Medieval Siena." In *City and Countryside in Late Medieval Italy*. London: Hambledon Press, 1990.

Preston, Percy. *Dictionary of Pictorial Subjects from Classical Literature*. New York: Scribner's, 1983.

Reardon, Colleen. *Holy Concord Within Sacred Walls: Nuns and Music in Siena, 1575–1700*. Oxford: Oxford University Press, 2001.

Ross, James Bruce, and Mary Martin McLaughlin, eds. *The Portable Renaissance Reader*. New York: Viking Press, 1977.

Roth, Leland M. *McKim, Mead, and White, Architects*. New York: Harper & Row, 1983.

Rowland, Ingrid D. *The Culture of the High Renaissance*. Cambridge, MA: Harvard University Press, 1999.

Rowland, Ingrid D., and Thomas N. Howe. *Vitruvius: Ten Books on Architecture*. Cambridge: University of Cambridge Press, 1999.

Rubinstein, Nicholai. *The Palazzo Vecchio 1298–1532: Government, Architecture, and Imagery in the Civic Palace of the Florentine Republic*. Oxford: Oxford University Press, 1997.

Rykwert, Joseph. *The Idea of a Town*. Cambridge, MA: MIT Press, 1988.

———. *The Seduction of Place*. London: Weidenfeld & Nicolson, 2000.

Scott, John Beldon. *Images of Nepotism: The Painted Ceilings of Palazzo Barberini*. Princeton, NJ: Princeton University Press, 1991.

Sennett, Richard. *Flesh & Stone: The Body and the City in Western Civilization*. New York: W. W. Norton, 1994.

Seznec, Jean. *The Survival of the Pagan Gods: The Mythological Tradition and Its Place in Renaissance Humanism and Art*. Translated by Barbara Sessions. Princeton, NJ: Princeton University Press, 1972.

Smith, Christine. *Architecture in the Culture of Early Humanism: Ethics, Aesthetics, and Eloquence 1400–1470*. Oxford: Oxford University Press, 1993.

Smith, Graham. *The Casino of Pius IV*. Princeton, NJ: Princeton University Press, 1976.

Spence, Jonathan D. *The Memory Palace of Matteo Ricci*. New York: Viking Penguin, 1984.

Stinger, Charles L. *The Renaissance in Rome*. Bloomington: Indiana University Press, 1985.

Tafuri, Manfredo. *Venice and the Renaissance*. Translated by Jessica Levine. Cambridge, MA: MIT Press, 1989.

Tatarkiewicz, Wladyslaw. *History of Aesthetics*. Edited by J. Harrell. The Hague, Netherlands: Mouton, 1970.

Trexler, Richard C. *Public Life in Renaissance Florence*. New York: Academic Press, 1979.

Tzonis, Alexander, and Lianne Lefaivre. *Classical Architecture: The Poetics of Order*. Cambridge, MA: MIT Press, 1997.

Waley, Daniel. *Siena and the Sienese in the Thirteenth Century*. New York: Cambridge University Press, 1991.

Warren, Charles W. "Brunelleschi's Dome and Dufay's Motet." *Musical Quarterly* 59 (1973).

Weil, Mark S. *The History and Decoration of the Ponte Sant Angelo*. State College: Pennsylvania State University Press, 1974.

Westfall, Carroll William. *In This Most Perfect Paradise: Alberti, Nicholas V and the Invention of Conscious Urban Planning in Rome, 1447–55*. State College: Pennsylvania State University Press, 1974.

White, John. *Duccio: Tuscan Art and the Medieval Workshop*. New York: W. W. Norton, 1980.

Wills, Garry. *Venice: Lion City*. New York: Simon and Schuster, 2001.

Wittkower, Rudolph. *Architectural Principles in the Age of Humanism*. New York: Random House, 1965.

———. *Art and Architecture in Italy: 1600–1750*. New York: Penguin Books, 1980.

Yates, Frances. *The Art of Memory*. Chicago: University of Chicago Press, 1966.

Zanker, Paul. *The Power of Images in the Age of Augustus*. Translated by Alan Shapiro. Ann Arbor: University of Michigan Press, 1990.

ACKNOWLEDGMENTS

This book began its life as another book: a career-long project to search out the ways in which Memory—or Mnemosyne—was mother of the Muses in classical culture. As the fabric of that myth took shape, it seemed that the story of how cities became the greatest examples of this familial bond between the past and inspiration deserved its own telling. Born therefore from such fruitful parents and siblings, this book thankfully acknowledges all those who have been a part of its genesis. To their inspiration, reflection and emendation whatever worthwhile insights are owed, while any errors of fact or judgment are wholly my own.

To the many art and architecture historians who inspired and informed me I am deeply grateful. To those I had the good fortune to meet and in some cases get to know well an even deeper bond compels me to acknowledge their specific influences: Joseph Connors, Director at the American Academy in Rome during my fellowship year, for providing a model of scholarship, fellowship and patronage; and Ingrid Rowland, Visitor at the Academy in that same year, for providing a continuing example of living humanism and good humor.

My education as an architect was graced by fortuitous encounters. Professor Richard Wesley, then of Notre Dame, instilled in me a lifelong commitment to architecture as narrative in both my work and what I draw on from the past. The late Colin Rowe first made me aware in Rome of how history could

inform practice today; and in walks on that city's streets Jeffery Blanchard made me fall in love with Rome herself.

In Rome as a student my collegial bond with Thomas Norman Rajkovich was forged and through collaboration and discussion in ensuing years has been cemented. I know of no other contemporary architect whose scholarship, persona and practice are as much all of a piece, and his rigorous, penetrating mind has sharpened both my outlook and the argument of this book. Beyond all that he has dared to draw the city of our dreams.

Many colleagues at the University of Notre Dame's School of Architecture offered helpful insights and good examples. Carroll William Westfall read the manuscript, saving me from several errors and omissions; those that remain are solely my responsibility. Victor Deupi pointed out several valuable avenues of inquiry. Chair Michael Lykoudis indulged my preoccupation with the manuscript and provided much-needed encouragement.

To the librarians at the American Academy in Rome and the University of Notre Dame, where much of the research for the manuscript was done, go my sincere appreciation for their assistance. This was written, thanks to my PowerBook, in many different places, some inspiring and some inconvenient; foremost among the former is the home of my patron, Lynn Aeschliman, and her husband, Dr. Michael Aeschliman—Capitignano was a glorious place to think about Florence and all the rest. To Lynn also go my thanks for opportunities to put some of these ideas into practice, and to Michael my appreciation for his insightful conversation, critical emendation and admirable academic example.

Two Graham Foundation travel grants gave me opportunities to study the history and routes of public processions in Rome, Florence and Venice. Cristiano Rosponi and Giampaolo Rossi in Rome and Duncan Stroik at Notre Dame published my article on Rome's processional routes that was the fruit of this

research in their catalogue of the exhibit *Riconquistare Lo Spazio Sacro: The Church and the City in the IIIrd Millennium.*

Several people read drafts of the manuscript (some mentioned here in other contexts). Christina Huemer, Head of the American Academy Library, provided helpful critiques. I especially owe it to the good sense of my editor at Westview Press, Sarah Warner, to have coaxed this book into existence from the seeds of another book. My agent, Ira Silverberg, has been a source of encouragement and clear-headedness. Taeho Paik, my coeditor of the online Humanist Art Review, has offered inspiring insights in many directions. Angelo Alberto clarified my thinking on town and country.

Finally, on a more personal note, my parents Emma and Joseph Mayernik bravely inculcated in me the folly of believing one could pursue his dreams, and I have translated that optimism to my reading of cities. My wife, Brette Ashley Jackson, has been muse, editor, researcher and fellow traveler. No amount of thanks can reward her complex role in the humanizing of this too-focused architect, nor her many contributions to the making of the manuscript. While this book may not have been possible without her, the best product of its pursuit has been sharing Rome, Venice, Florence, Siena and Pienza with her in situ.

INDEX